ANTARCTICA

YVES PACCALET

PHOTOGRAPHY BY PATRICK DE WILDE

ANTARCTICA

Flammarion

Atlantic Ocean

0° Bouvet Island

Marion Island Prince Edward Island

South Georgia South Sandwich Islands

South Orkney Islands

Crozet Island

Falkland Islands

King Haakon Bay

QUEEN MAUD LAND

South Shetland Islands

ANTARCTIC PENINSULA

ENDERBY LAND

Kerguelen Islands

COATS LAND

KEMP LAND

SOUTH AMERICA

Weddell Sea

MACROBERTSON LAND

McDonald Island
Heard Island

Bellingshausen Sea

ANTARCTICA

PRINCESS ELIZABETH LAND

Indian Ocean

Peter I Island

SOUTH POLE

90° West

ELLSWORTH LAND

90° East

WILHELM II LAND

MARY BYRD LAND

QUEEN MARY LAND

WILKES LAND

Amundsen Sea

Ross Sea

ADÉLIE LAND

Scott Island

Balleny Islands

Southern Ocean

Macquarie Island

Campbell Island

Auckland Islands

Antipodes Islands

TASMANIA

Snares Island

Bounty Islands 180° NEW ZEALAND

AUSTRALIA

CONTENTS

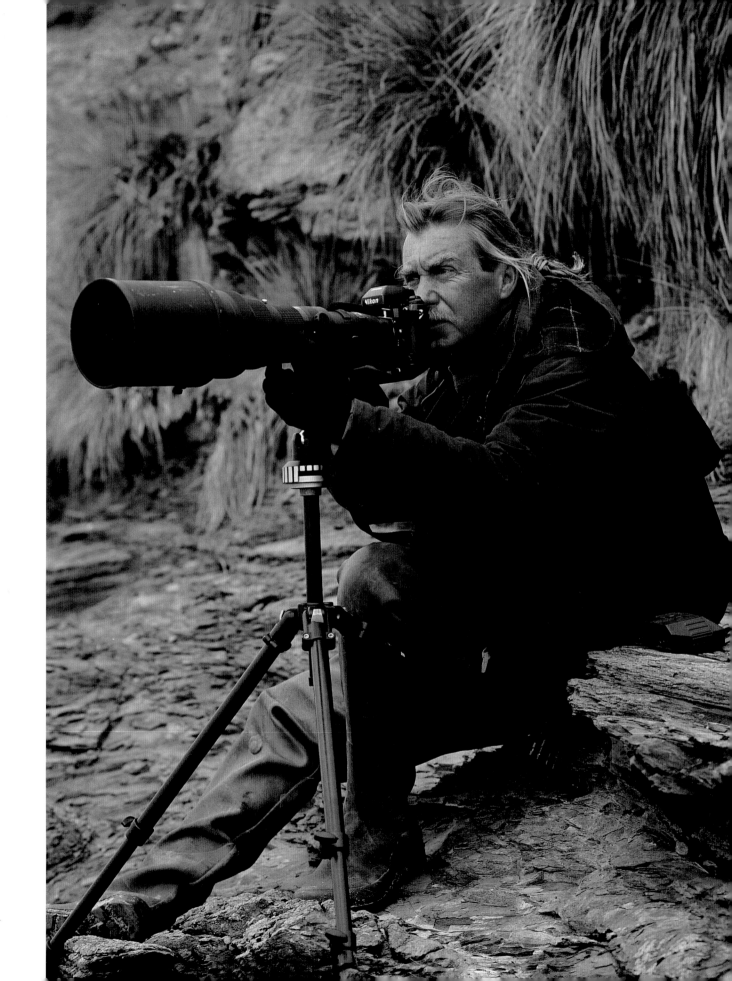

FOREWORD:
The Call of the Wild

Whole days spent rising and falling on the powerful ocean swell. Nothing to do but watch the waves surge, rise into crests, and crash in stinging, icy sea spray. I follow the albatrosses—which seem to skim the surface of the water—with my gaze, and look out for the green crystal droplets that glitter at the crest of each wave. Nothing to distract me from the endless surge of the ocean, which clutches my stomach and drives me to distraction. How many times was I tempted to lean just that little bit further over the gunwale to put an end to my seasick misery?

The Falklands, South Georgia, the South Orkneys, the South Shetlands, Elephant Island, Deception Island, King George Island, the Kerguelen Islands, Macquarie Island, Campbell Island, the Auckland Islands, Snares Island. The Roaring Forties, the Furious Fifties, the Screaming Sixties. The call of the wild. I first ventured to these southern fringes of the earth in late 1988. Since then I have been back five times, traveling via Tierra del Fuego or Tasmania. During these voyages, upon the solid *Society Explorer* or the humbler *Pelagic*, all that we ever saw at sea was one ship—the *Marion-Dufresne*—and countless whales and icebergs. My introduction to the fauna of the subantarctic region took place on Sea Lion Island in the Falklands Archipelago, also known as Las Malvinas.

It takes me back. . . . The ocean studded with shards of blue ice. Black-and-white petrels riding the airstreams like kites. Walking on a bed of moss in a land outside time, a new world; the only sound the strident cry of the gulls. I must tread carefully, as the ground is covered in the nests of orange-beaked Magellanic penguins. I walk to the top of a cliff. Down below, a flock of ducks splashing in the water, which shines with yellow glints. I pick my way down between tussocks of tall grass. I lean against a tree stump and watch the mating dance of the upland geese. A movement amid the rocks catches my eye—a sea lion, an old, solitary male, almost perfectly camouflaged against the polished gray of the rocks. Penguins waddle back to their nests. A caracara flies overhead, biding its time, then darts down and just as quickly away with its prey—a penguin egg. Here, nature rules supreme. Difficult to imagine the scenes that took place here until the mid-twentieth century, when ships would weigh anchor to slaughter hundreds of thousands of animals for their fur and blubber.

The Falklands are the only subantarctic islands that can be reached by plane, courtesy of the Royal Air Force. They are difficult, hostile terrain. Planes land on New Island. The landing is risky, but the sight that greets visitors on arrival is remarkable. The walls of the natural amphitheater towering over the white plumes of the waves are home to thousands of rockhopper penguins and black-browed albatrosses. It takes great adaptability and force of character to survive on this harsh terrain.

In normal sailing conditions, it takes two days to reach South Georgia from the Falklands. On the far side of the bay, where the white spray flies from the waves, I can just make out a few buildings with battered roofs—Grytviken Harbor. The village is gradually crumbling into rust. In days gone by, this was a whaling station. Now that whaling is strictly limited, the factory has shut and the men have left, leaving the elephant seals free to loll on the moss-covered shore.

On Salisbury Plain, thousands of penguins nest on the short yellow grass. The cliffs of Prion Island have a curious metallic sheen, where shrouds of snow meld with impenetrable mists. Along the coast, the Antarctic fur seals protect their territory. During the birthing season, in November, scavengers—gulls, skuas, sheathbills—squabble over the placentas. Further east, Gold Harbor shows off the glittering splendor of its crests, its ice-blue glaciers, and its rocks covered with lacy lichens. To the south, Copper Bay looks like the gigantic set of some Wagnerian opera. Between the rust-colored peaks, sea leopards lounge by cave entrances like the sirens of Greek mythology.

The ship sets out for Antarctica. The weather reports warn of storms. I stand on deck, muffled against the biting cold, and try to pierce the dense fog that shrouds the ship. From time to time, the swathes of mist part to reveal an iceberg. We are in a world without limits. Antarctica is not a country, barely a geographical entity at all, in fact. It is a moment, a gigantic breath that sweeps away the idea of frontiers as, every winter, the biting chill adds to the millions of square miles of blinding white. The ship crosses the Screaming Sixties and approaches Elephant Island on the storm-tossed far reaches of Antarctica. Dark rocks, lashed by whips of

spray, form a black-and-white landscape like a sketch in India ink. Here, paradoxically, light is born from darkness, as the emerald and crimson flare of the polar dawn caresses the quivering reflection of the snow-capped mountains.

The ship passes a rosary of islands—King George, Ardley, Livingstone. A white ring, like a garland of apple blossom, seems to float in the sky. It is the pinnacle of Deception Island, crowned with snow and wreathed with clouds. The only sounds are the shrieks of the cormorants and the waves lapping against the hull. Now and then, a penguin plunges into the depths, while petrels squabble over a catch. I catch sight of a colony of sea leopards lying on chunks of free-floating pack ice. The soothing lull of the waves hides a world of mysterious creatures—sea urchins, crayfish, strange starfish, vast ribbons of seaweed. Contrary to what you might think, the seas around Antarctica swarm with life. The plankton that multiplies at an incredible rate in the brief summer feeds vast banks of krill—tiny shrimps that attract squid, crabeater seals, fish, birds—and whales.

We weigh anchor, and I leave the ship for a short walk on the ice floe. It feels like being in a world made entirely of crystals carved of pure light. I trust to my senses, catching sounds and smells, following a narrow pink corridor to a nesting site which is home to a colony of chinstrap penguins, with golden eyes and a black line around their neck. The birds fold their wings back and waddle along, reminding me irresistibly of Charlie Chaplin. I notice that some of the birds hold a stone in their beak, which they carefully—almost tenderly—place in front of their mate. A proof of fidelity? I return to the ship, which sails on between icebergs glittering in shades of jade, ultramarine, and cobalt, shimmering with fluorescent light. From a distance, they appear like magical palaces and temples. Close up, they become living beings, with streams of meltwater for veins and worn furrows for wrinkles. The hull of the ship easily crushes the thin summer ice. A whale surfaces to blow its spout—a small rorqual or minke whale. We enter the Lemaire channel, where, in the early years of the twentieth century, the French explorer Jean Charcot braved the rigors of the Antarctic winter on board the *Pourquoi Pas*. The ice blocks us within the Antarctic circle. Snow petrels twist acrobatically overhead, as if to scorn us puny humans, then fly off toward the Biscoe Islands.

We turn around and head back out to sea, making for the Kerguelen Islands, on the outermost fringes of the Indian Ocean, some 2,500 miles (4,000 km) from the nearest continental land mass. The islands are constantly swept by the tearing winds stirred by Antarctic drift. It has taken the *Marion-Dufresne* ten days to sail down from La Réunion, bringing a group of scientists to the research station in Port-aux-Français. Sooty albatrosses, petrels, skuas, and sheathbills are the kings of the sky, riding the airstreams, while the beaches of black sand are home to immense crowds of royal penguins, huddled together against the wind. The bright orange patches on their cheeks are the only splashes of color in the monochrome landscape.

The ship heads further south, toward Adélie Land, named for the wife of the man who first explored this part of Antarctica, Jules Dumont d'Urville. Over the continental ice sheet, the sky glowers, only occasionally revealing a shimmering sunbeam. The ice beneath the bows splits into a thousand fragments. I am stunned into silent contemplation by the sight of the vast frozen dome of Antarctica. The virgin purity of the void. The ship turns around once more and sails north. The waves are tipped with spatters of snow. Through the mist, I catch my first glimpse of the Campbell archipelago. The jagged summits are surprisingly rich in color, thanks to the mosses and ferns that cling to the rocks. I find some minuscule orchids, green streaked with red or white with a yellow lip. Royal albatrosses nest on the heights. Every year, seven thousand breeding pairs come here to lay their single egg in a cone-shaped nest of earth held together with saliva.

Back on the open sea, petrels, puffins, and gulls are our daily companions. We leave a series of mountain peaks in our wake—Azimut, Fuseau, Faille, Dumas, Paris, all sink into the copper sunset. When I wake up, we have reached the Auckland Islands. This is a land of mirages, covered in dense forests of rata trees, which are used as Christmas trees in New Zealand. They are certainly striking, with their short silver trunk, sinuous branches, and clusters of scarlet blossom. On Enderby Island, I can make out a series of lilliputian tunnels leading into the dense foliage. They are made by the yellow-eyed penguins, which spend their lives in the shadows of the undergrowth or in the depths of the waves. I spend a happy

few hours here in the company of Hooker's sea lions, albatrosses, gulls, terns, and parrots.

The most beautiful island of all is Snares. Coiffed with thick forest, it is a maze of reefs and rocks eroded into fantastical shapes and shrouded in emerald or yellow-green mosses or, lower down toward sea level, bottle-green and red seaweed. Lower still grow long strands of shiny brown sea-weed, twisted like serpents, which sometimes coil their fronds around Macaroni penguins, which flap their stubby wings in panic at the thought of a killer whale rising silently up through the liquid depths.

Patrick de Wilde

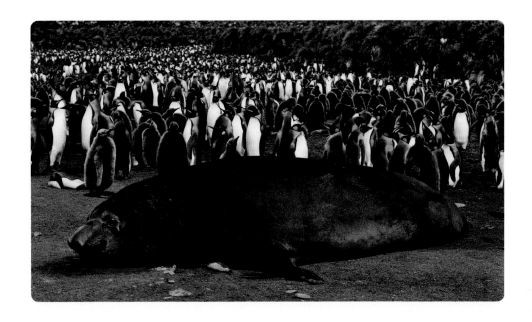

INTRODUCTION:
The Lure of the Far South

I have always felt the lure of the far South—of Antarctica, the ends of the earth, an inhospitable world where the wind can drive a man mad. An empty world of rock and ice. The extreme hostility of the environment has long proved a challenge to explorers and adventurers. Its reputation intrigues and entices geographers and scientists, fascinates travelers—and terrifies sailors. The waters around Antarctica are some of the most hostile on the planet—constantly swept by storms and blizzards and scattered with immense blue-white icebergs, some so gigantic that they have been mistaken for islands. Antarctica, in geographic and magnetic terms the southernmost point of the globe, is also the coldest place on earth. On July 21, 1983, scientists at the Vostok base measured a record low of -129°F (-89.2°C). Yet the waters around this icy desert swarm with life. The subantarctic islands that encircle the endless wastes of ice are home to flourishing colonies of sea lions, elephant seals, petrels, albatrosses, fulmars, and penguins. In the summer, the channels that form in the ice floe fill with plankton, which provides an ample food supply for krill, which in turn attract birds, fish, seals, and whales.

Once seen, it is impossible to forget this magnificent environment, almost untouched by the hand of man. Here, birds fly through water as elegantly as in the air, elephant seals plunge to depths of five thousand feet (1,500 m), and whales, each one a vast colossus, slip gracefully through the waves. The howling wind whips glittering spume into the air, while the eerie lights of the polar dawn play overhead. The cobalt and silver waves hollow grottoes in the crystal cliffs of mysterious islands, where the barking of seals resonates like the song of the sirens.

I will always remember my first voyage to Antarctica, with the famous oceanographer Jacques Cousteau, on board the *Calypso*. A mysterious, luminous dawn broke over the peninsula—if dawn is the right word, as during the Antarctic summer, the sun never sets. The crew gradually fell silent, awed by the purity of the landscape, where a sparkling white sugarloaf island was perfectly reflected in the calm sapphire waters of a channel in the pack ice.

My fascination for Antarctica began when I was a child, when I would dream of huddling with the penguins in a blizzard. As a teenager, I was given the chance to meet the great polar explorer Paul-Émile Victor. He inspired me with his fabulous descriptions of Adélie Land. Now, as I sit down to write this introduction, the images come rushing back. A humpback whale greeting us with a plume of spray from his blowhole before plunging back into the deep with a final flourish of his tail. A group of elegant black-and-white killer whales gliding along the edge of the ice floe like deadly troops going into battle. A colony of Weddell seals lounging on the ice, their whiskers curled like Dali's moustache. Gentoo and Adélie penguins, their plumage a parody of evening dress, marching along on the ice.

The ship has passed the Drake Passage. I watch the albatrosses flying on their heavy wings overhead. They spend almost all their lives in the air, only returning to land when it is time to nest and breed. I am lulled by the dance of the gulls, terns, fulmars, and storm petrels. One question returns obsessively to mind: What is there beneath the icebergs? The *Calypso* approaches one such giant with a profile like the Egyptian sphinx—a human head on a lion's body. The divers pull on the special wetsuits that will enable them to spend a few minutes in these icy waters that clutch a man's heart and kill him in seconds.

Philippe Cousteau, Jacques's son, later described the dive to me:

I slip into the water between the paws of the blue-white sphinx. I drop through the clear water. I feel like a drop of quicksilver. No one has ever dared explore the interior of an iceberg before. I spot a crevice leading to the heart of the sphinx. I kick forward into a fairy world. All around me I hear the ice cracking. The crystal mass of the iceberg creaks and moves, its pulse beating. It whispers and groans, a terrifying and yet marvelous music. At any moment it could shift, punishing me for my temerity by snuffing my life out in a second. The sides are carpeted with an infinity of tiny bubbles like stars. I find a secret chamber, its walls starred with geodes that sparkle like diamonds. I am in another world, a dazzling treasure chamber straight from the *Arabian Nights*. Time stands still. I am an embryo in the womb of Beauty.

Yves Paccalet

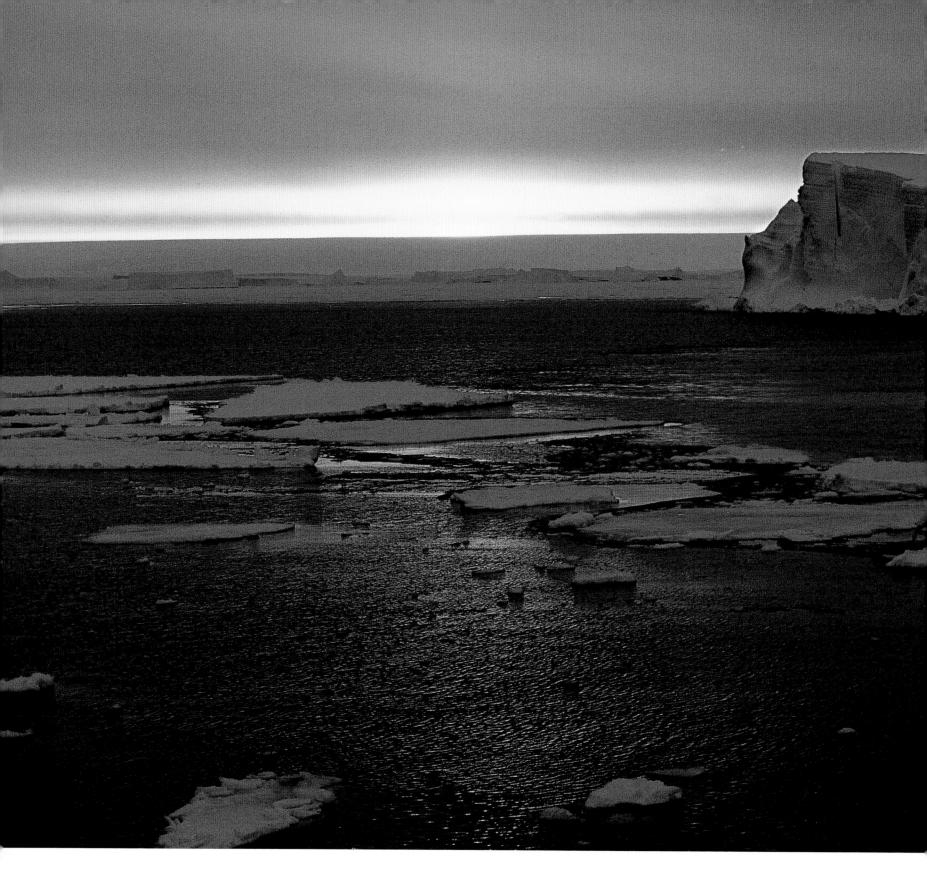

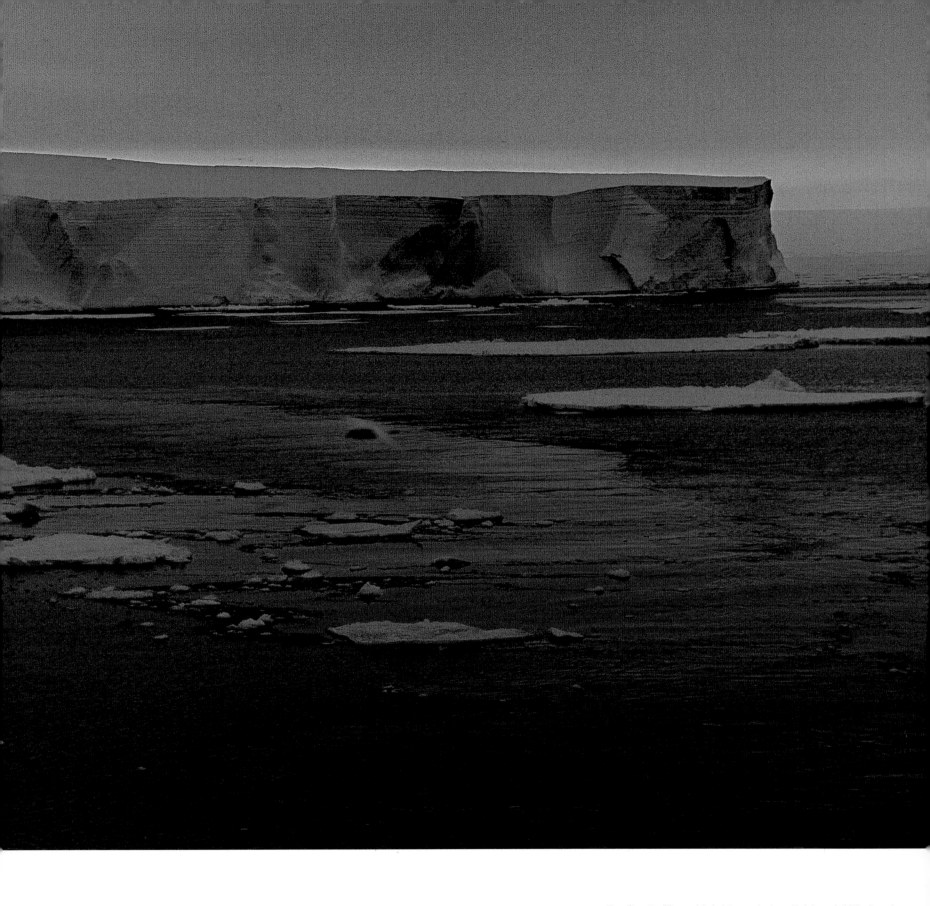

Far South. The midnight sun is bewitching. Adélie Land.

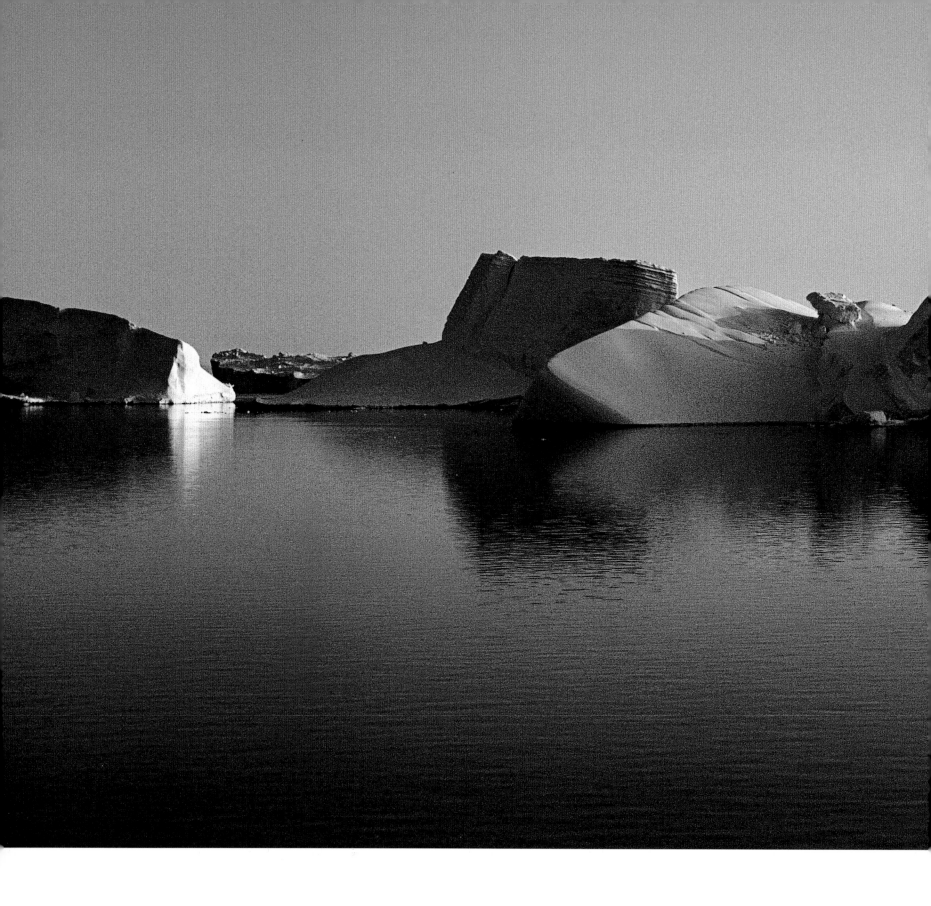

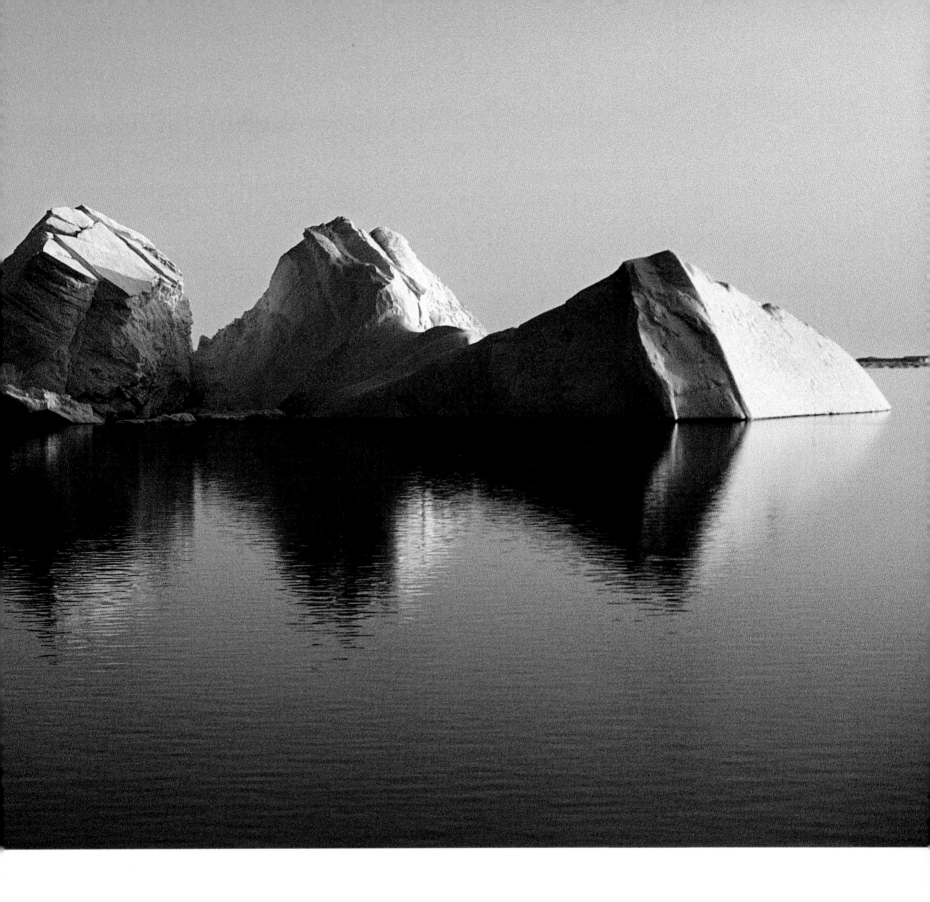

Water is life. Erebus and Terror Gulf.

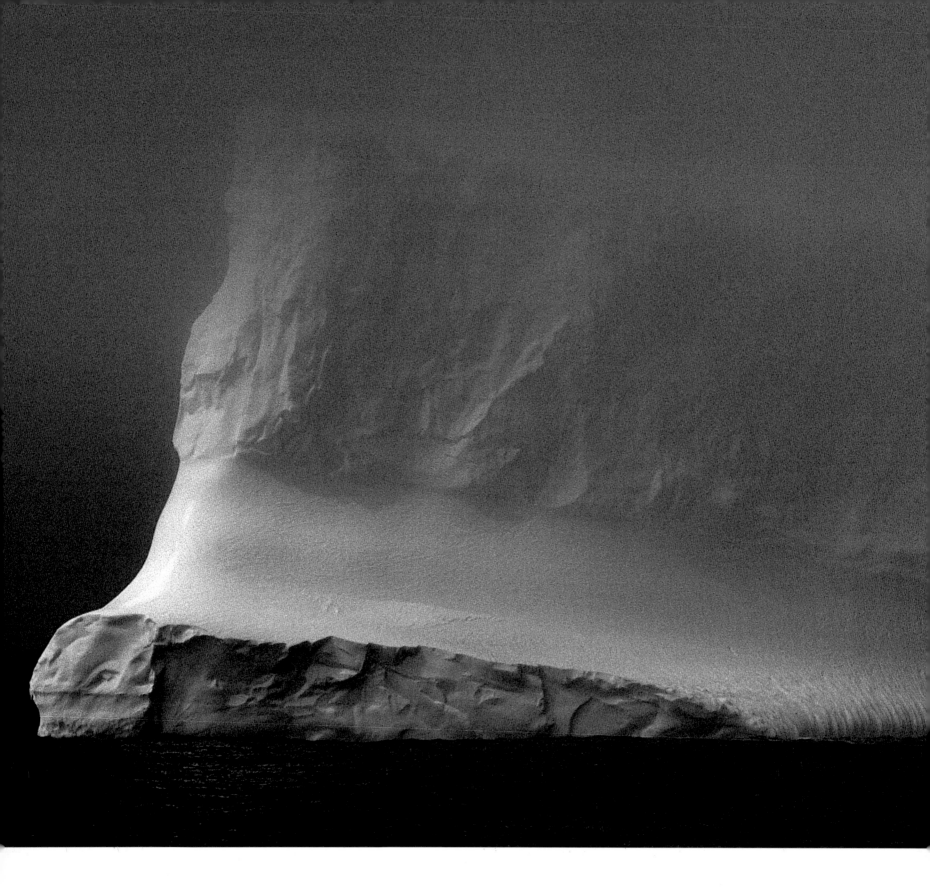

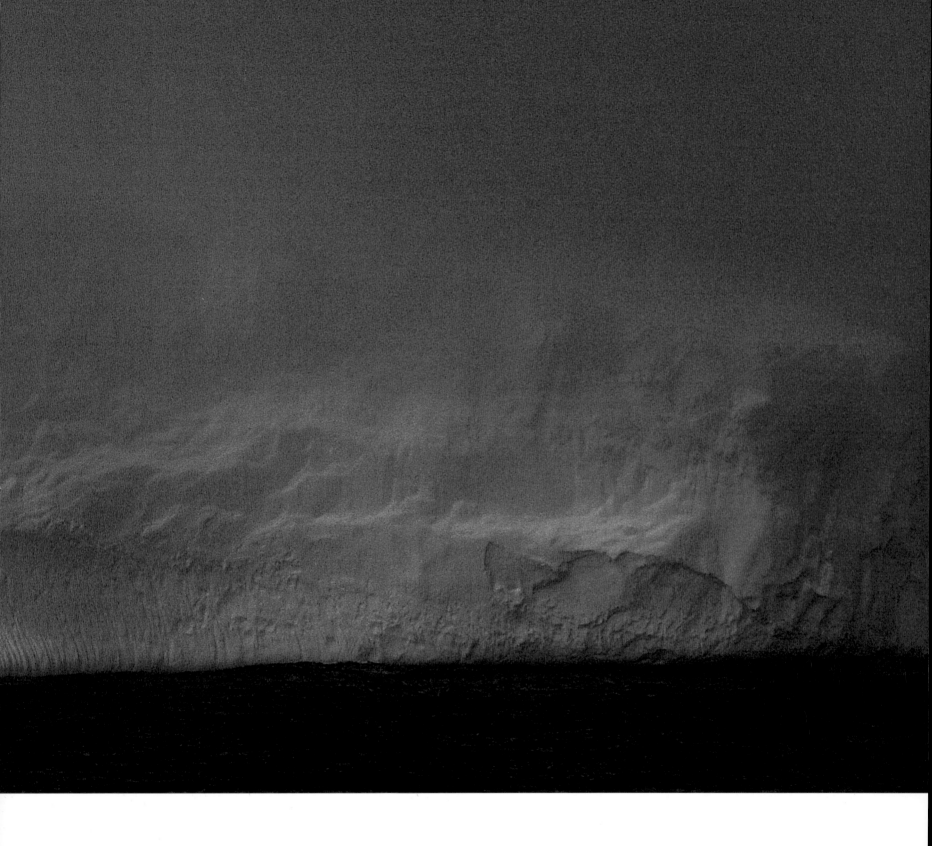

A streak of milky blue in the heart of an iceberg. South Orkneys.

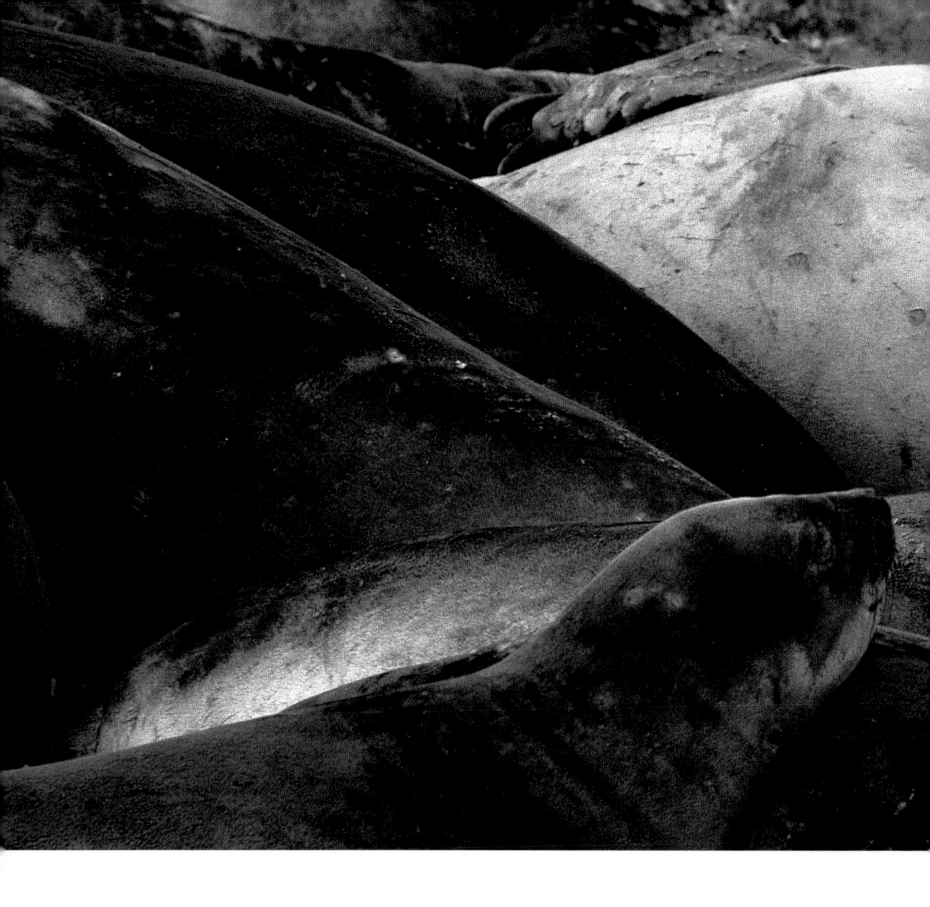

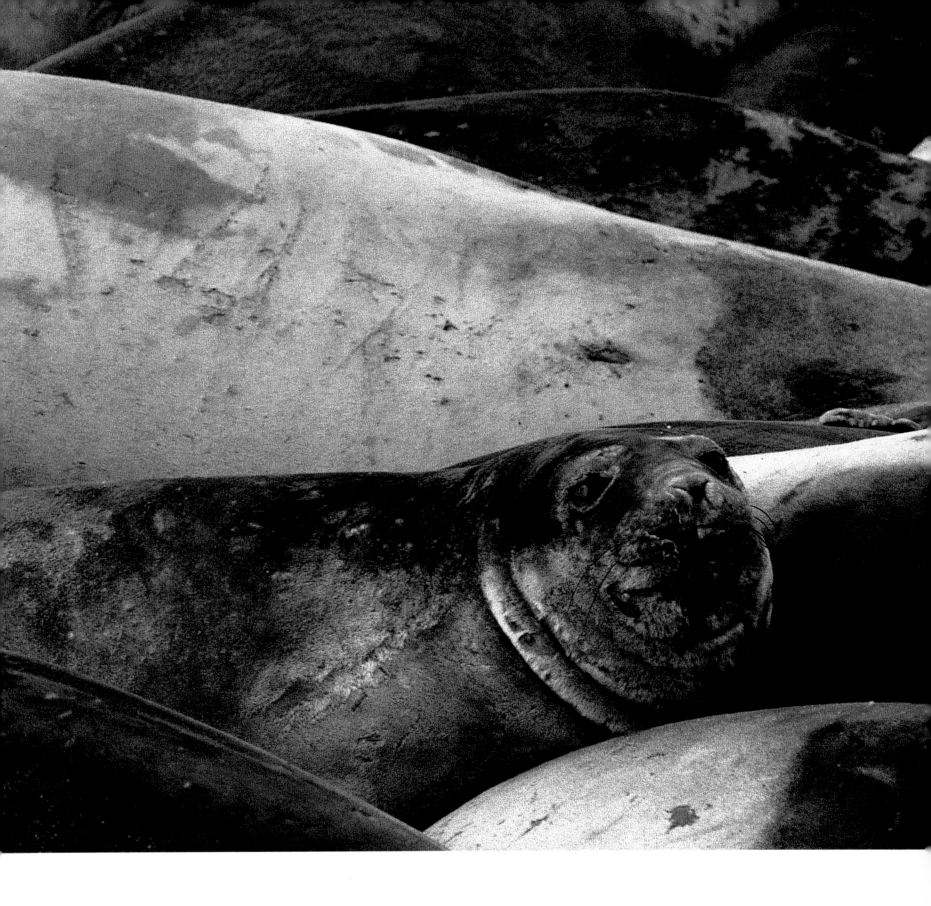

A female elephant seal. King George Island.

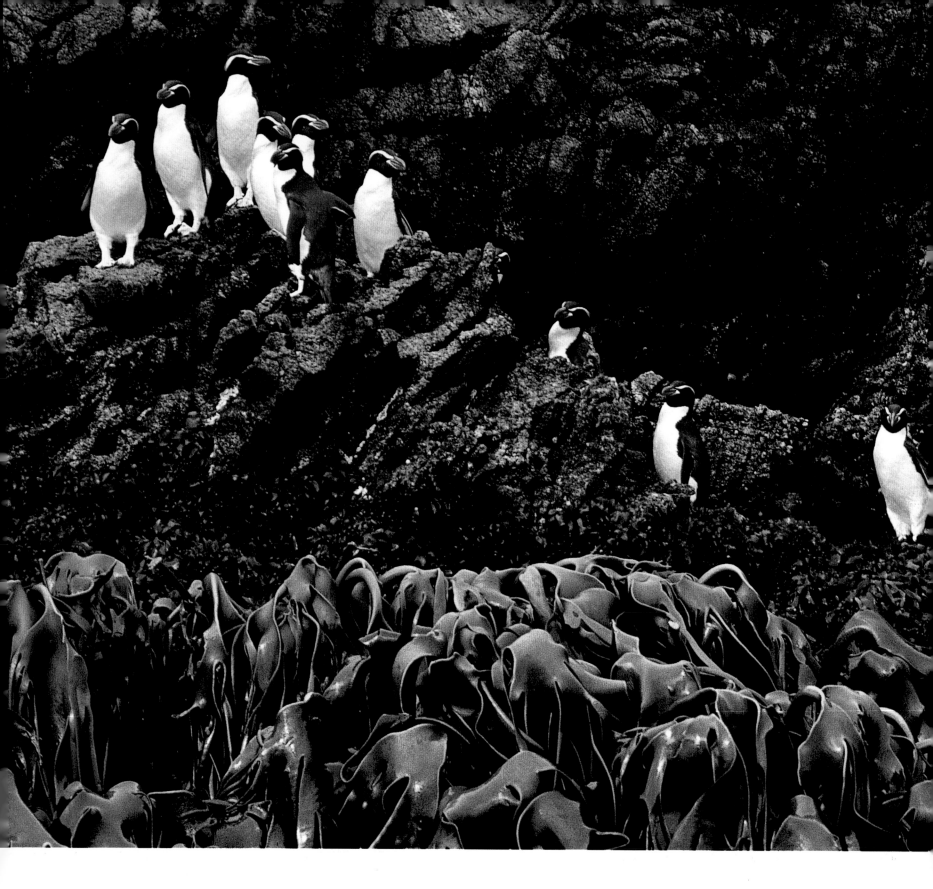

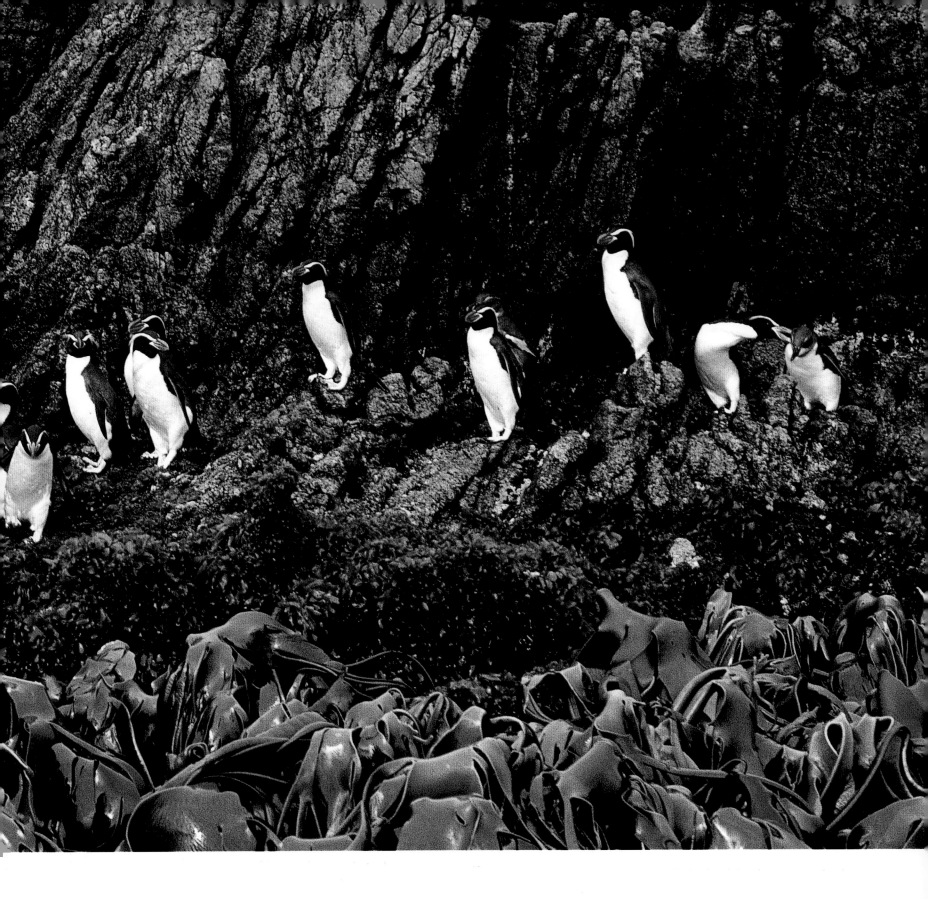

Macaroni penguins playing in the kelp. Snares Island.

Atlantic Ocean

0°　Bouvet Island

Marion Island　Prince Edward Island

South Georgia　South Sandwich Islands

Crozet Island

South Orkney
Islands

FALKLAND ISLANDS

Kerguelen Islands

South Shetland
Islands

SOUTH
AMERICA

McDonald Island
Heard Island

Indian Ocean

Peter I Island

ANTARCTICA

90° West

90° East

Scott Island　Balleny Islands

Southern Ocean

Macquarie Island

Campbell Island

Auckland Islands

Antipodes Islands
Bounty Islands

Snares Island

TASMANIA

180°　NEW ZEALAND

AUSTRALIA

THE FALKLANDS

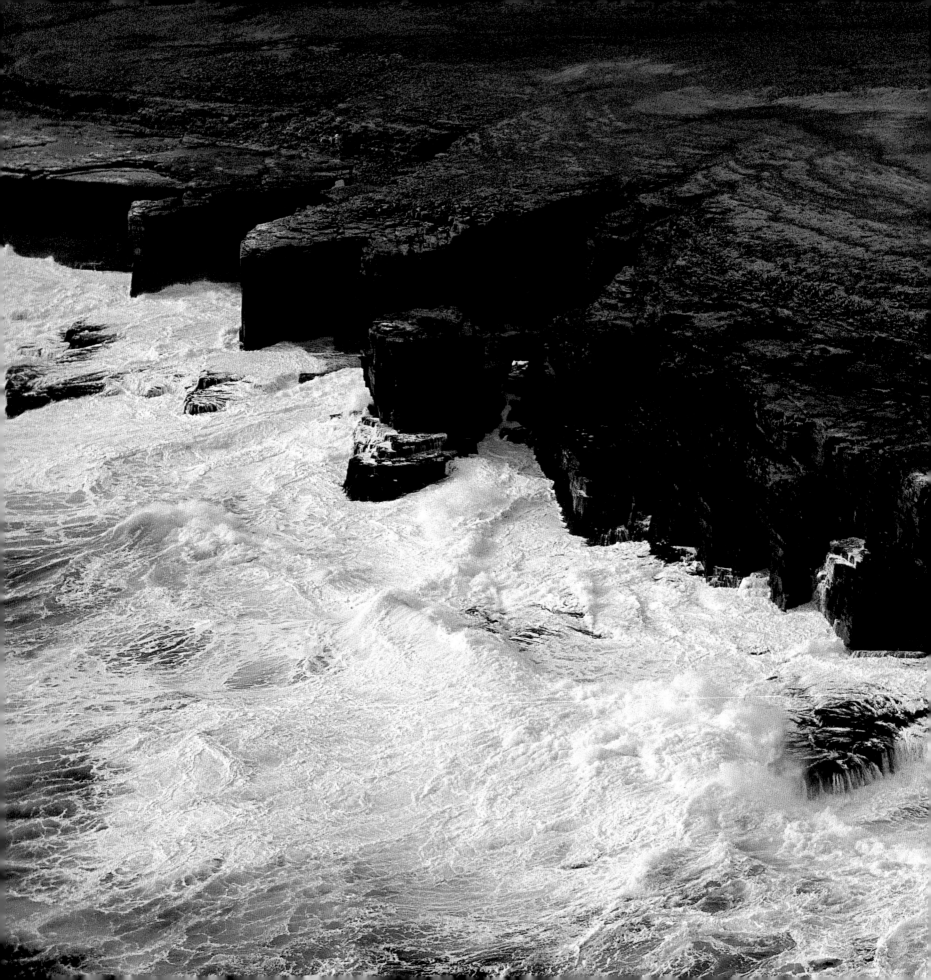

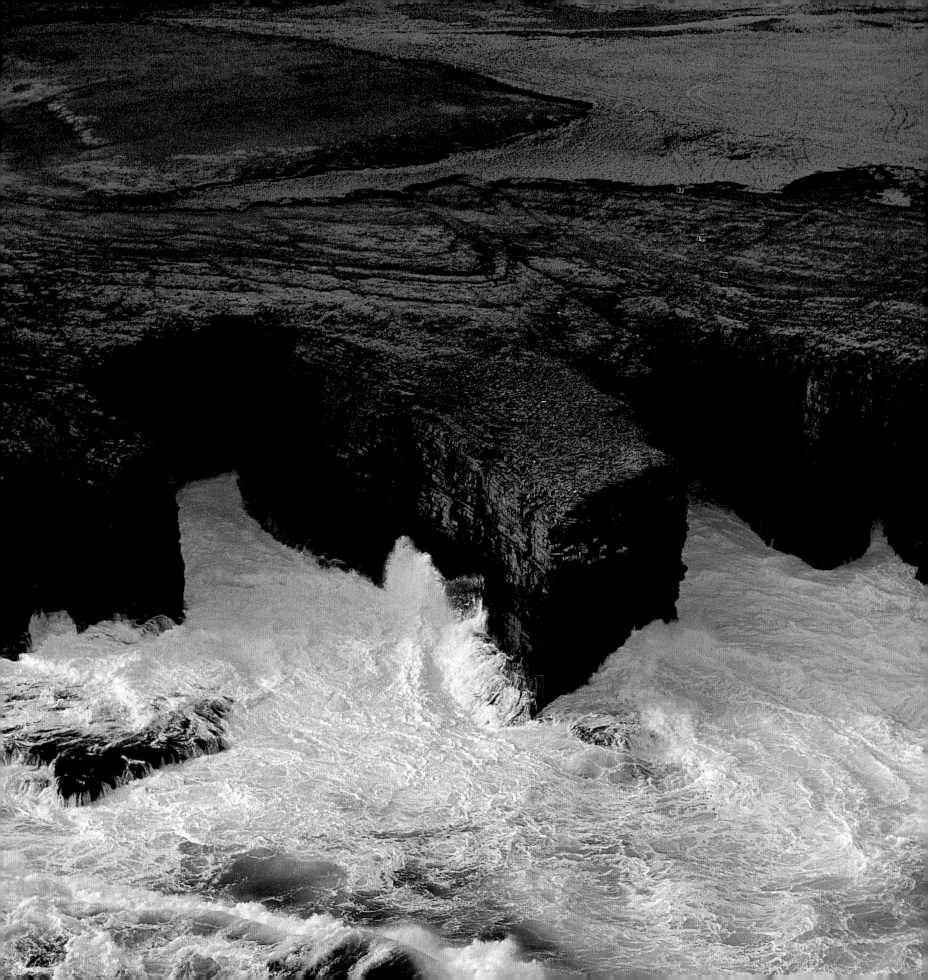

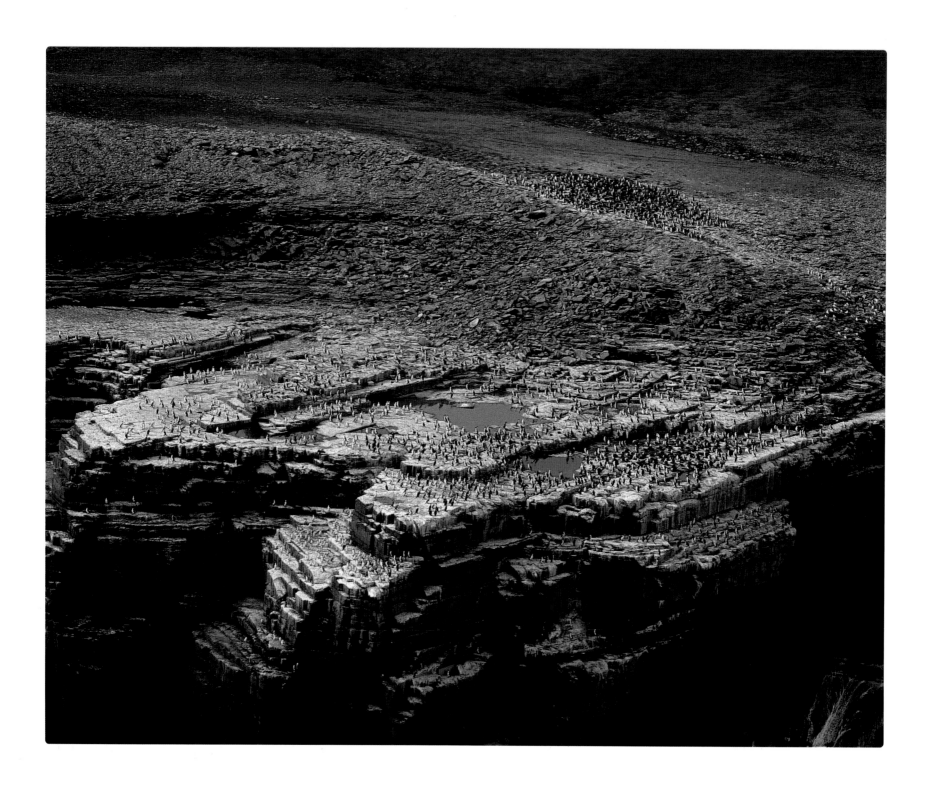

Preceding double page: The wind and the waves carve the shore into fantastic shapes. Sea Lion Island.
Above: Penguins as far as the eye can see. Sea Lion Island.

BEAUCHENE ISLAND

Apart from geographers, diplomats, and sailors, few people could have pointed without hesitation to the Falkland Islands before April 2, 1982, when they became the focus of world attention as war broke out between Britain and Argentina for their possession.

Britain held the Falklands; Argentina laid claim to the islands they knew as Las Malvinas. After an intensely fought campaign, Britain held on to the Falklands, and the islanders remained subjects of Her Majesty.

The Falklands lie in the southern reaches of the Atlantic, between 51° and 53° south. In geological terms, they are a continuation of the continental plateau of Patagonia. The islands were discovered in 1592 by the British navigator John Davis. However, the first settlements were only founded between 1764 and 1766 by French sailors, on the orders of the great explorer Louis-Antoine de Bougainville. He named the islands *Les Malouines* in honor of the French port of Saint-Malo. The islands became a pawn in European politics when Louis XVI of France gave them to Spain. Bougainville disapproved but had no choice but to complete his voyage around the world. The islands—by now known in Spanish as Las Malvinas—remained uninhabited until 1832, when the British arrived, using them as a base for their whaling expeditions. A number of families settled there as sheep farmers.

Today, the Falklands are home to some two thousand islanders, most of whom live in the capital, Port Stanley. There are also some two thousand military personnel stationed at the

Mount Pleasant base. The human population is vastly outnumbered by the 650,000 sheep—more than 150 per inhabitant. The archipelago consists of two main islands, West and East Falkland, and some nine hundred smaller islands and islets, with names like Steeple, Jason, Carcass, Saunders, Pebble, New, Beaver, Lively, Bleaker, Speedwell, George, Barren, and Sea Lion. It is an inhospitable world of rocks and sea spray, of keening wind, and of solitude.

Lost in the ocean, two hundred miles south of the main islands, is an almost bare rock constantly battered by storms and angry waves. Beauchene, named after one of Bougainville's lieutenants, is a small dot in the immensity of the ocean, measuring just 460 acres (187 ha). It typifies the wild splendor of the Falklands. It lies beyond Sea Lion Island, inhabited, as the name suggests, by sea lions, as well as South American fur seals; enormous elephant seals, which can weigh up to six tons for the largest males; Magellanic and gentoo penguins; brown-hooded, dolphin, and kelp gulls; arctic terns; Magellanic oystercatchers; and upland geese.

Landing on Beauchene, even in what passes in these climes for good weather, is like riding a sled down a particularly bumpy slope. The green waves boil and throw up plumes of white spray as they crash on the razor-sharp teeth of the rocks that bristle along the coastline. The giant fronds of seaweed—Durvillea, Lessonia, and giant bladder kelp—float on the surface like languid serpents.

How could I forget Beauchene? Cousteau and his team put in there on the *Alcyone*. We clamber on shore, slipping on the fronds of seaweed, following a family of rockhopper penguins. We climb the rocks along the shore, still behind the penguins with their characteristic bushy "eyebrows" of yellow feathers. When we arrive at the top, we are stunned into silence. The central plateau of the island is home to millions of birds, huddled together so closely we can scarcely see the ground. The black-and-white birds look like a gigantic, living chessboard. There are an estimated two to three million penguins on this nesting site. The birds are busy adding to their nests or feeding their young. The noise is deafening: a cacophony of squawks and harsh cries. Acrid wafts of guano drift toward us, stinging in our throats and making our eyes water. Most of the birds here belong to four species—rockhopper penguins, gentoo

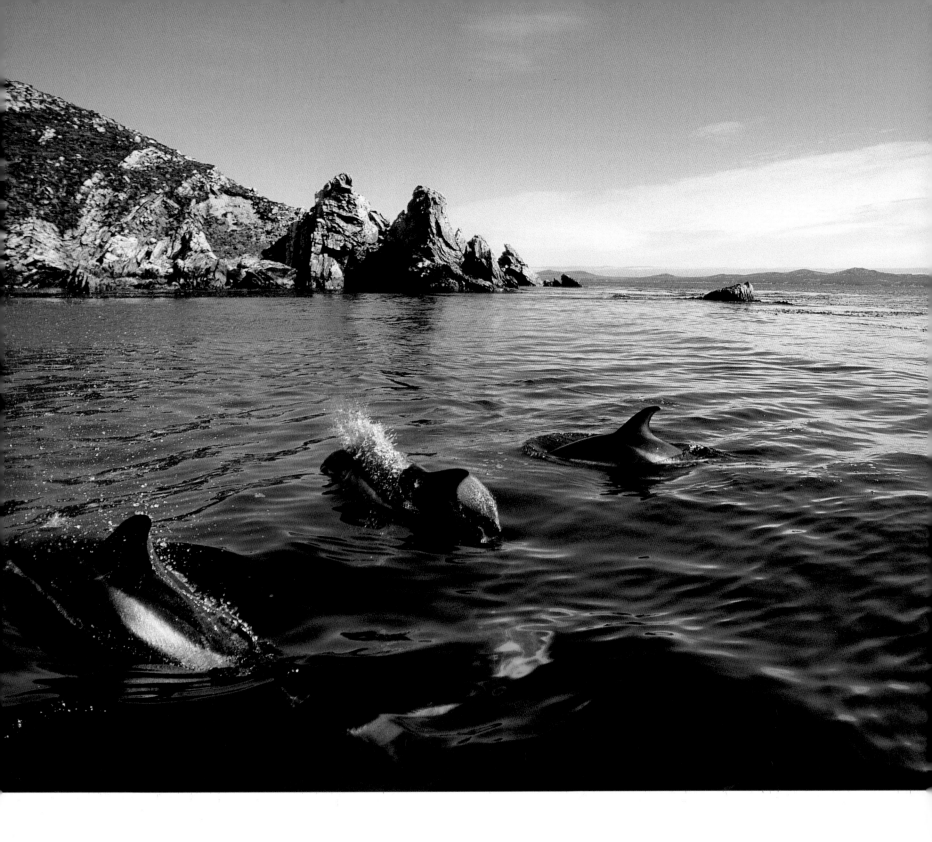

A school of Peale's dolphins. Falkland Sound.

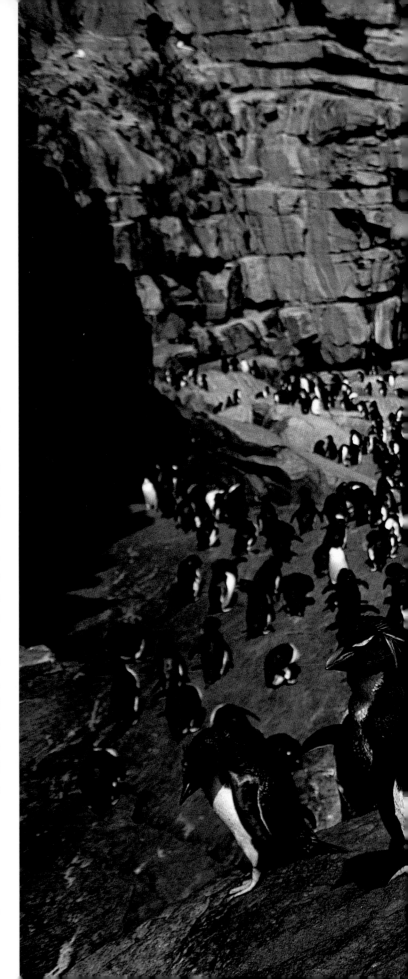

penguins, king cormorants, and black-browed albatrosses. The nesting site looks chaotic, but in fact there is a remarkable logic to it. Each species occupies its own territory. Each pair has its own few square inches and defends them vigorously against intruders. The penguins and the cormorants lay their eggs in a shallow hollow scratched in the scanty soil and protected with a few twigs. The albatrosses take a little more care, building a cone of earth and saliva topped with a soft mattress of grass. This is the largest colony of black-browed albatrosses anywhere in the world.

Other species of birds nest here in smaller colonies, including gulls, terns, sheathbills, skuas, and caracaras. Sheathbills are beautiful birds with a pure white plumage that belies their taste for carrion. Skuas are closely related to gulls. They have hooked beaks and brown plumage and eat the eggs and chicks of other species. Caracaras are related to sparrow hawks. Their plumage is coal-black and they have a striking, blood-red beak.

In the midst of this vast nesting site is a gentle slope of smooth, bare rock, which has not been colonized by the birds. This is where the albatrosses take off. One of their number, graceless and unwieldy on the ground, encumbered by his large wings, reaches the top of the slope. He tests the wind, waiting for the right airstream. He waddles around on his webbed feet until he is facing down the slope. He spreads his wings and starts down the incline until his wings lift him off the ground. Suddenly, his inelegant waddle is forgotten, and he becomes the king of the skies, gliding effortlessly on the air, higher and higher, until he is no more than a dot in the achingly blue sky.

Rockhopper penguins. New Island.

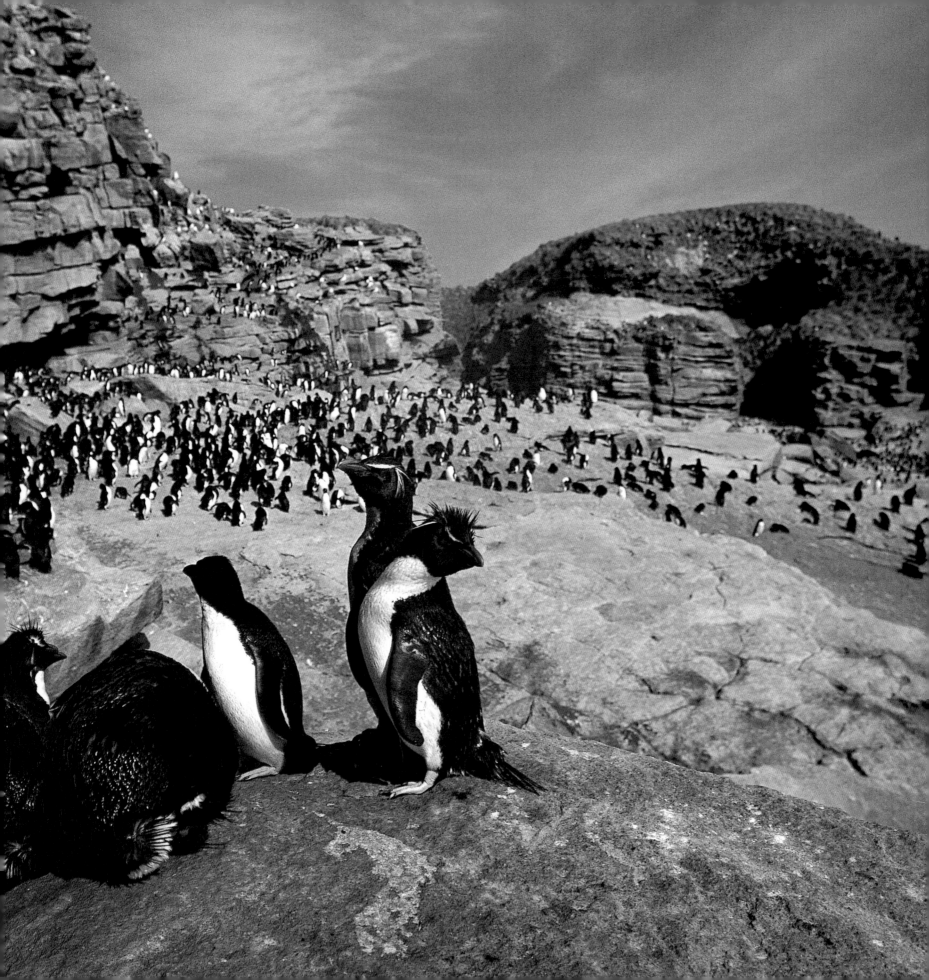

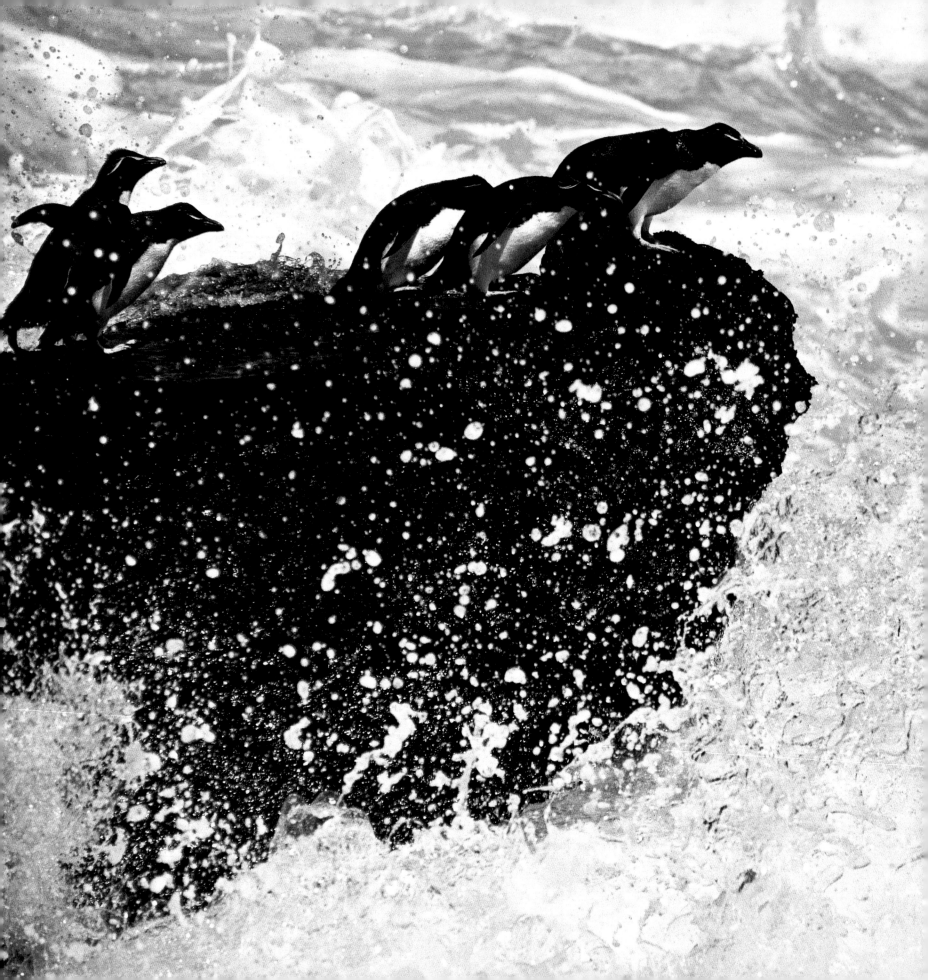

Rockhopper penguins on the shore.
New Island.

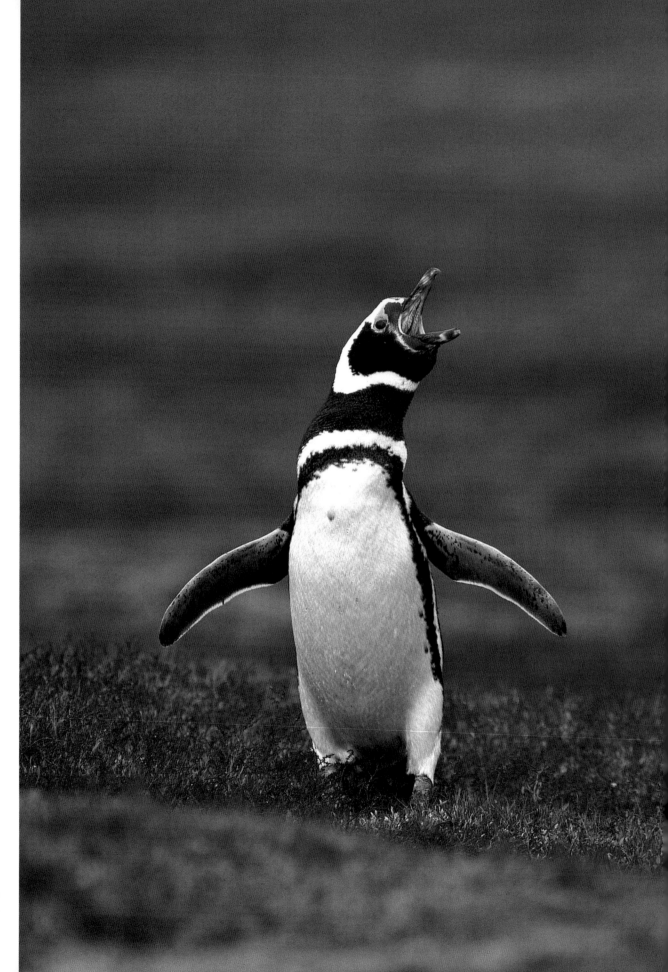

Magellanic penguins.
Sea Lion Island.

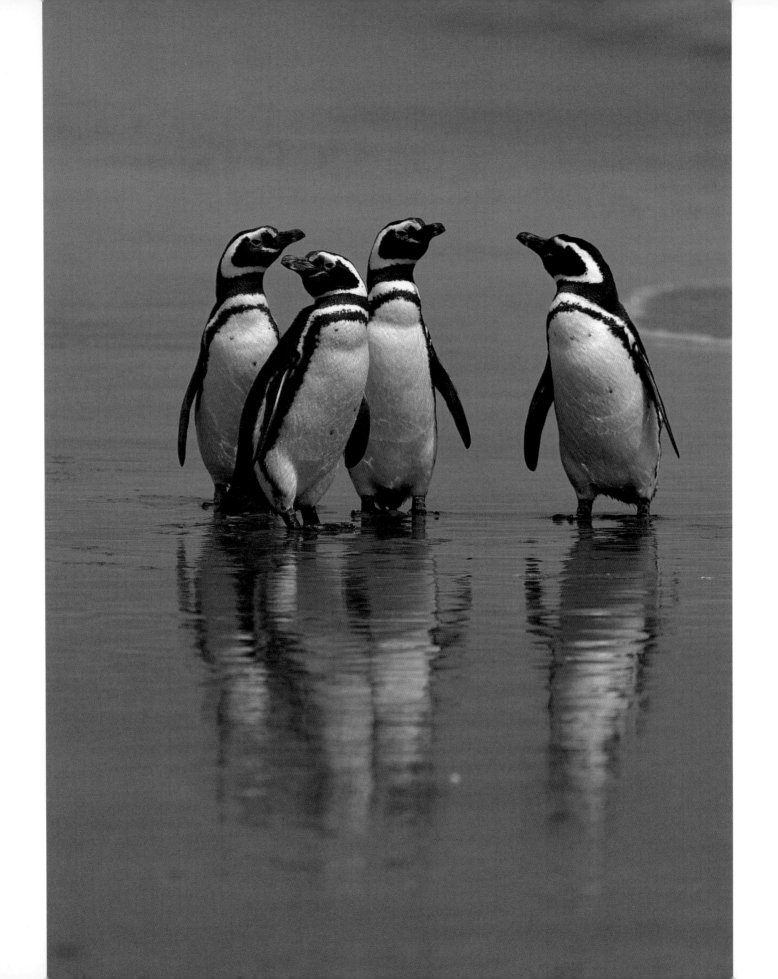

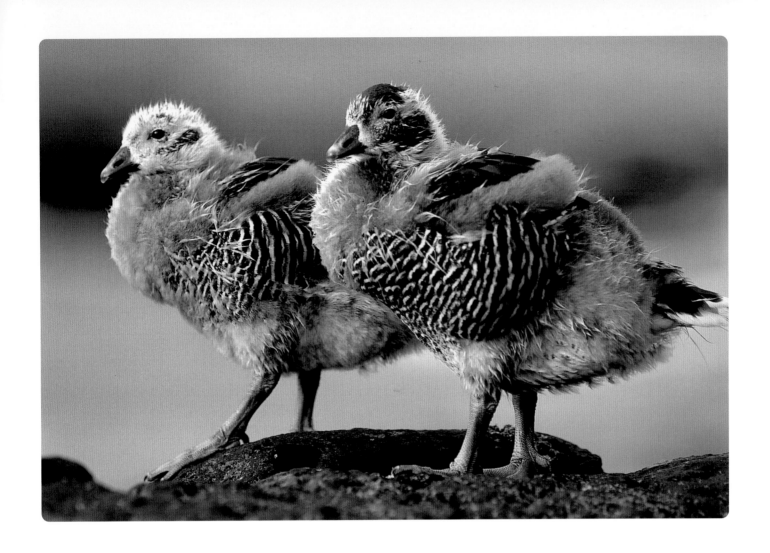

Facing page: Albatrosses mate for life.
These black-browed albatrosses nest on Sea Lion Island.
Above: Upland geese amid the kelp. Sea Lion Island.

Below: The blue eyes of the young imperial cormorant.
Facing page: The cruel beak of the caracara. Sea Lion Island.

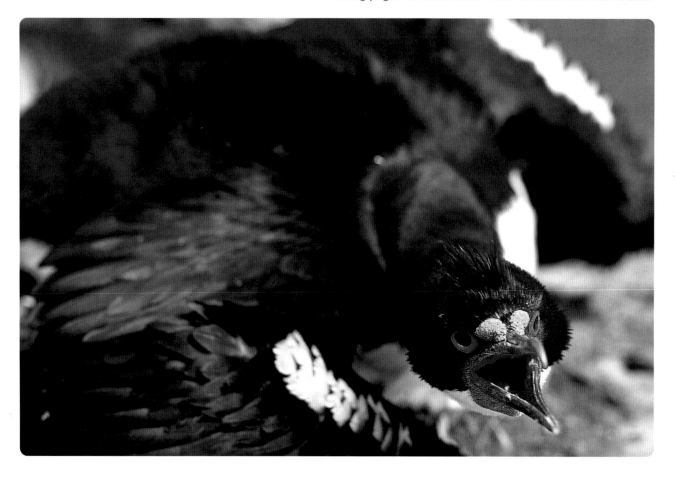

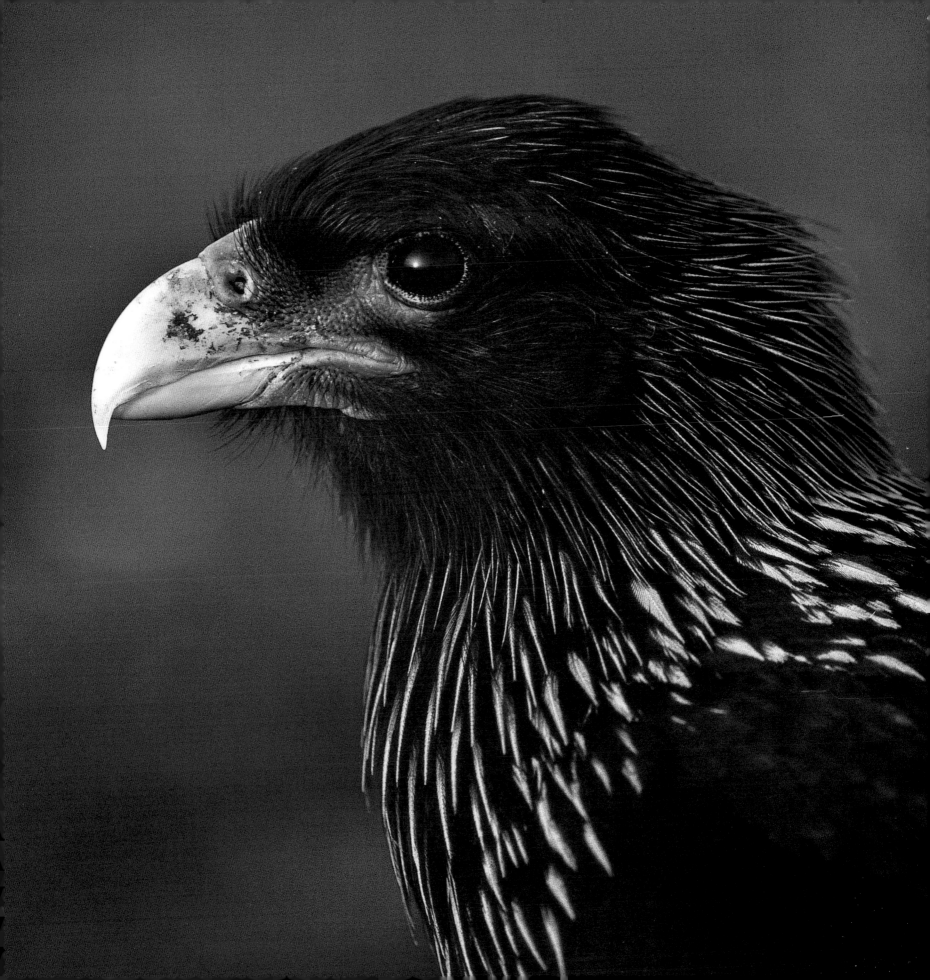

Atlantic Ocean

0° Bouvet Island

Marion Island Prince Edward Island

South Georgia South Sandwich Islands

South Orkney
Islands

Crozet Island

Falkland Islands

King Haakon Bay

QUEEN MAUD LAND

South Shetland
Islands

Kerguelen Islands

ANTARCTIC PENINSULA

ENDERBY LAND

COATS LAND

SOUTH
AMERICA

KEMP LAND

Weddell Sea

MacROBERTSON
LAND

McDonald Island
Heard Island

Bellingshausen Sea

ANTARCTICA

Indian Ocean

PRINCESS ELIZABETH
LAND

Peter I Island

SOUTH POLE

90° West

ELLSWORTH LAND

90° East

WILHELM II LAND

MARY BYRD LAND

QUEEN MARY LAND

Ross Sea

WILKES LAND

Amundsen Sea

ADÉLIE LAND

Scott Island Balleny Islands

Southern Ocean

Macquarie Island

Campbell Island Auckland Islands

TASMANIA

Antipodes Islands

Snares Island

Bounty Islands 180° NEW ZEALAND AUSTRALIA

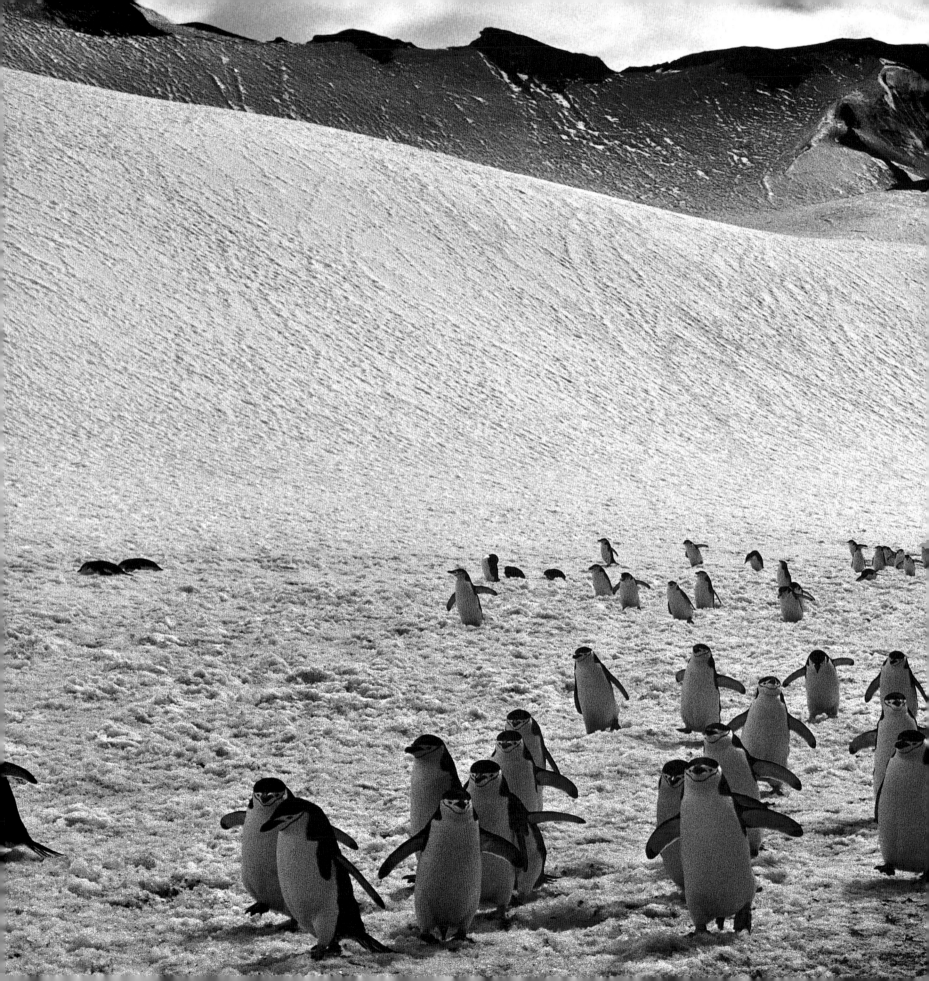

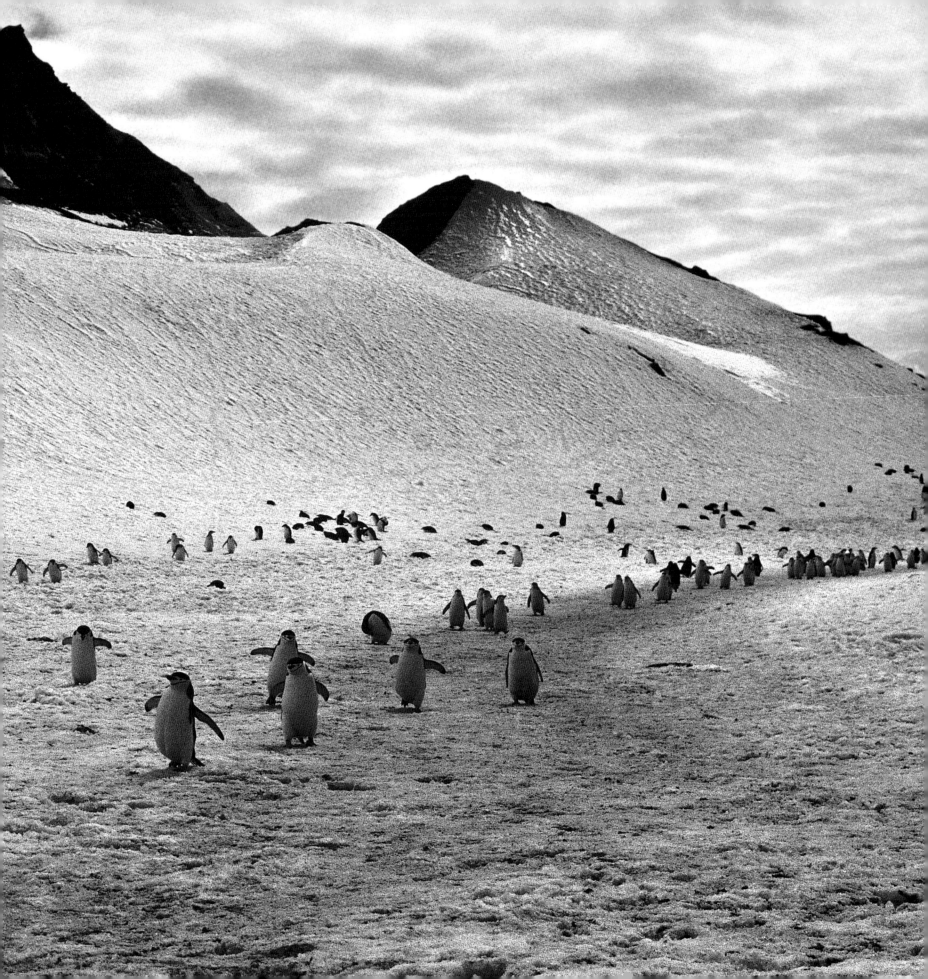

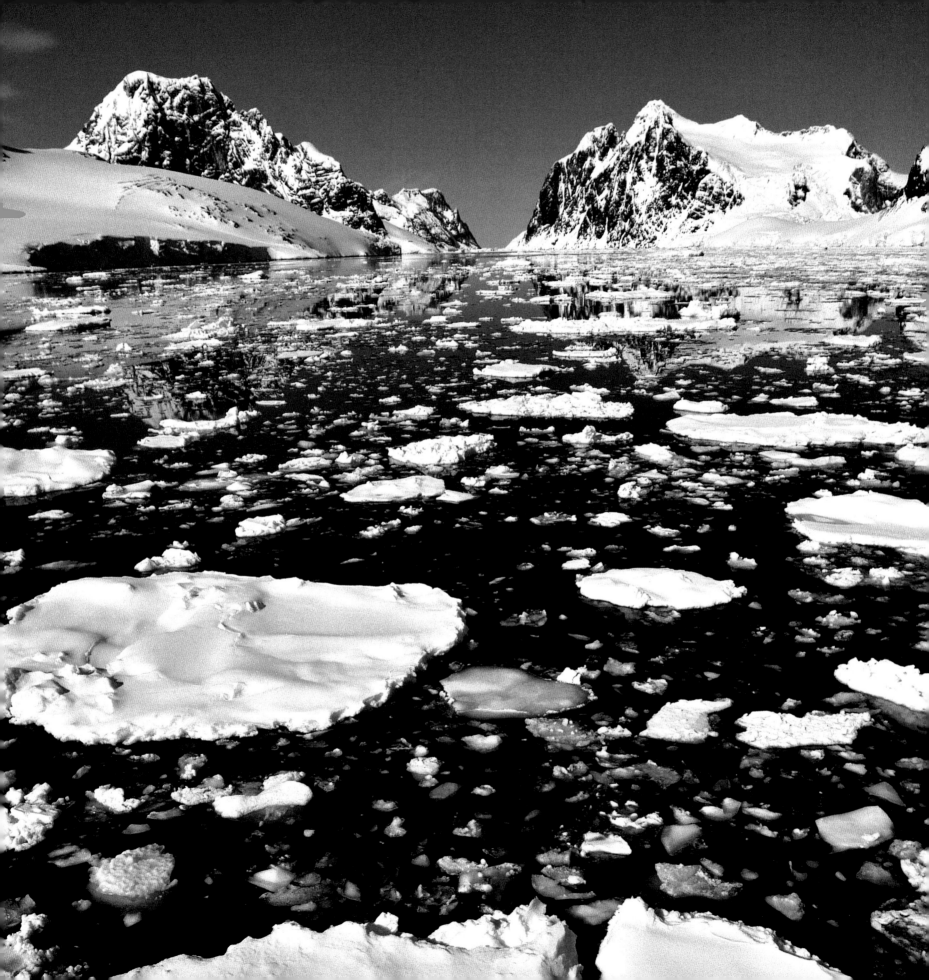

WILD WHITENESS

Antarctica is one of the last great wildernesses on Earth—a magnificent, savage world where man is at the utter mercy of the elements.

I am awed by the power of the landscape. I spot an albatross overhead. The bird seems at ease in this hostile world, and I find myself following it in my imagination, setting out from the summit of the slope on Beauchene Island and soaring high above the waves. I dip down and skim the crests of the waves and the giant fronds of kelp that drift lazily in the current. The strands of thick, rubbery seaweed can reach one hundred and fifty feet (45 m) in length, forming fantastic underwater forests that are home to anemones, crayfish, mollusks, bryozoans or moss animals, and echinoderms (starfish, sea urchins, and sea cucumbers). Mauve- or pink-shelled brachiopods creep along the fronds as they did in prehistoric times. There are sun starfish with twenty arms, purple sea urchins, red and blue lobster species, and giant king crabs.

I fly south, the wind ruffling my feathers. As I approach Antarctica, the temperature of the air and the water suddenly drops several degrees. This invisible frontier came into being at the beginning of the Tertiary era, when Australia and Antarctica completed the process of separation from the supercontinent Gondwanaland, which also included South America, Africa, and India. To the north are the three major oceans: the Atlantic, the Indian, and the Pacific. To the south, the Antarctic Ocean. The dense, cold waters sink and flow north in hidden, sluggish currents for thousands of miles, ending up north of the Equator. They play a key role in regulating the Earth's climate.

Tiring after a long flight, I rest for a while, feeding on the swarming banks of krill that are so plentiful in the summer months. Rested and replenished, I fly further south, over a family of elephant seals, then a colony of fur seals and migrating sea lions. A plume of

Preceding double page: Chinstrap penguins. Deception Island.
Facing page: The Antarctic Peninsula, a soft palette of whites and blues.

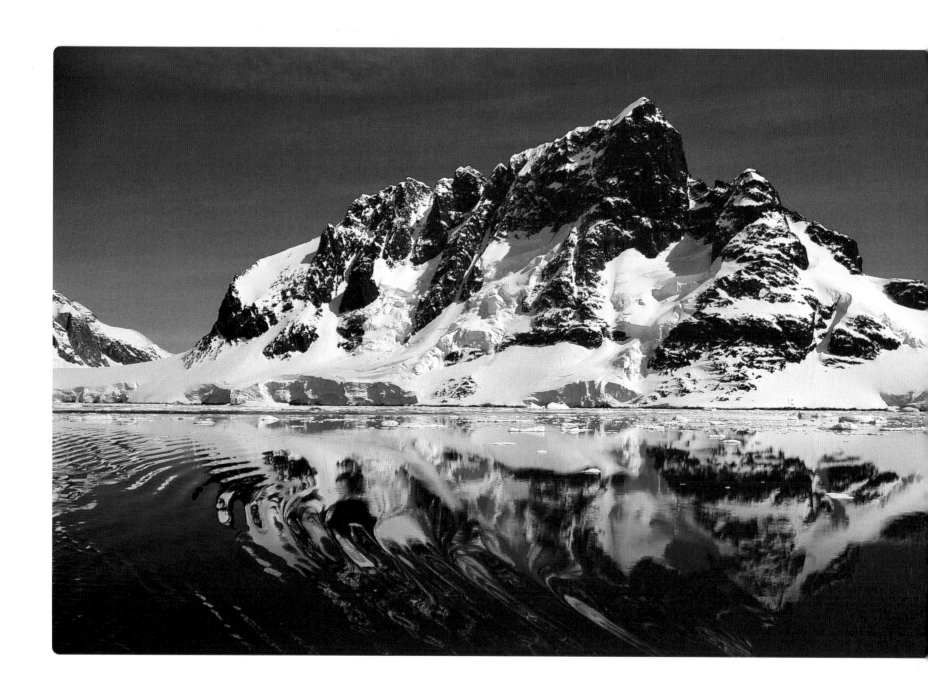

The harsh yet beautiful landscape of the Lemaire Channel.

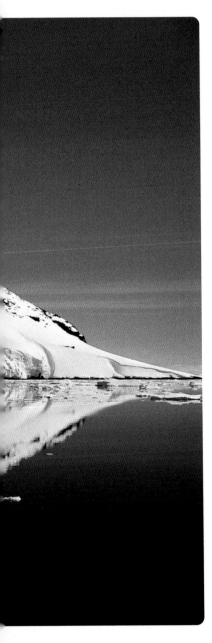

spray—a blue whale breaks the waves. Blue whales are the largest creatures on the planet, weighing up to one hundred and fifty tons and measuring up to a hundred feet (30 m) in length. For decades, they were ruthlessly over-hunted. They have been a protected species for thirty years, but their total population is now estimated at under five thousand. In the 1930s, whalers slaughtered as many as thirty thousand blue whales during the hunting season.

A little further south, I catch sight of a number of carcasses. Although a large whaling exclusion zone has been set up in Antarctica, sei whales and minke whales are still harpooned for "scientific purposes." Southern right whales are still rare, as are humpback whales. If this slaughter is allowed to continue, then their magnificent song—from a deep rumble to a soft chirruping—may be lost forever. The whales migrate to the polar regions in summer to feed on the vast banks of krill and build up a thick layer of blubber for the winter. With every mouthful, they swallow a great gulp of the tiny pink shrimps that make these icy waters so rich in fauna. It is difficult to imagine the mind-boggling number of shrimps that make up the 500 to 750 million tons of krill that flourish in these waters every year.

I have flown for days, snatching brief moments of sleep on the waves. I have come to the end of my journey, to a world of rock and ice, the wild whiteness. I set myself down on a bare rock. No flowering plants grow in the harsh conditions of Antarctica, except for two species which have a foothold on the edges of the continent, Antarctic hair grass, *Deschampsia antarctica,* and a pearlwort named *Colobenthos subulatus*, related to the carnation. Lichens cling to the rocks. The animal species all depend on the ocean for their food. The underwater ecosystem is a brightly colored jungle. Few fish can survive in these icy waters. Most of the fish here belong to the Notothenioid family, such as the Antarctic cod, which, despite its name, is unrelated to the cod we are familiar with in the northern hemisphere. The most astonishing species is the ice fish, which is completely transparent, as its blood contains no hemoglobin. It produces its own antifreeze in the form of glycopeptide, so that it does not freeze solid, even when the temperature of the seawater drops below the freezing point (salt water freezes at 30°F [-1.8°C]).

There are plenty of birds—six species of albatross, puffins, petrels, prions, storm petrels and diving petrels, cormorants, sheathbills, skuas, gulls, and terns. By far the most common birds are penguins, which do not fly but are excellent swimmers. Antarctica is home to a number of species of penguin, including rockhopper, Macaroni, chinstrap, gentoo, Adélie, royal, and emperor penguins. However, only two species—Adélie and emperor penguins—remain for the winter months, when they stoically brave the worst winter storms on the planet.

Among the larger animals are a number of species of seal—Antarctic fur seals; elephant seals; crabeater seals; Ross seals, which feed on squid; Weddell seals, which are outstanding underwater swimmers; and leopard seals, which devour large numbers of baby penguins every year.

Until recently, Antarctica was isolated from the rest of the world, and its precious resources were undiscovered. The harshness of the climate protected the riches from exploitation and meant that the continent remained pristine, untouched by man. In recent years, however, trawlers have begun catching hauls of krill. Overfishing of the krill banks would be an ecological disaster. For the moment, there are safeguards in place to ensure that Antarctica remains a sanctuary. Visits are strictly regulated. But imagine if the continent were to be opened up to industrial fishing and tourism, with all their concomitant ills—pollution, oil slicks, mountains of trash. In 1991, after a long and often heated international debate, the Antarctic treaty, first signed in 1961, was renewed for another fifty years. The treaty was designed to preserve Antarctica as a haven of peace and purity that was open only to a handful of scientists—a sort of natural park for the planet.

The endless wastes of ice in Antarctica play a vital role in the ecology of the planet. Not only is it by far the largest stock of fresh water we have, but by reflecting part of the sun's rays and thus cooling the waters of the ocean and the atmosphere, Antarctica's ice sheets regulate the global climate.

Close to the pole itself there are two types of ice—fresh water and seawater. In the summer, the frozen reserves of fresh water cover 1.5 million square miles (4 million km^2); in the winter, 7.7 million (20 million km^2). The ice forms in chunks known as pancakes, which gradually agglomerate, thicken, and solidify into masses three to six feet thick. Fresh water ice is

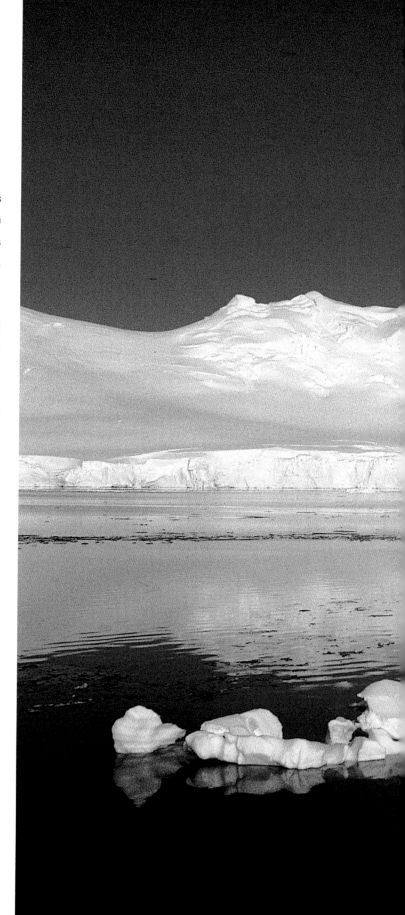

Stunning reflections in the Lemaire Channel.

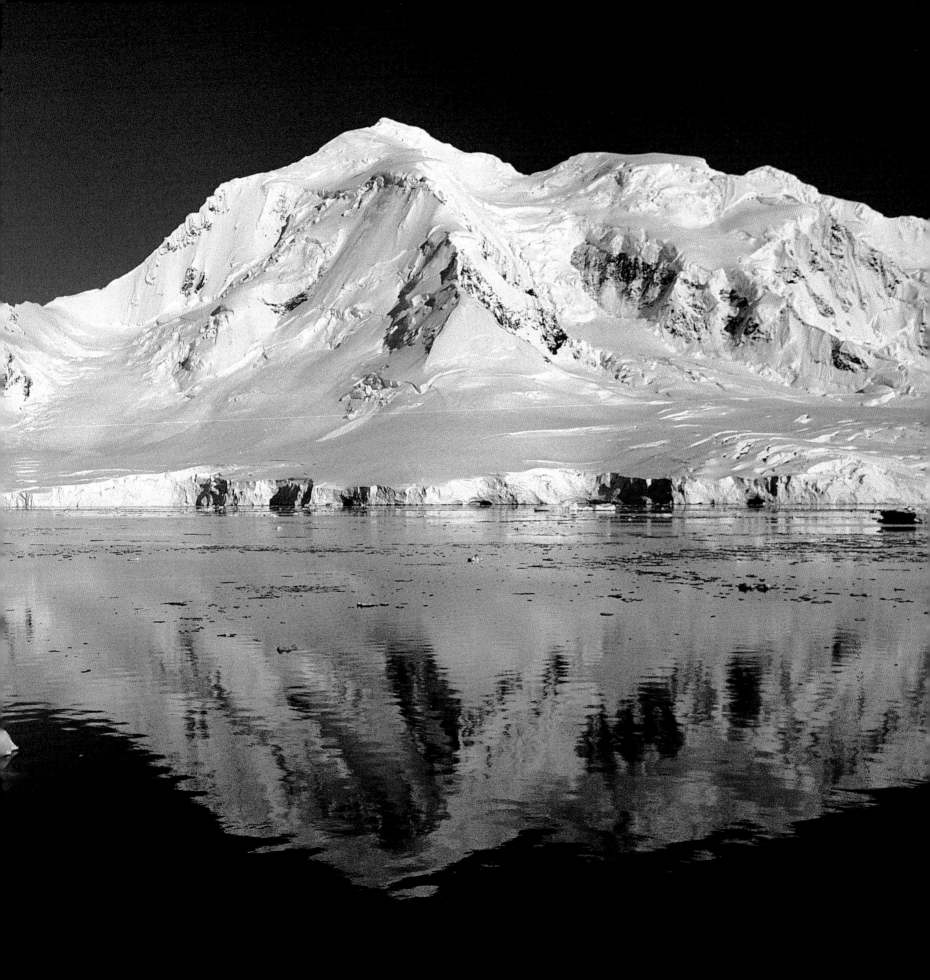

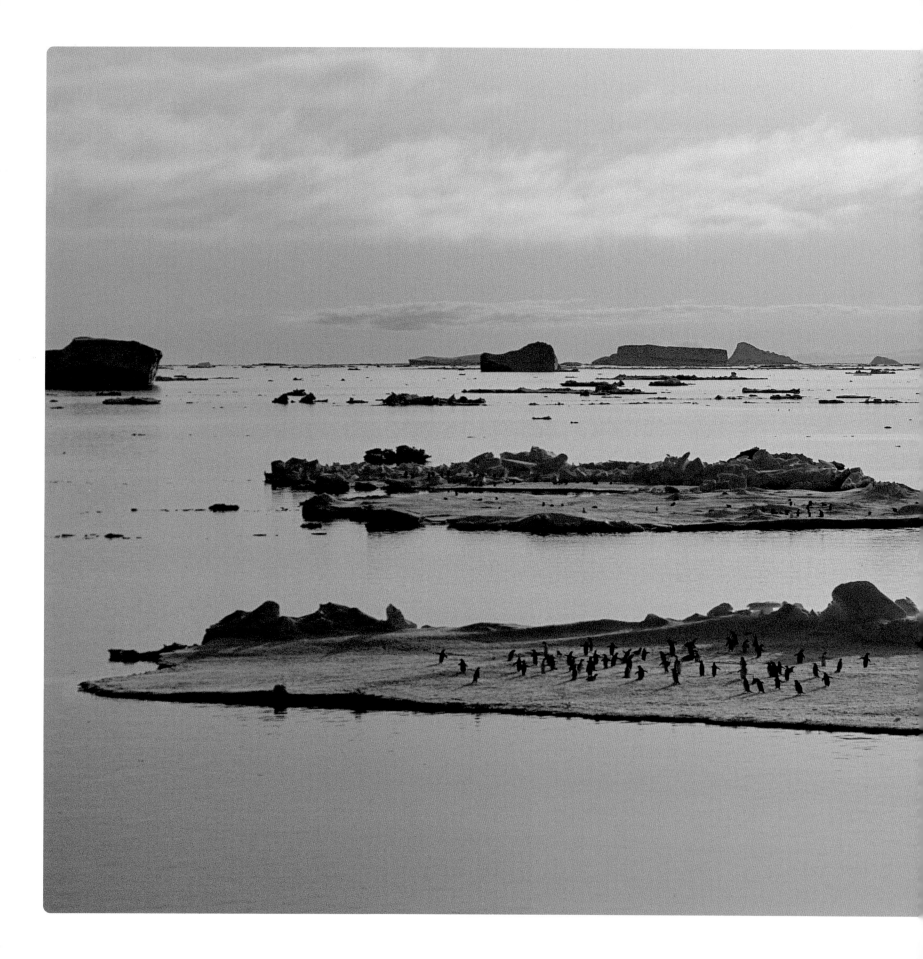

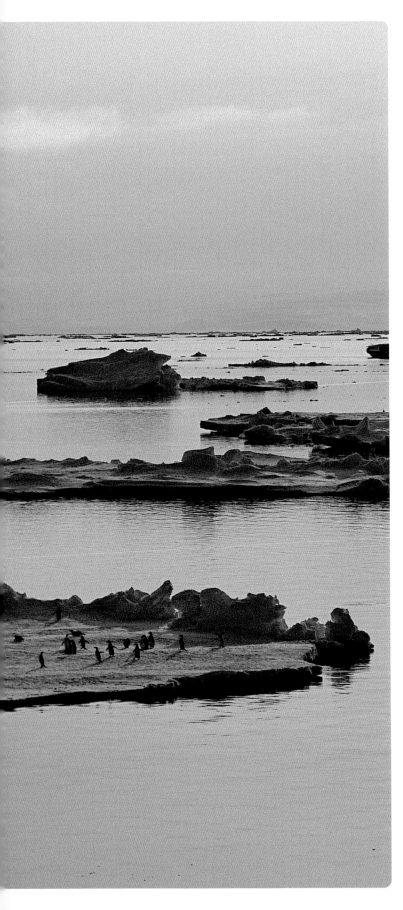

formed on the continental land mass—5.3 million square miles, representing 90 percent of the world's ice and 70 percent of its fresh water. As you head south, the first icebergs you see have flat tops. These are known as tabular icebergs and are formed by huge chunks breaking off from the ice shelves that sprawl into the sea along the coastline. These ice shelves are the edge of the gigantic glaciers of the continental ice sheet. Some tabular icebergs measure as much as 93 miles (150 km) in length. Navigators have been known to mistake them for islands and claim them for their country.

In such vast surroundings, man seems a puny creature indeed. I am over six hundred miles (1,000 km) from the southernmost tip of South America, fifteen hundred miles (2,500 km) from Australia, twenty-five hundred miles (4,000 km) from Africa. Antarctica stretches over 5.5 million square miles (14 million km²), one and a half times the size of the United States. The ice shelves of Ronne-Filchner in the Weddell Sea and Ross in the Ross Sea are both roughly the size of France. And the climate is as hostile as the continent is vast. In summer, the average temperature is 14°F (-10°C). In winter, the temperature can drop as low as -129°F (-89.2°C), recorded at the Vostok research station. The frozen wastes are constantly assailed by blizzards, with wind speeds of 125 miles (200 km) an hour commonplace, and with peaks of up to 200 miles (320 km) an hour.

In geological terms, Antarctica consists of two regions, divided by the Transantarctic Mountain range. To the east is a base of ancient rock formed in part 3.8 billion years ago. This is where the geographic South Pole lies, at an altitude of 9,200 feet (2,800 m). The western region is more fragmented. The ice sheet covers an archipelago of several thousand islands. Here, the Antarctic Peninsula is flung out toward South America. This is where you will find Antarctica's highest peak, Mount Vinson, 16,800 feet (5,140 m) in altitude, and the two volcanoes discovered by the explorer James Clark Ross, which he named Erebus and Terror, after his two ships. Contrary to what you might expect, it does not snow very much in Antarctica. The center of the continent sees barely four inches (10 cm) of snow per year, while the average annual snowfall on the fringes of the continent is about three feet (1 m). But the snow that does fall never melts. It is compacted into solid layers known as firns, which then turn into ice. This gradually creeps toward the coast in the form of

Penguins. Erebus and Terror Gulf.

glaciers, where eventually it breaks away in icebergs. The ice sheet rarely measures less than one and a quarter miles (2 km) thick, and in many places is more than two and a half miles (4 km) thick. The glaciers cover over three hundred and fifty feet (100 m) a day, as compared to just three feet (1 m) per day for the fastest-moving glacier in the Alps. However, the distance they must cover is so great that a snowflake that falls at the center of the continent can take up to five hundred thousand years to reach the ocean.

Scientists have recently discovered a vast lake of non-frozen water, Lake Vostok, buried under a layer of ice two and a half miles (4 km) thick. It is mysteries like these that teach us that Antarctica holds the key to the Earth's past. For hundreds of thousands of years, the snow has locked away bubbles of air that are now being analyzed by scientists to track changes in the levels of carbon dioxide in the atmosphere. The samples indicate that the level of greenhouse gases has risen by a third since the Industrial Revolution. The greenhouse effect will eventually have a serious impact on the ice sheet covering Antarctica. It has been calculated that if all the ice in Antarctica were to melt, sea levels around the globe would rise by two hundred feet (60 m). Coastal cities, including London, New York, Bombay, Shanghai, and Tokyo, would be wiped out. Low-lying countries such as the Maldives and Bangladesh would simply cease to exist. These coastal regions are home to more than two-thirds of the world's population.

Icebergs and penguins. Erebus and Terror Gulf.

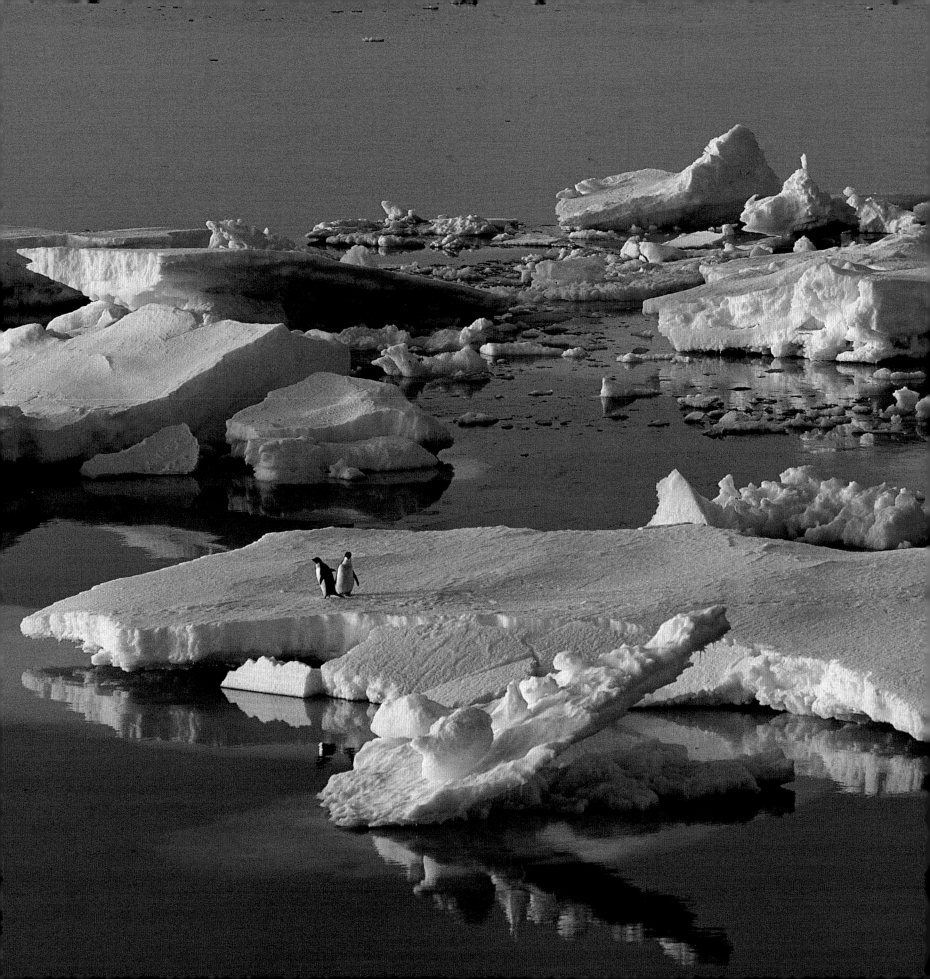

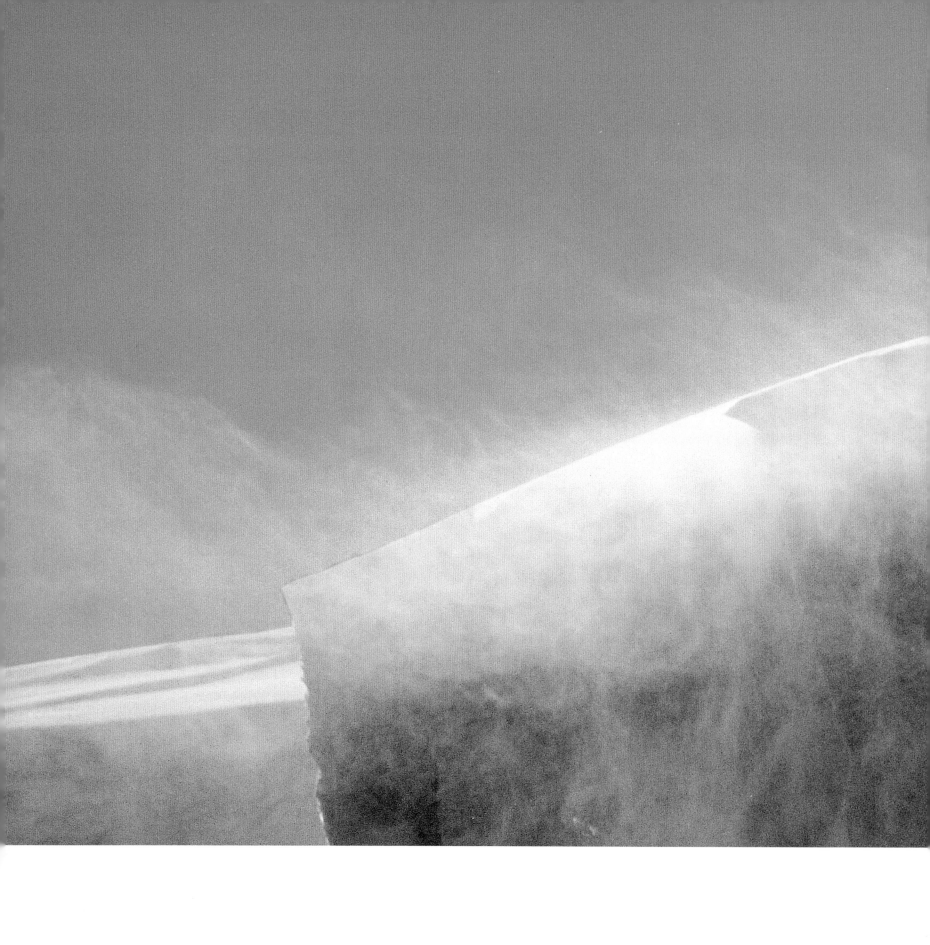

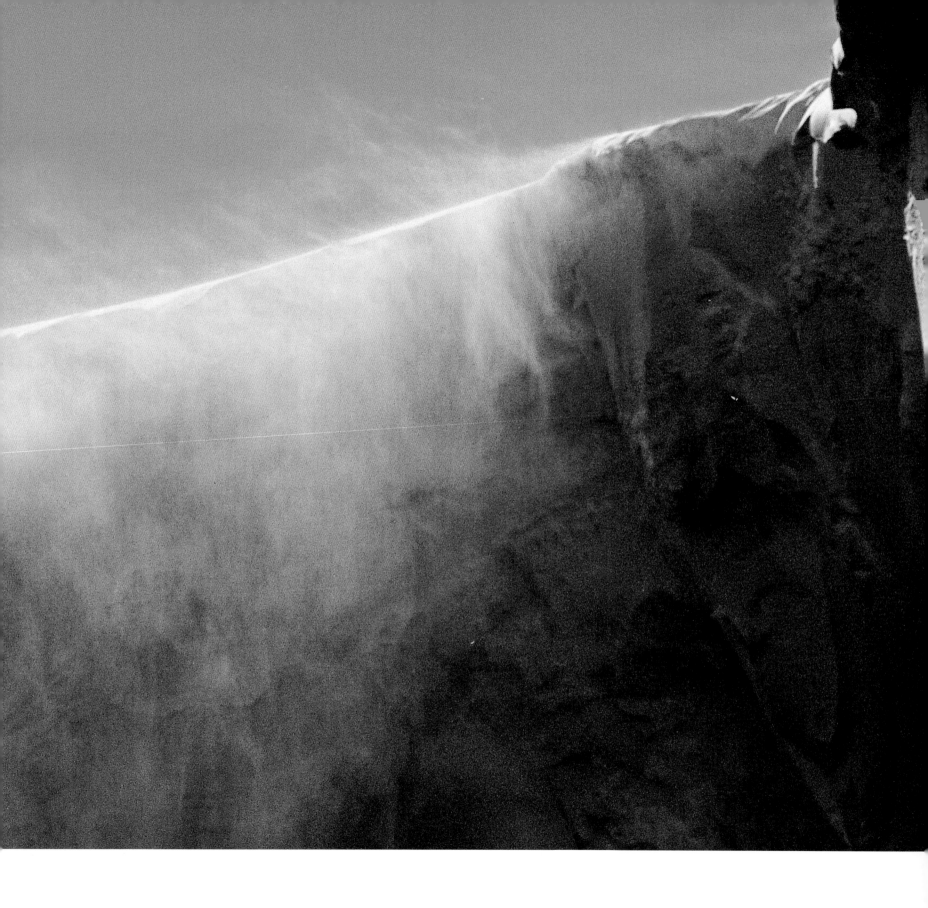

A blizzard on the Mertz glacier.

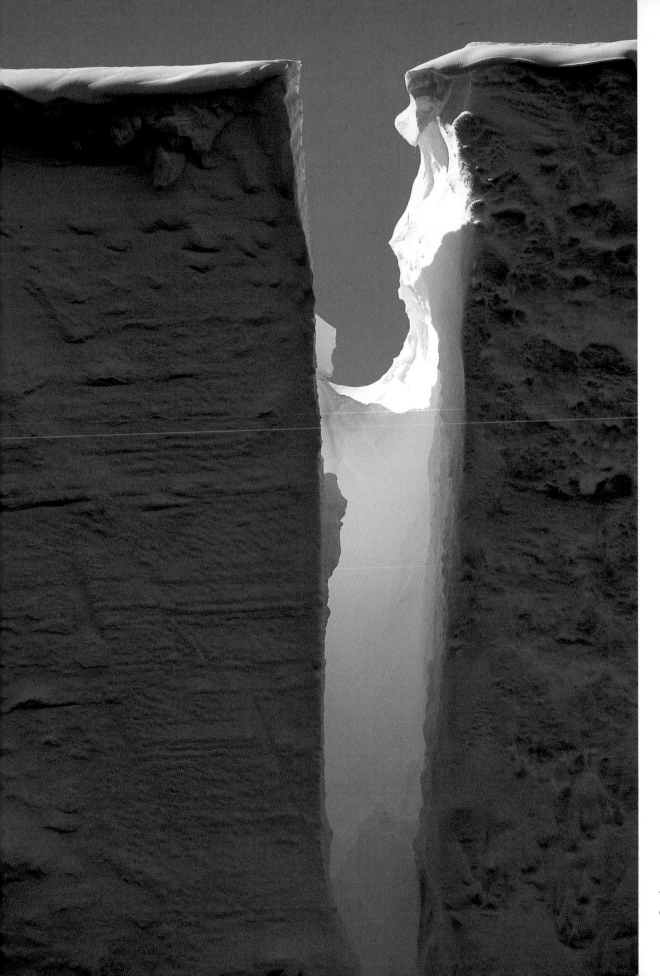

The clouds lift to reveal the cold heart
of an iceberg. Weddell Sea.

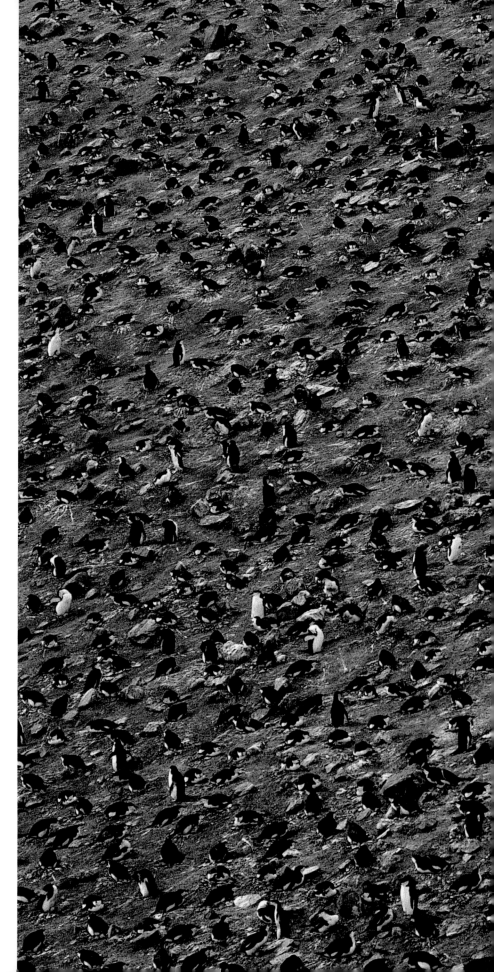

A colony of chinstrap penguins.
Weddell Sea.
Following double page: Gentoo penguins.
Dollemann Island.

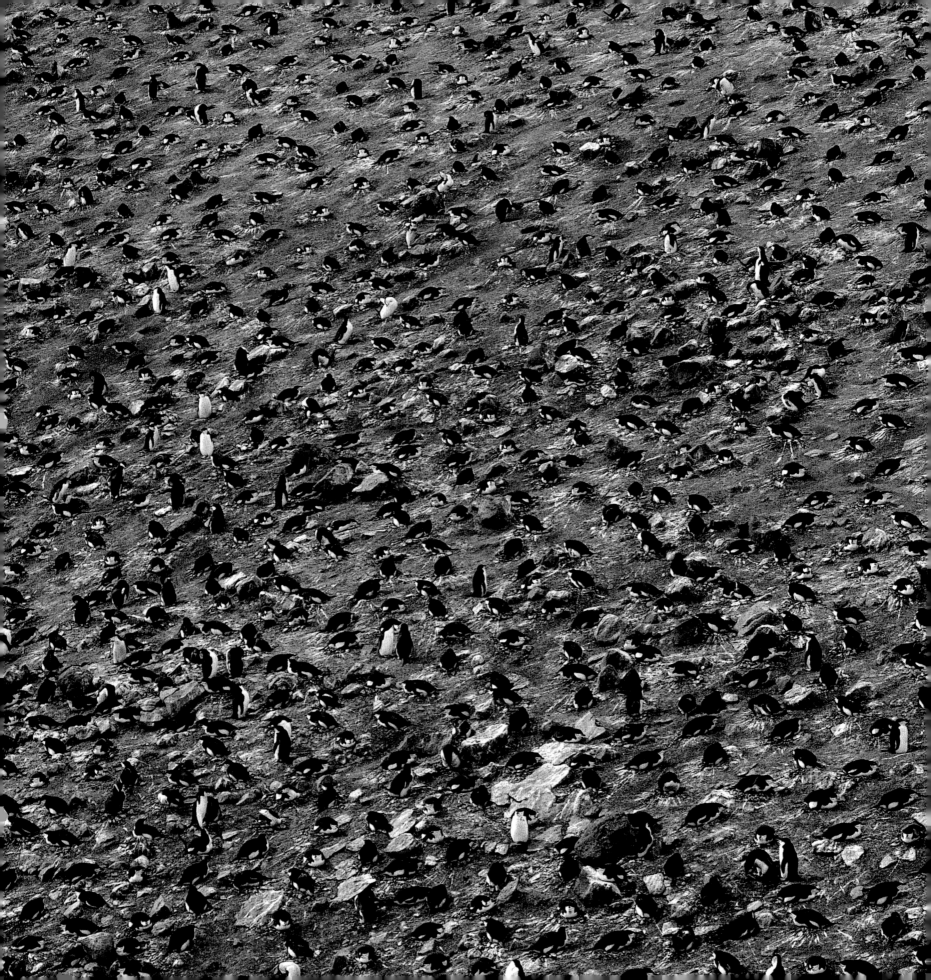

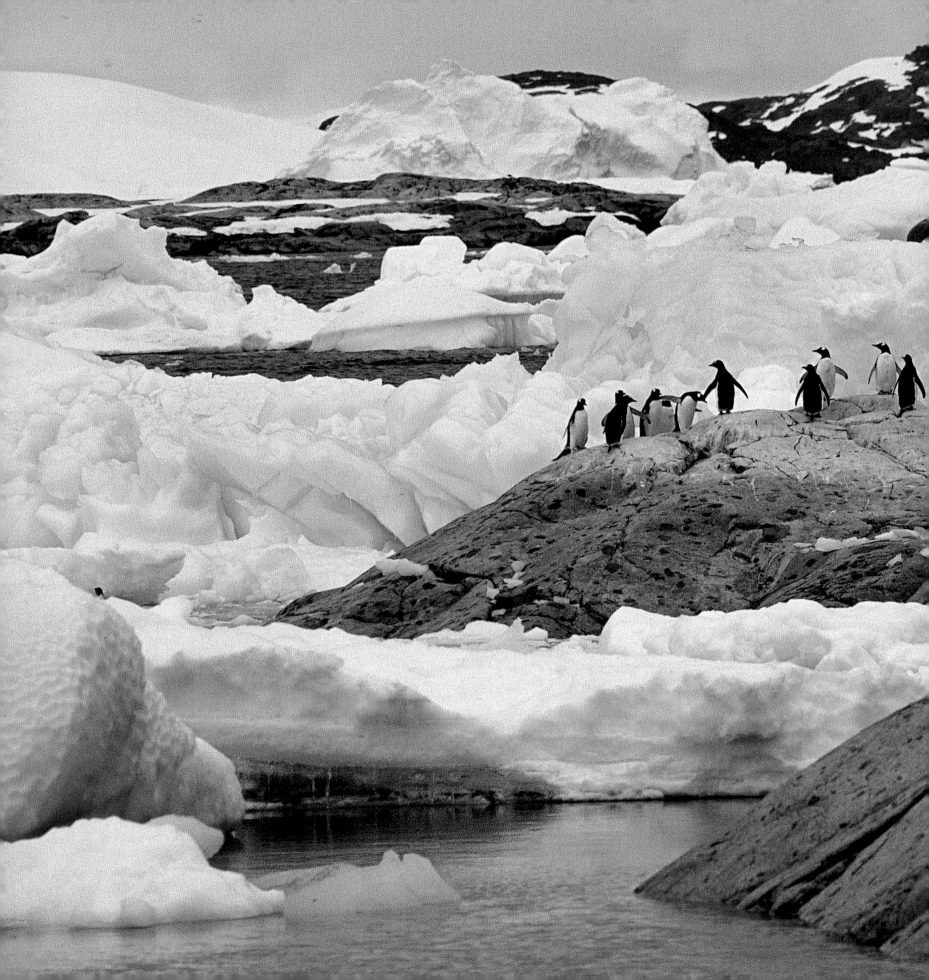

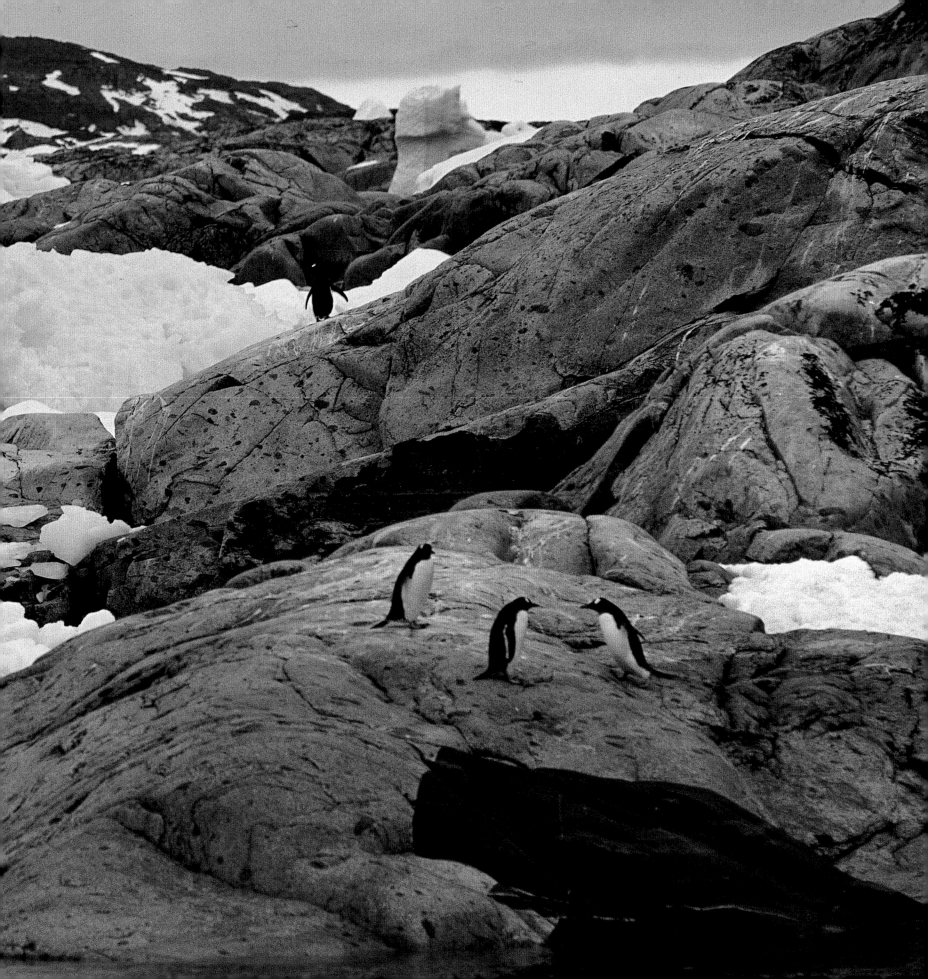

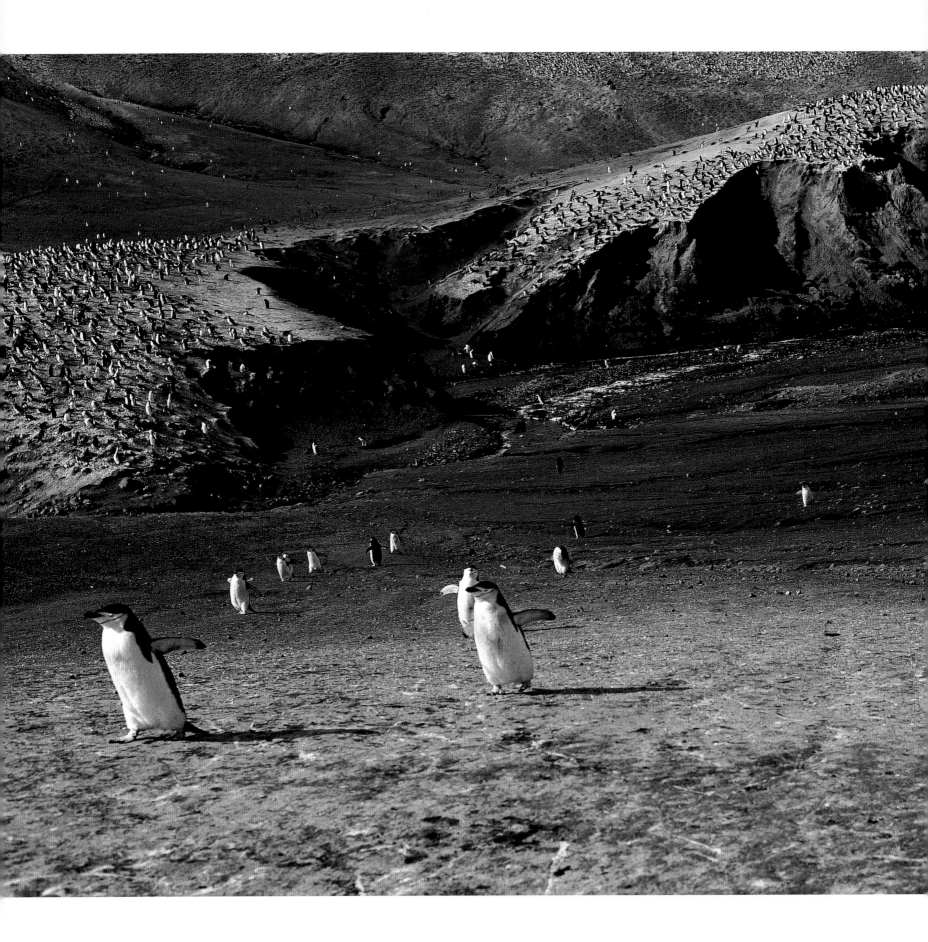

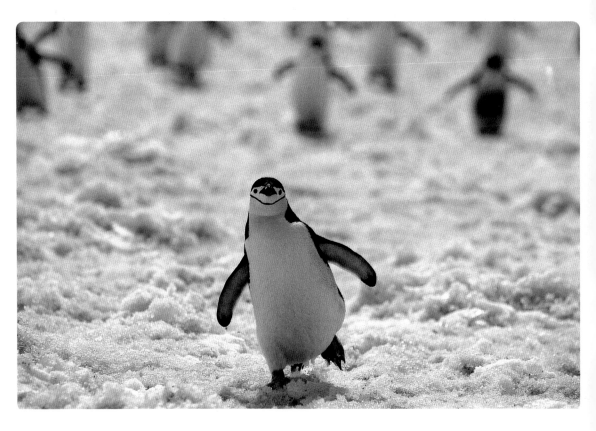

A procession of chinstrap penguins.
Deception Island.

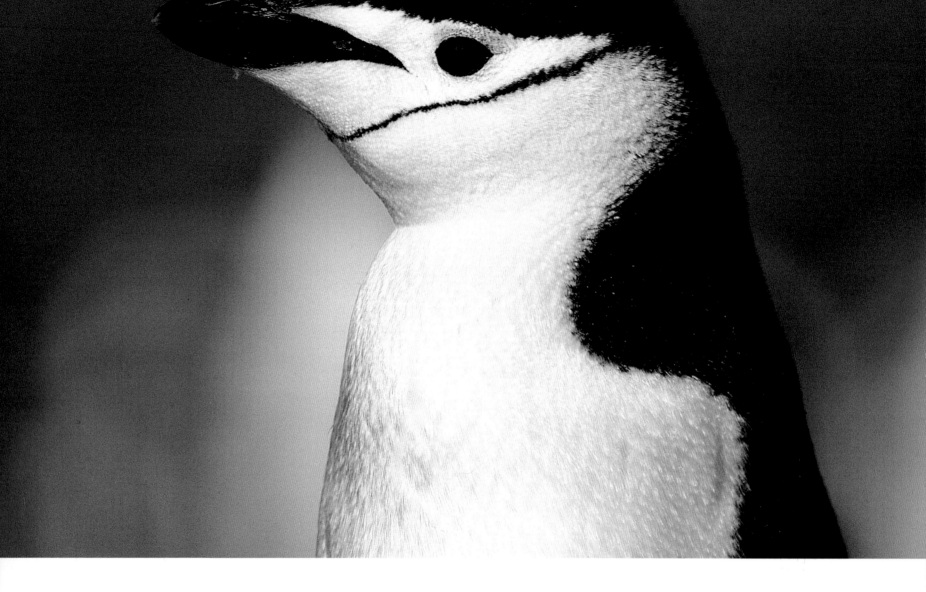

Whether chinstrap (above), Adélie (facing page), or emperor,
the penguin incarnates the spirit of the Antarctic. Deception Island.

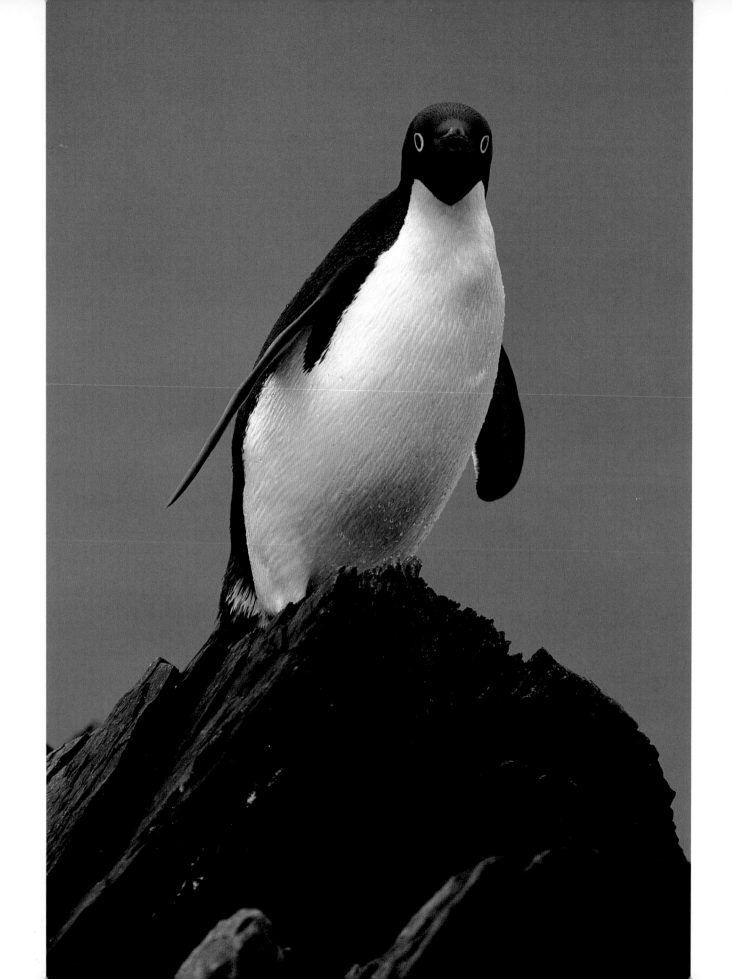

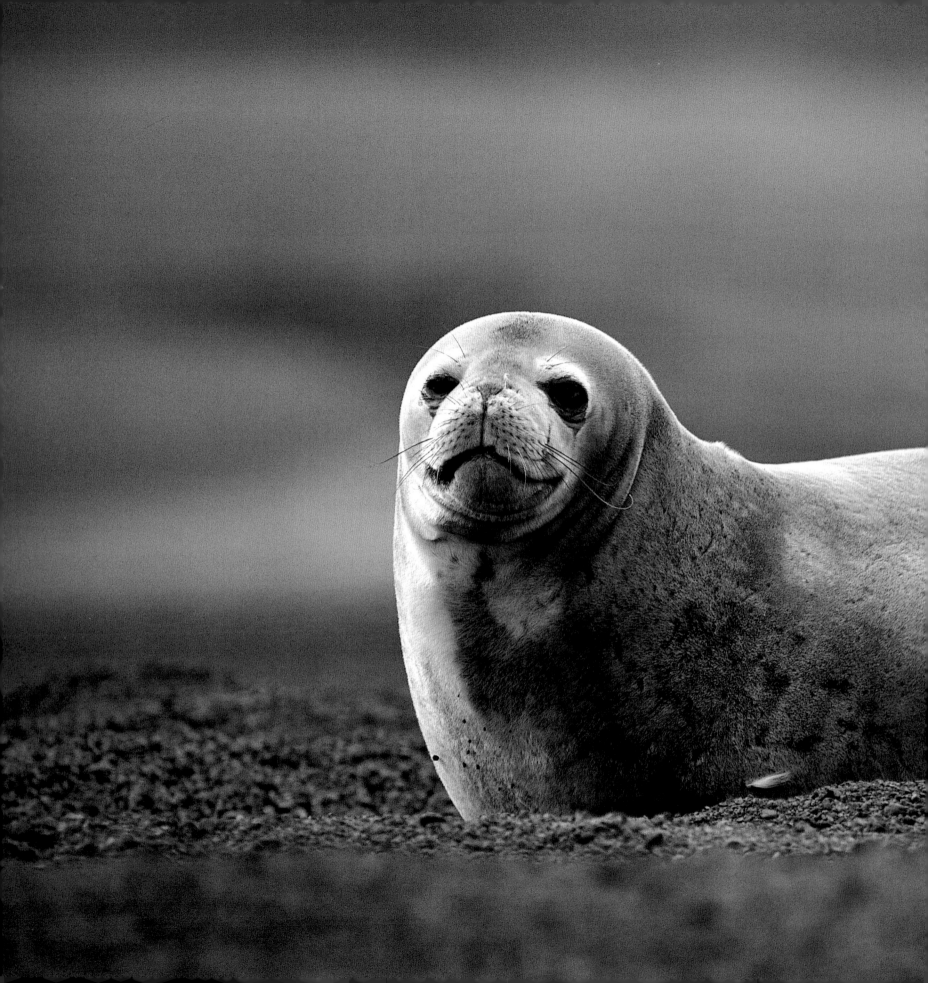

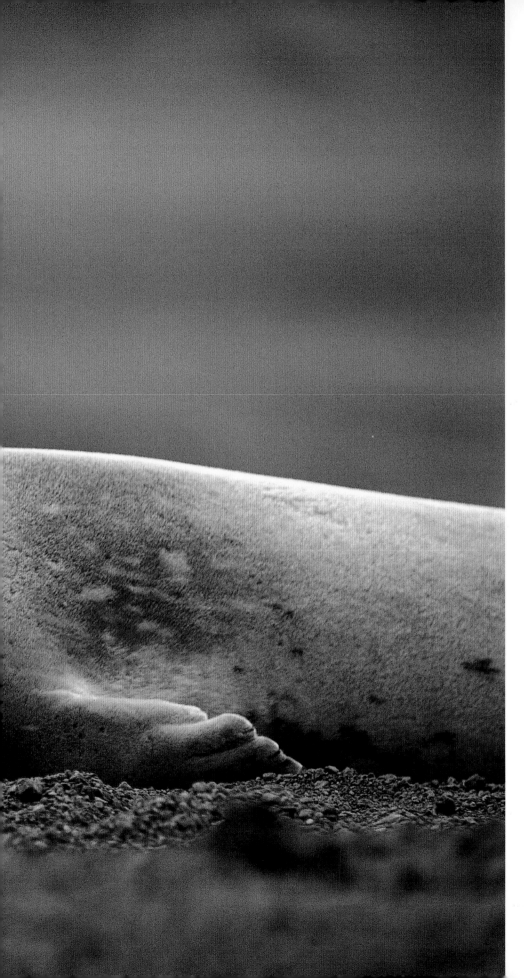

The perfect contour of the body of a Weddell seal.
Weddell Sea.

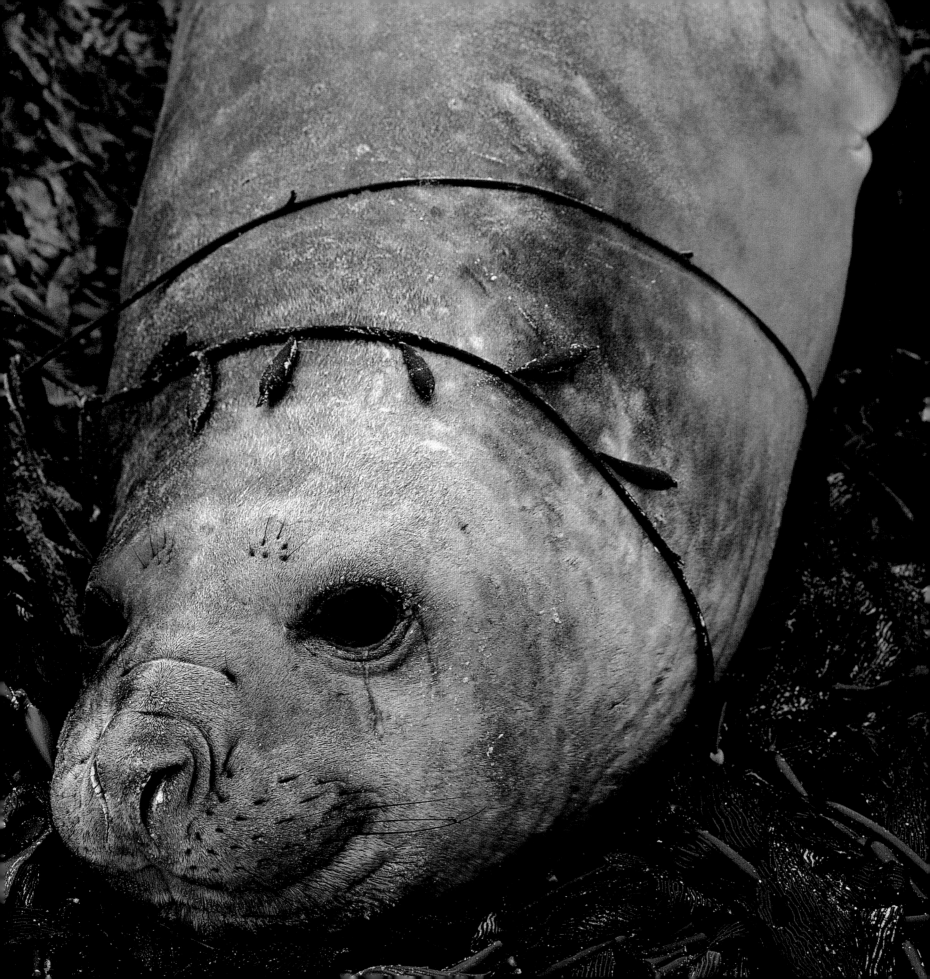

Facing page: Fishing lines and nets seriously injure a large number of animals every year.
Below: Young male elephant seals play-fighting. King George Island.

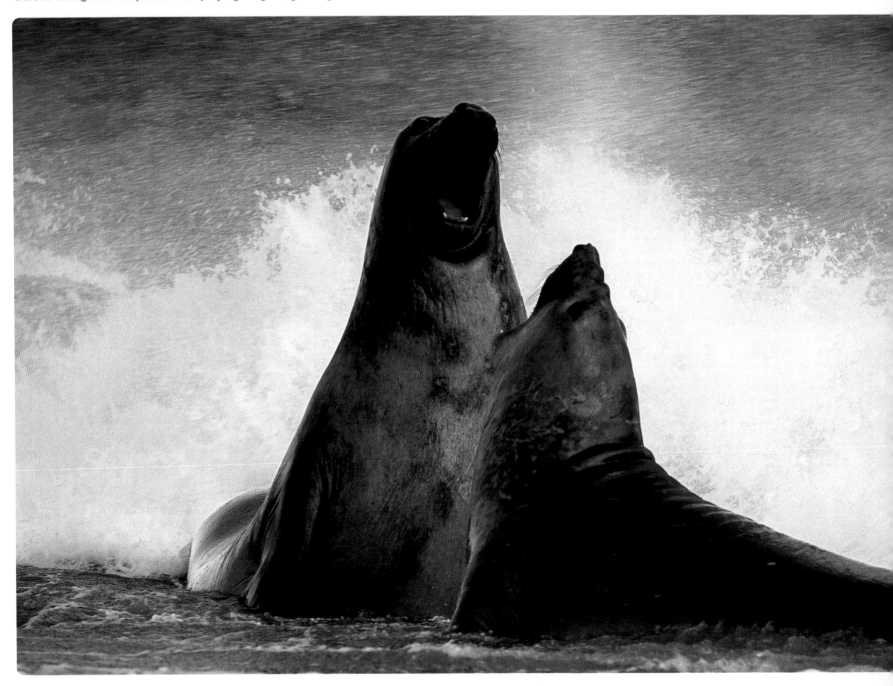

Atlantic Ocean 0° Bouvet Island

Marion Island Prince Edward Island

SOUTH GEORGIA

South Sandwich Islands

South Orkney Islands

Crozet Island

Falkland Islands

Kerguelen Islands

South Shetland Islands

SOUTH AMERICA

McDonald Island
Heard Island

ANTARCTICA

Indian Ocean

Peter I Island

SOUTH POLE

90° West

90° East

Scott Island

Balleny Islands

Southern Ocean

Macquarie Island

Campbell Island

Auckland Islands

Antipodes Islands

Snares Island

TASMANIA

Bounty Islands 180° NEW ZEALAND

AUSTRALIA

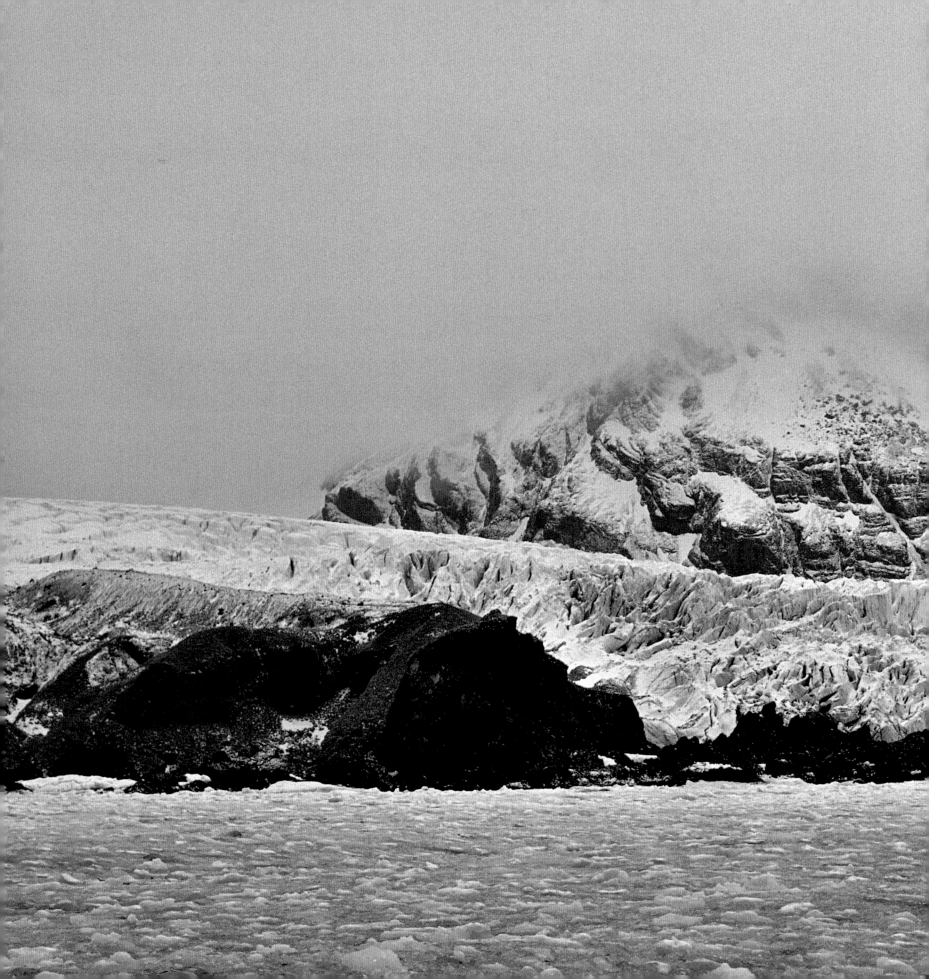

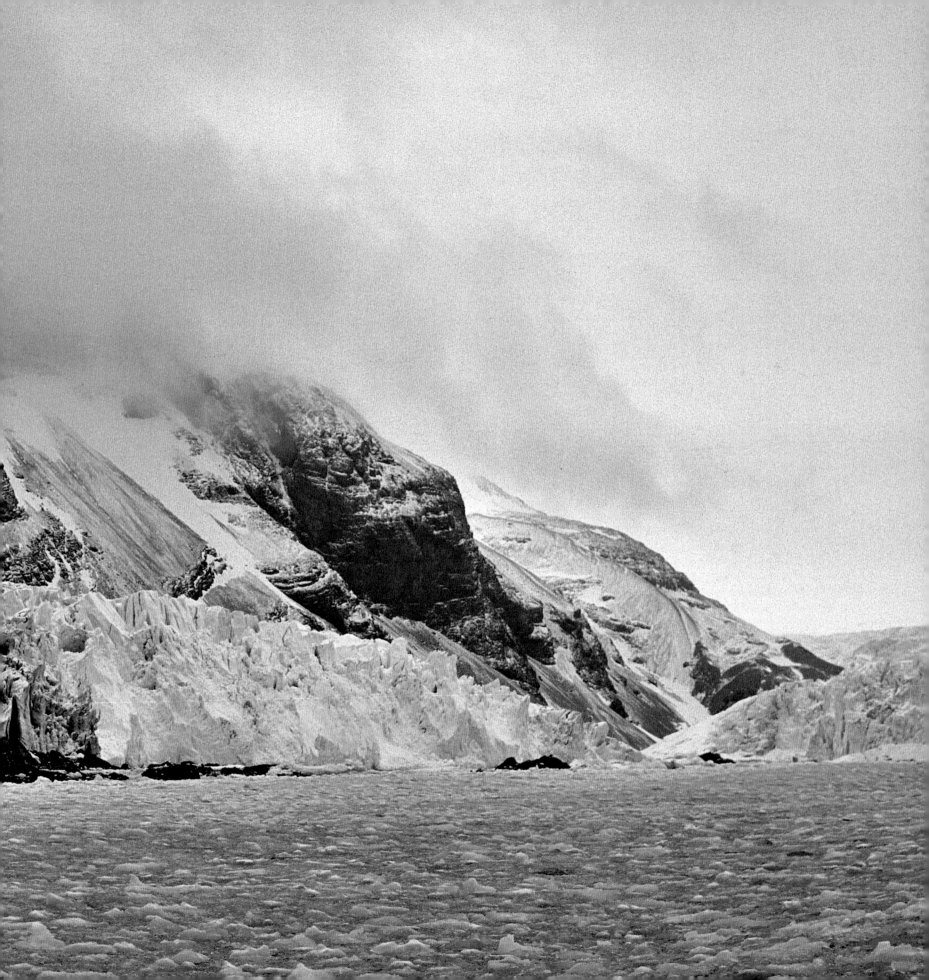

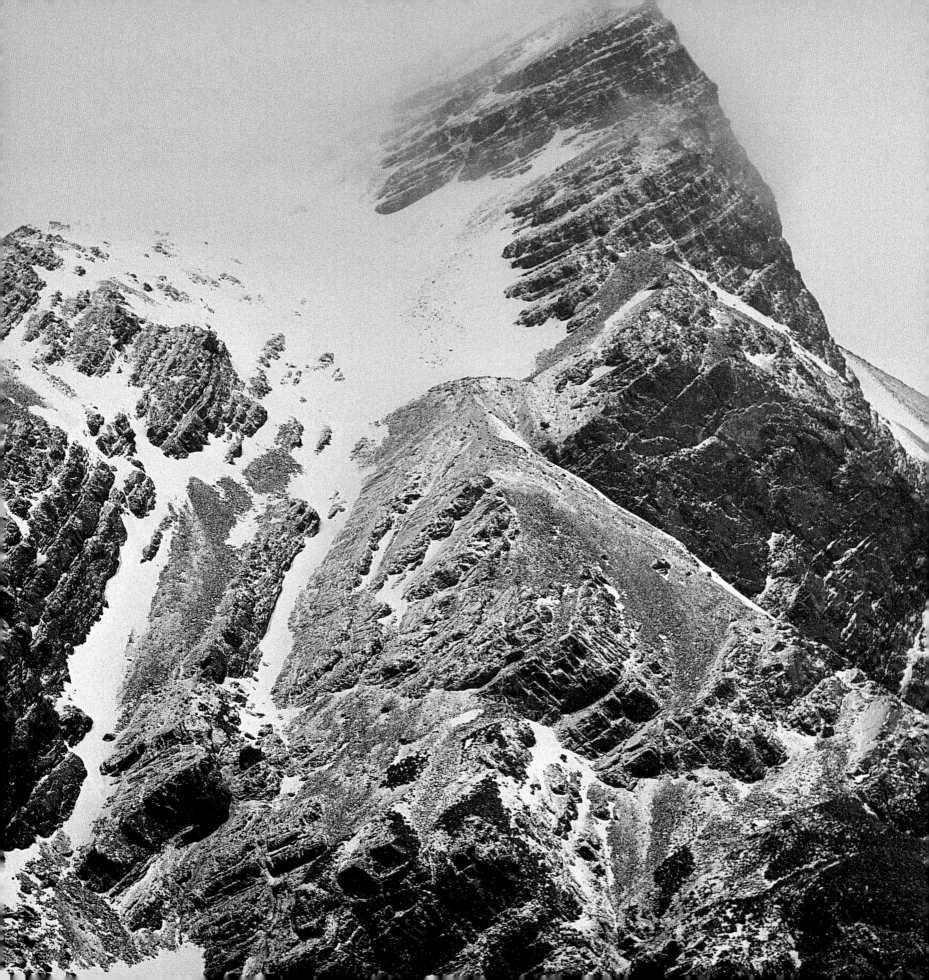

THE DANCE OF THE SEA LIONS

I can see something moving in the water. A mass of dark shadows flits beneath the waves.

What can it be? An animal? A head breaks the surface, then another, then another, until I realize that it is a whole colony of sea lions, making their annual migration to South Georgia. They are magnificent creatures, sleek and elegant, perfectly at home in the waves. Watching them at play in the surf, it is easy to see how sailors took them for mermaids. They are so graceful in the water they seem to have been born of the sea foam, like Aphrodite.

These are Kerguelen or Antarctic fur seals. Zoologists have identified several species of seal in the southern oceans, including distinct sea lion species in Patagonia and New Zealand, South American fur seals (found in the Falklands), and species endemic to New Zealand, Amsterdam Island, and the Kerguelen Islands. The scientific name of this last species is *Arctocephalus gazella*. It is the only species of seal to breed south of the Antarctic convergence, on the shores of the Kerguelen Islands, Heard Island, Bouvet Island, South Georgia, the South Sandwich Islands, the South Orkneys, and the South Shetlands, and even on the fringes of the Antarctic peninsula. The males can measure up to six feet (2 m) in length and weigh four hundred and fifty pounds (200 kg). They have a blunt head and broad shoulders, a snub muzzle, and a magnificent mane. The females measure some four and a half feet (1.5 m) on average and weigh half as much as the males. They are smaller and slenderer. Unfortunately for the seals, the fur that enables them to survive in such harsh weather conditions has long attracted hunters. Over the course of the nineteenth and twentieth centuries, vast numbers of seals were slaughtered for the fashion industry. They were hunted to the brink of extinction in many of their traditional breeding grounds, and their numbers are just beginning to climb back to their former levels. Yet they show no fear of man. The seals we saw allowed us to come up close, eyeing us curiously but making no move to flee as we approached.

Preceding double page: Glaciers and the ice floe. Cooper Bay.

Facing page: The coast between Cooper Bay and King Haakon Bay. South Georgia.

South Georgia is harsh but stunningly beautiful. The rugged landscape is cloaked in snow piled into treacherous drifts by the unceasing winds. On the day that we arrived, the coastline was veiled in mist and persistent fine drizzle that soaked through our layers and chilled us to the bone. South Georgia is the most mountainous region of Antarctica. The highest peak is Mount Paget, with an altitude of 9,625 feet (2,934 m). There are a total of twelve mountains higher than 6,500 feet (2,000 m). The coastline is furrowed with deep fjords gouged by over one hundred and fifty glaciers. Some have been given names, such as Royal Bay, Cumberland Bay, and Stromness Bay. There are dozens of tiny islets strung along the coastline, with names like Willis, Bird, Albatross, and Annenkov.

South Georgia was first sighted in 1675 by a London navigator, Anthony de la Roche, driven into these southern latitudes by a storm off Cape Horn. It was rediscovered about a century later by Captain Cook, who approached Antarctica on his second voyage with his ships *Resolution* and *Adventure*. On January 30, 1774, sailing along the edge of the ice floe, he noted their position in his log as 71°11 south. He returned to the region the following year. On January 17, 1775, he caught sight of South Georgia, taking possession of it for Britain and naming the new land after King George III. His next discovery was the South Sandwich Islands. He noted in his diary that the risks he and his crew ran exploring the coastline in these icy seas were such that no explorer would ever dare venture further south. He remained convinced that any lands that might lie closer to the South Pole would never be discovered. On this point, he was proved wrong. In 1819, the British seal hunters William Smith and Edward Bransfield discovered the South Shetland Islands. At the same time, in 1819–21, a certain Von Bellingshausen traveled to Antarctica for the Russian court. In the following decades, many great explorers took up the challenge, including Nathaniel Palmer, James Weddell, John Biscoe, Peter Kemp, Jules Dumont d'Urville, Charles Wilkes, and James Clark Ross. In the late nineteenth and early twentieth centuries, adventurers from many countries headed for Antarctica: the Belgian Adrien de Gerlache, the Norwegian Carsten Borchgrevink (who later took Australian nationality), the German crew of the *Gauss*, the Swede Otto Nordenskjöld, the Scot William Bruce, the Frenchman Jean Charcot, and the Englishman Ernest Shackleton.

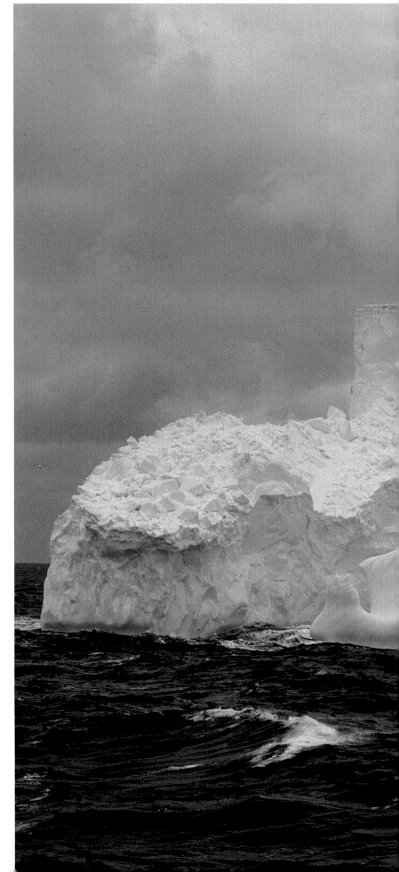

The slow majesty of icebergs. King Haakon Bay.

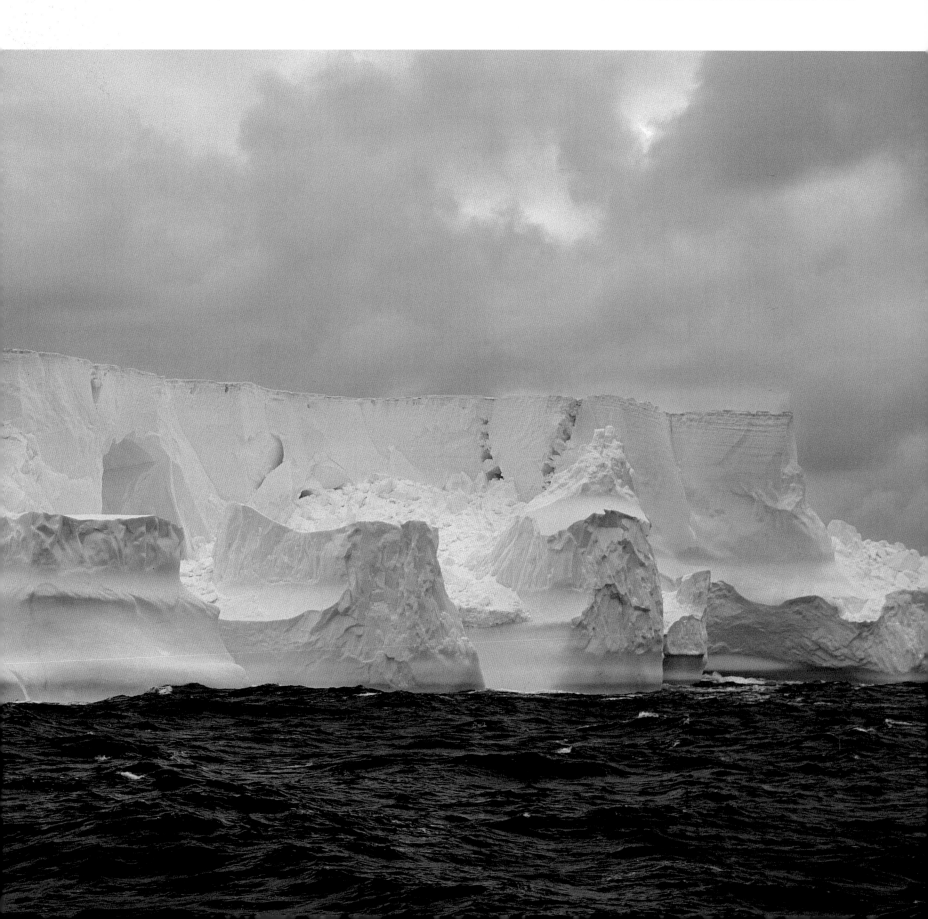

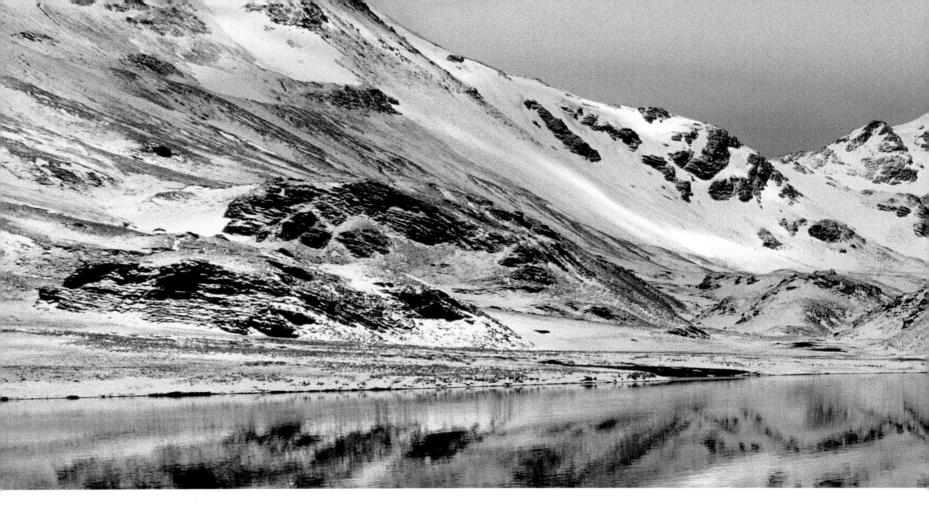

View of Stromness Bay. South Georgia.

The race to the South Pole was famously won by the Norwegian Roald Amundsen, who planted his flag on the southernmost point of the planet on December 14, 1911. He was closely followed by the British explorer Robert Falcon Scott, who arrived on January 17, 1912, only to find Amundsen's flag. He bravely noted in his diary, "The Norwegians have forestalled us and are first at the Pole. . . . All the day dreams must go; it will be a wearisome return." The tragedy of their return journey is the stuff of legend. Scott and his fellow explorers eventually succumbed to exhaustion, cold, and hunger. The final entry in Scott's diary is dated March 29, 1912. It reads, "It seems a pity, but I do not think I can write any more. R. Scott. For God's sake look after our people." Eight months later, the frozen bodies of Scott, Wilson, and Bowers were found and buried beneath a cairn, with a cross inscribed with the last line of Alfred Lord Tennyson's "Ulysses": "To strive, to seek, to find, and not to yield." A fitting epitaph.

South Georgia is bathed in pale spring sunshine. The glaciers are glistening in the weak sun that breaks between the high scattered clouds. A family of elephant seals is out on the shore. A pair of males is fighting, but the other members of the colony seem to be enjoying the sun. Seen from this close range, they are truly impressive creatures, measuring up to twenty feet (6 m) in length and weighing from four to six tons for an adult male. Scientists have recently discovered that these ungainly creatures are outstanding deep-sea divers, descending to depths

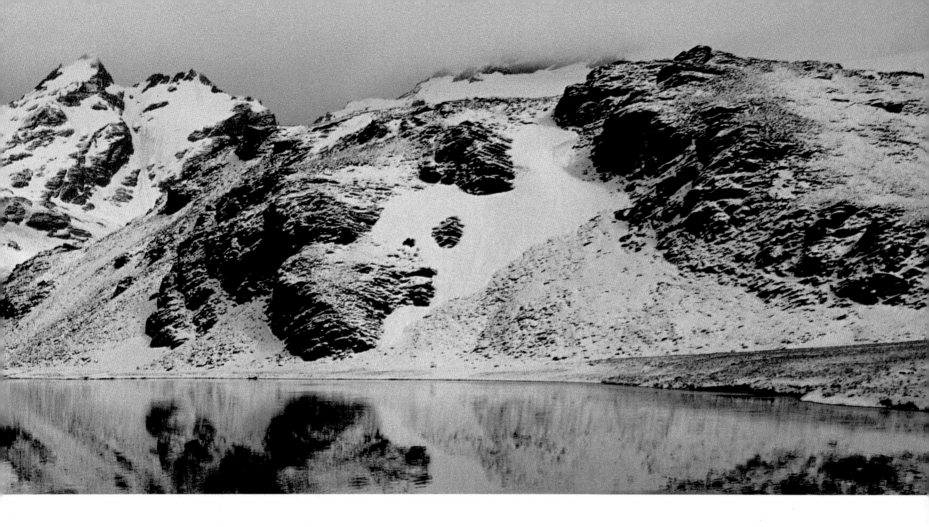

of five thousand feet (1,500 m). How they hold their breath for half an hour at a time and find their way in the black night of the ocean at such depths remains a mystery.

Captain Cook made a note in his diary about the vast numbers of penguins in South Georgia. There are also large numbers of fur seals, elephant seals, and whales. Between 1785 and 1913, South Georgia was basically one huge whaling station, where countless animals were slaughtered. In 1902 to 1904, the Norwegian whaling captain Carl Anton Larsen built the world's largest whaling station at Grytviken. At its height, it counted six factories on land and a further eight on ships. Vast numbers of Southern right whales, humpback whales, minke whales, and above all blue whales were harpooned. In a period of about twelve years, 180,000 whales were processed in Grytviken. In the words of the Chilean poet Samuel Lillo, "It [was] as if the sea [was] clothed in a cloak of floating crimson."

As the numbers of whales dwindled, so did those of the fur seals and elephant seals. Whaling was only subjected to international regulations in 1962. However, as early as 1925, the British government set up a scientific research station in South Georgia. The station is still an active research center. The scars are gradually healing. As we leave, I spy a Kerguelen fur seal playing in a bed of kelp. It seems like a symbol of hope for the future of South Georgia.

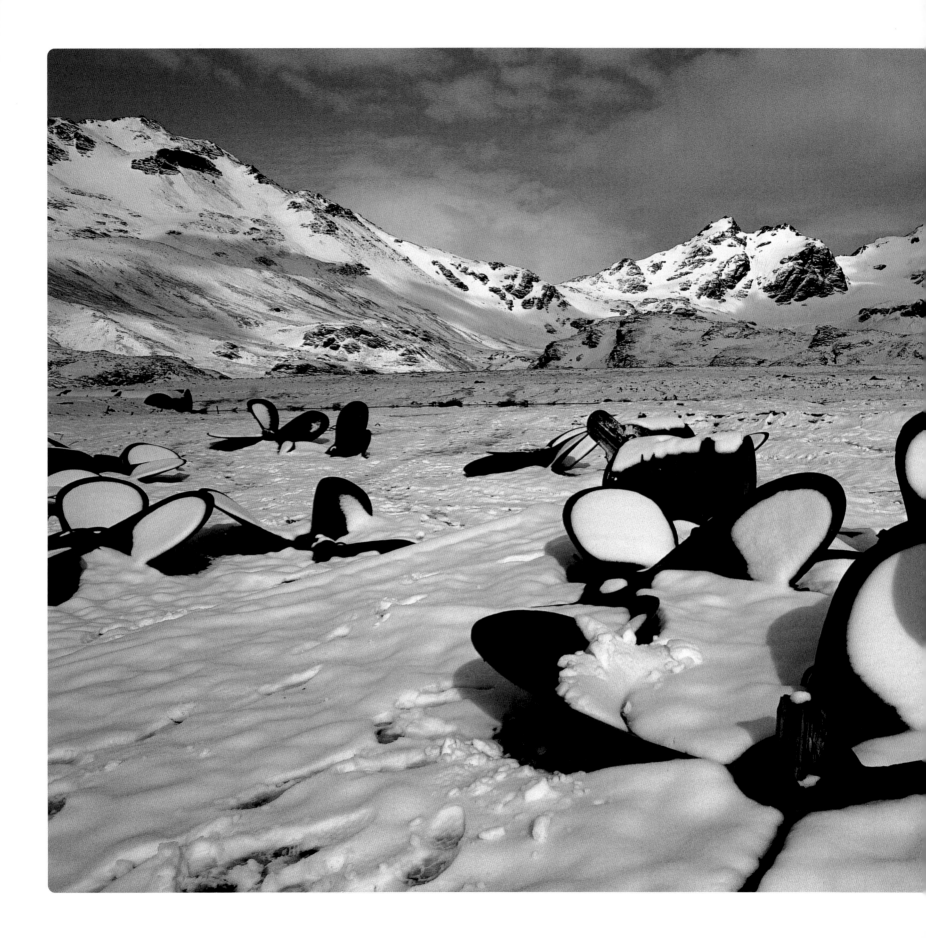

View of islands in Stromness Bay.

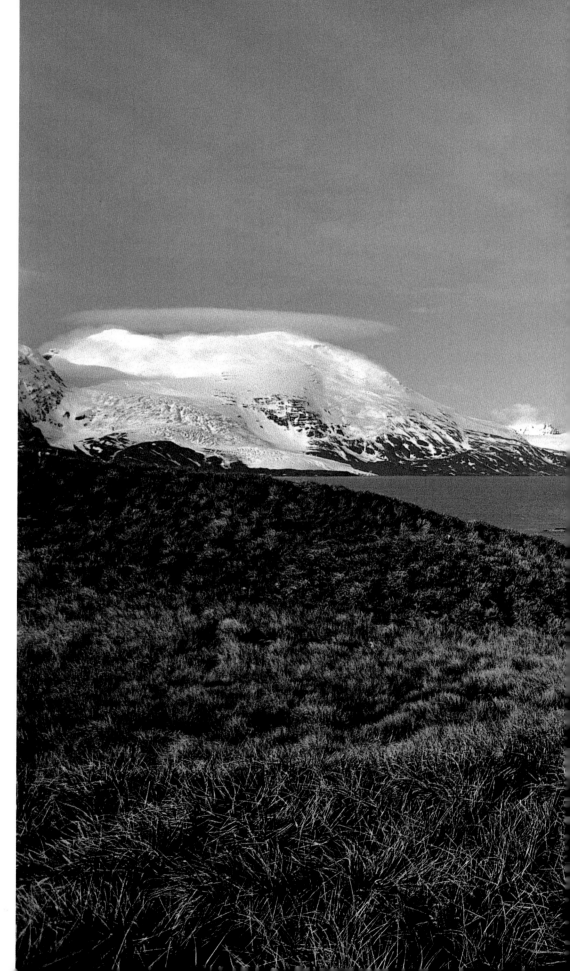

The brief flowering of summer.
King Haakon Bay.
Following double page: A colony of royal penguins
in the tussock grass. Salisbury.

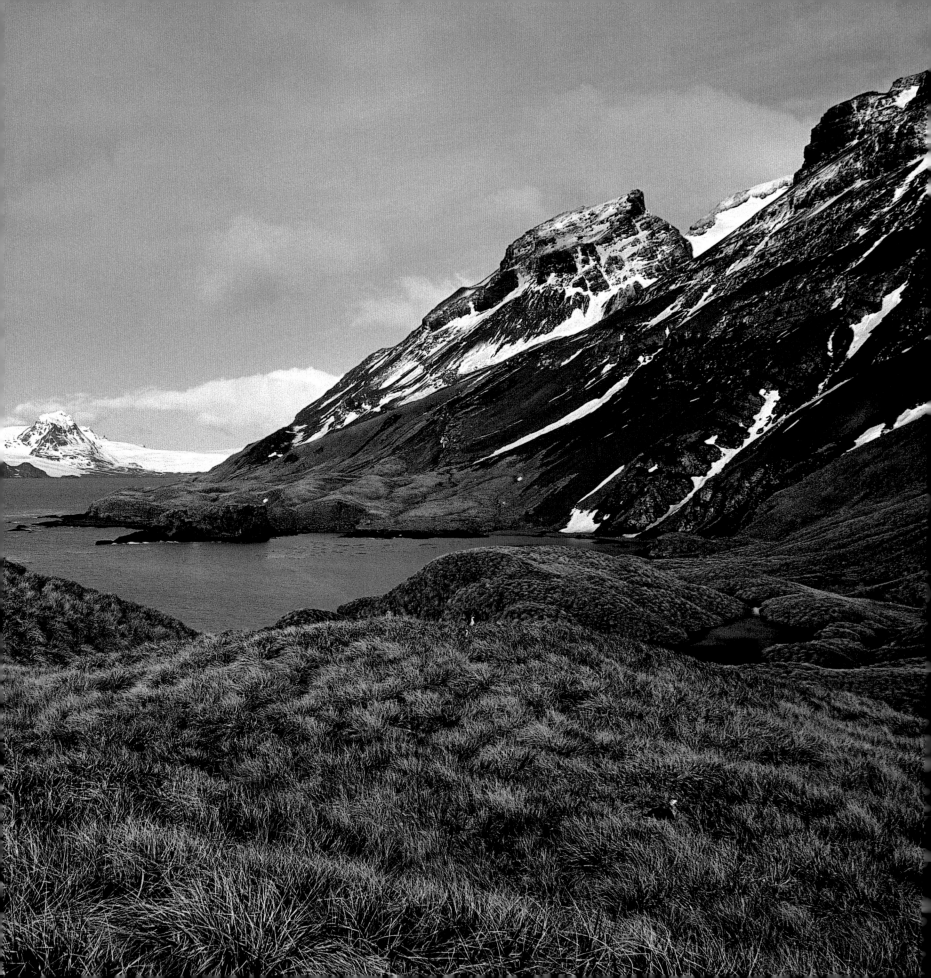

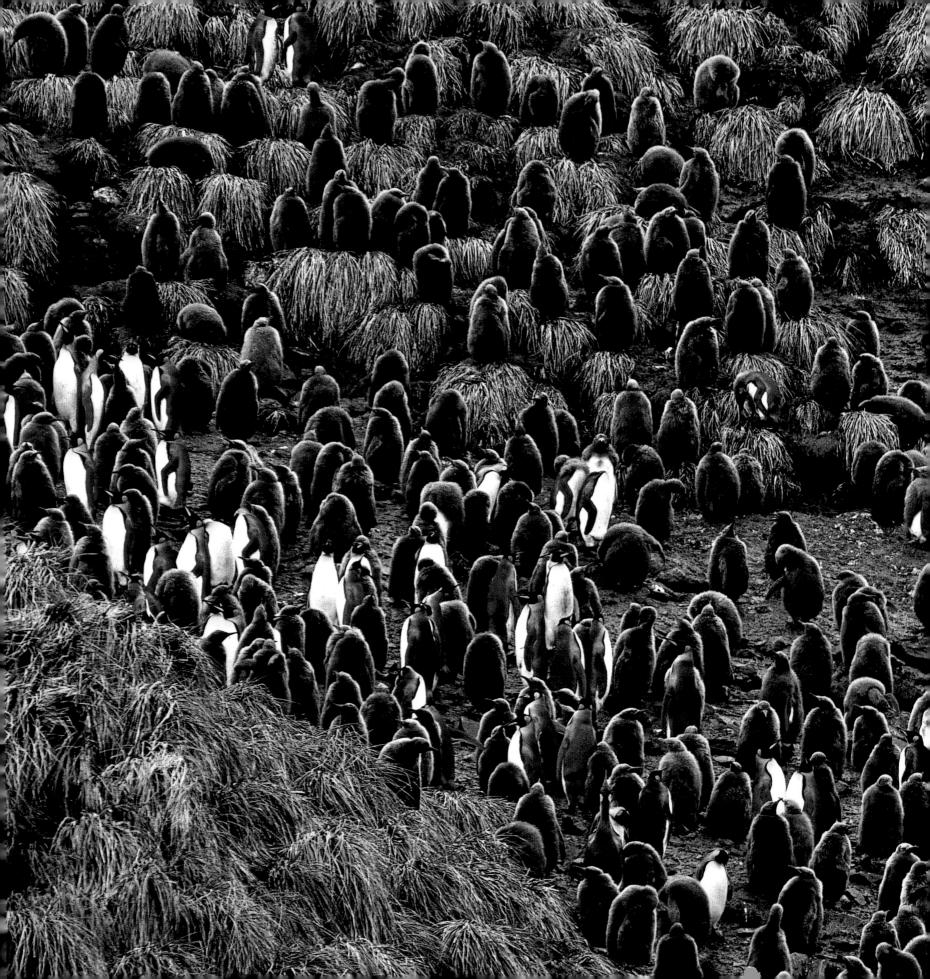

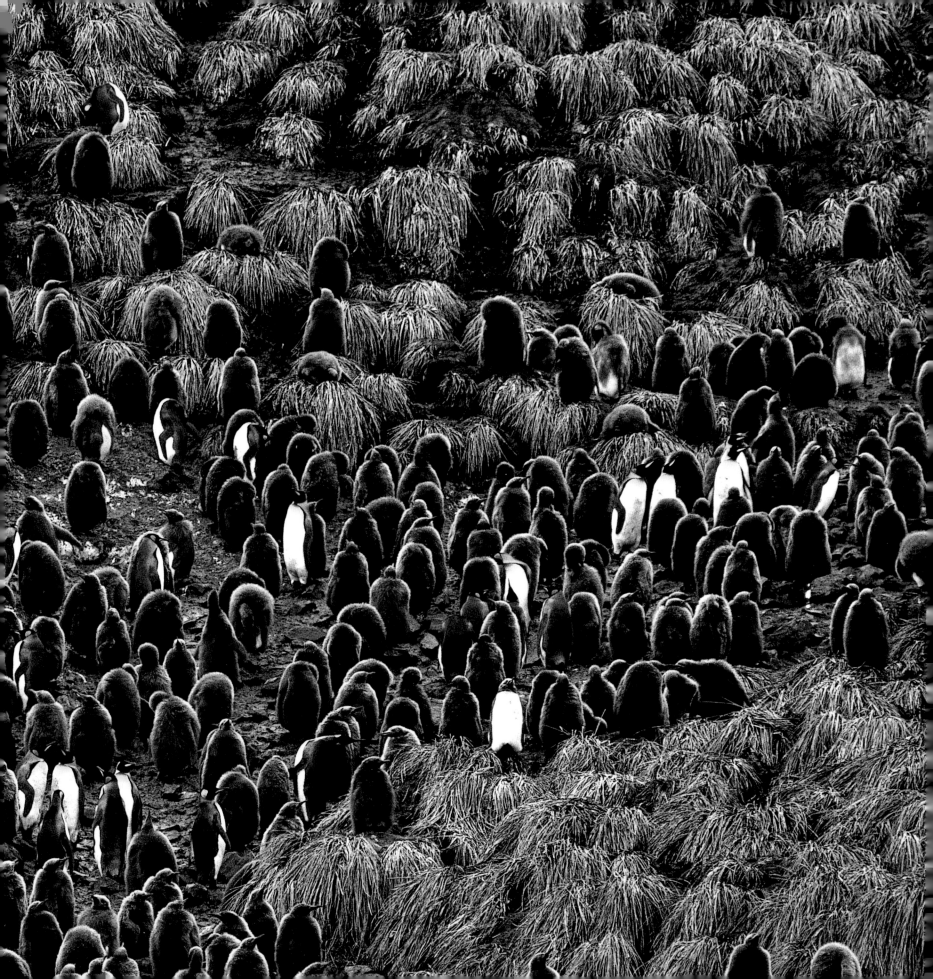

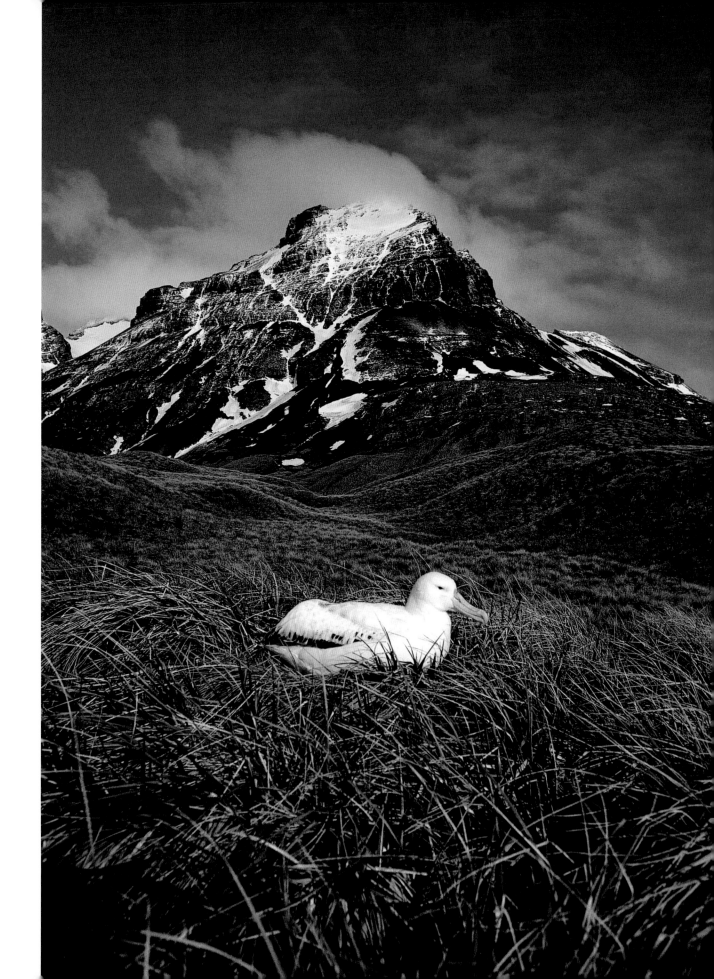

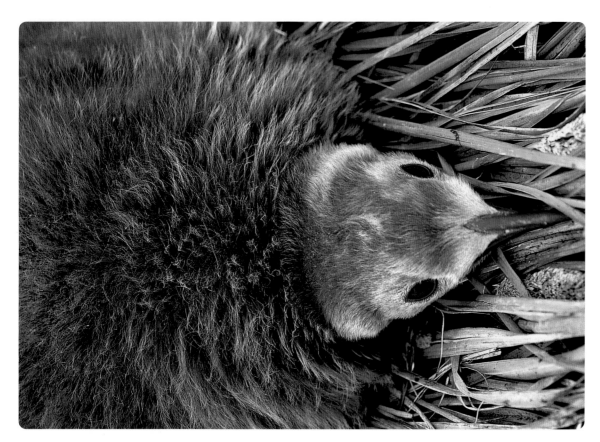
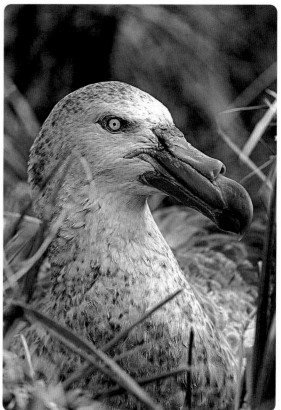

Facing page: A wandering albatross.
Top, left: A royal penguin chick.
Top, right: A giant petrel. King Haakon Bay.

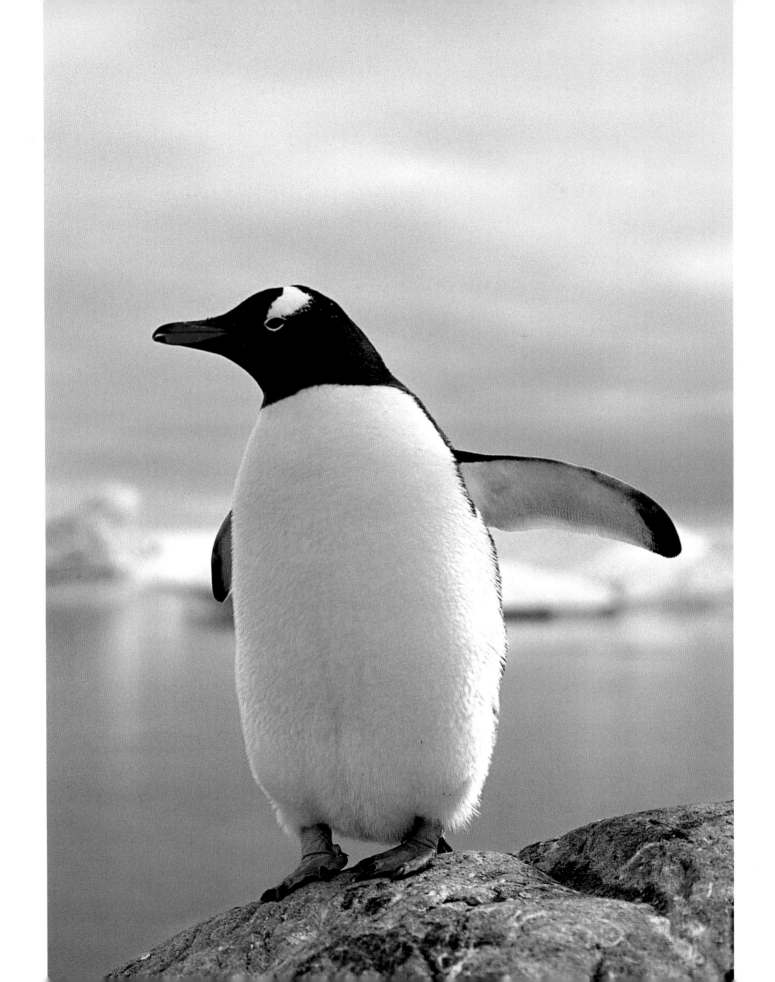

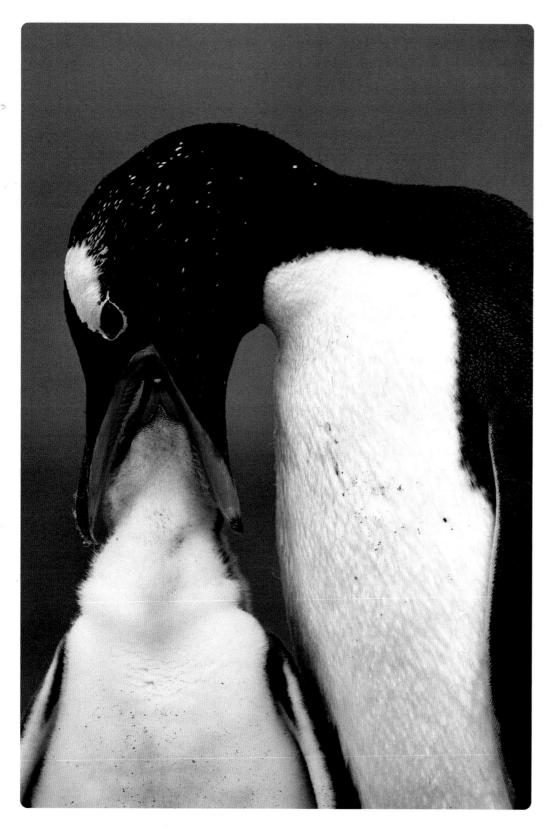

Gentoo penguin
and chick.
Couverville Island.

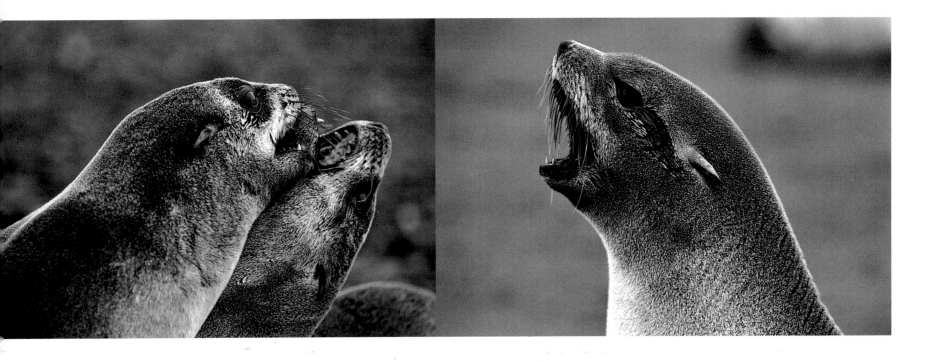

Antarctic fur seal.

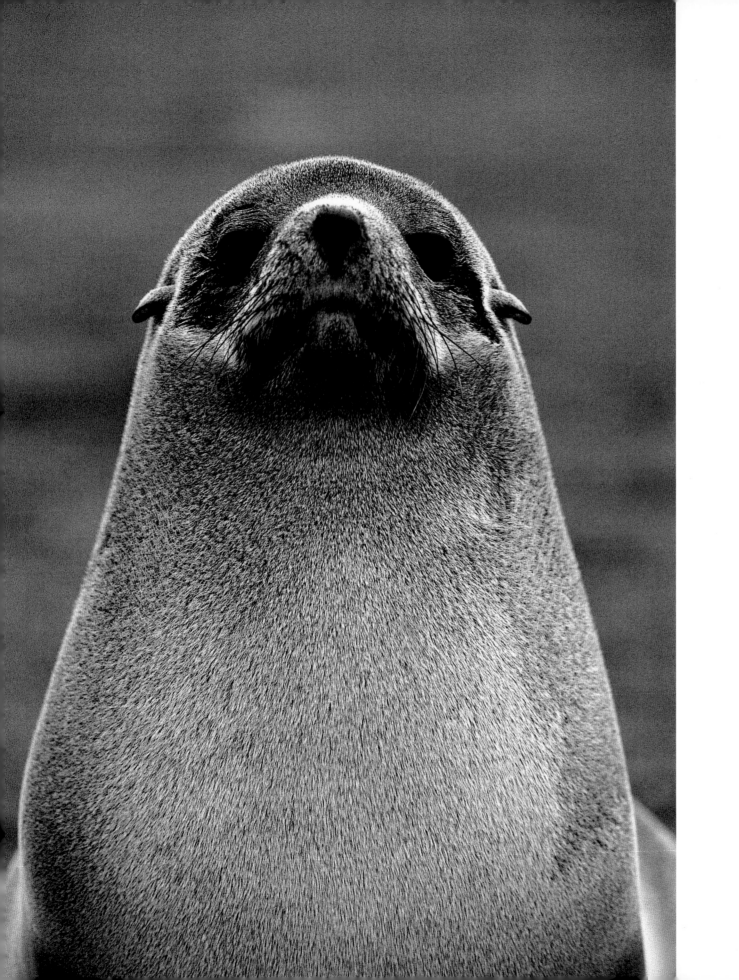

THE FALKLANDS

THE ANTARCTIC

SOUTH GEORGIA

THE KERGUELEN ISLANDS AND ADÉLIE LAND

SNARES ISLAND,
THE AUCKLAND ISLANDS,
AND MACQUARIE ISLAND

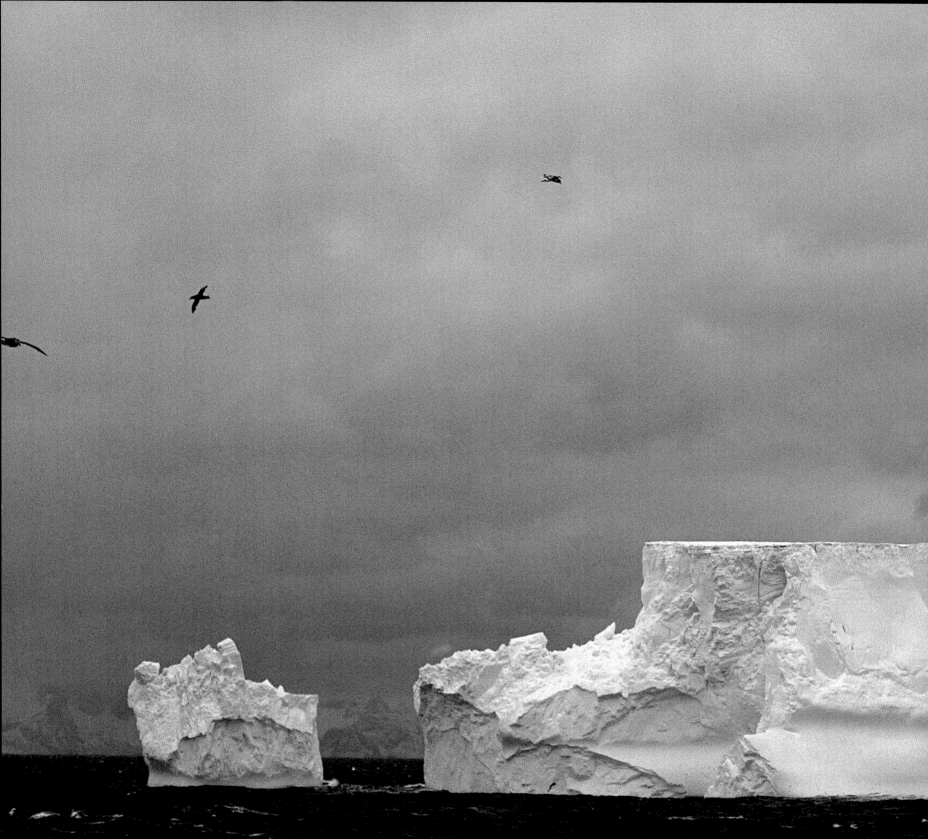

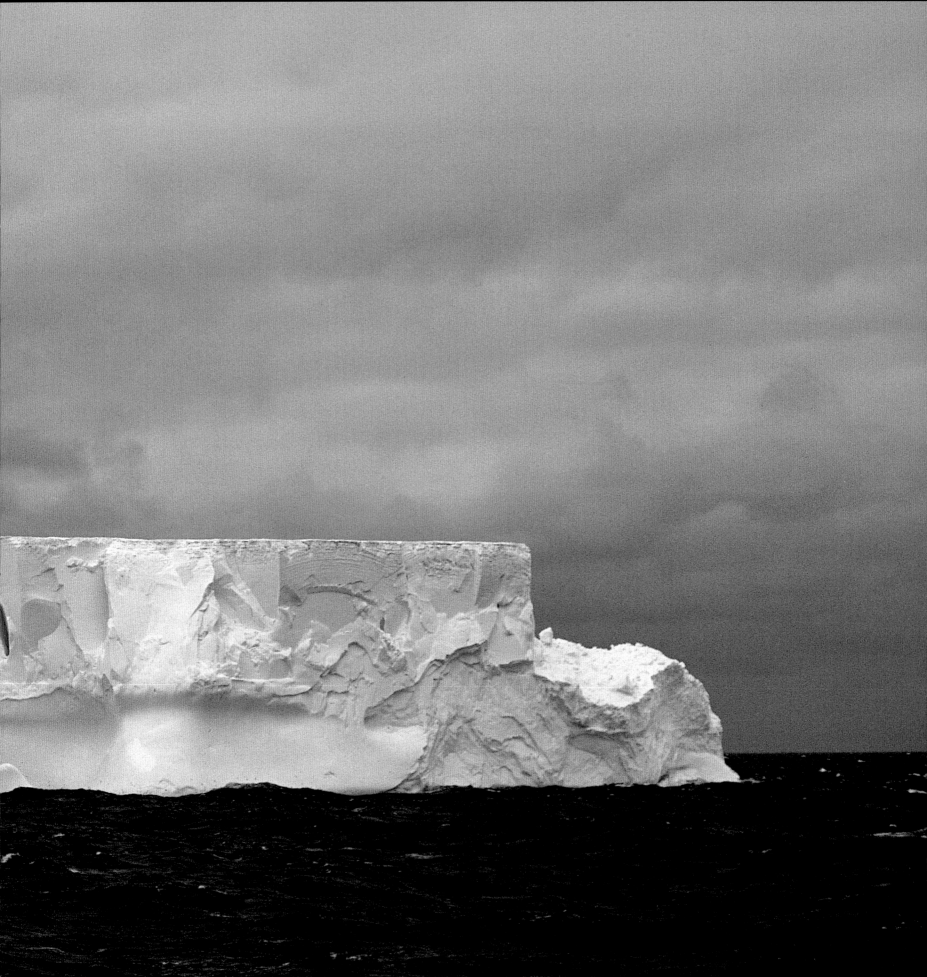

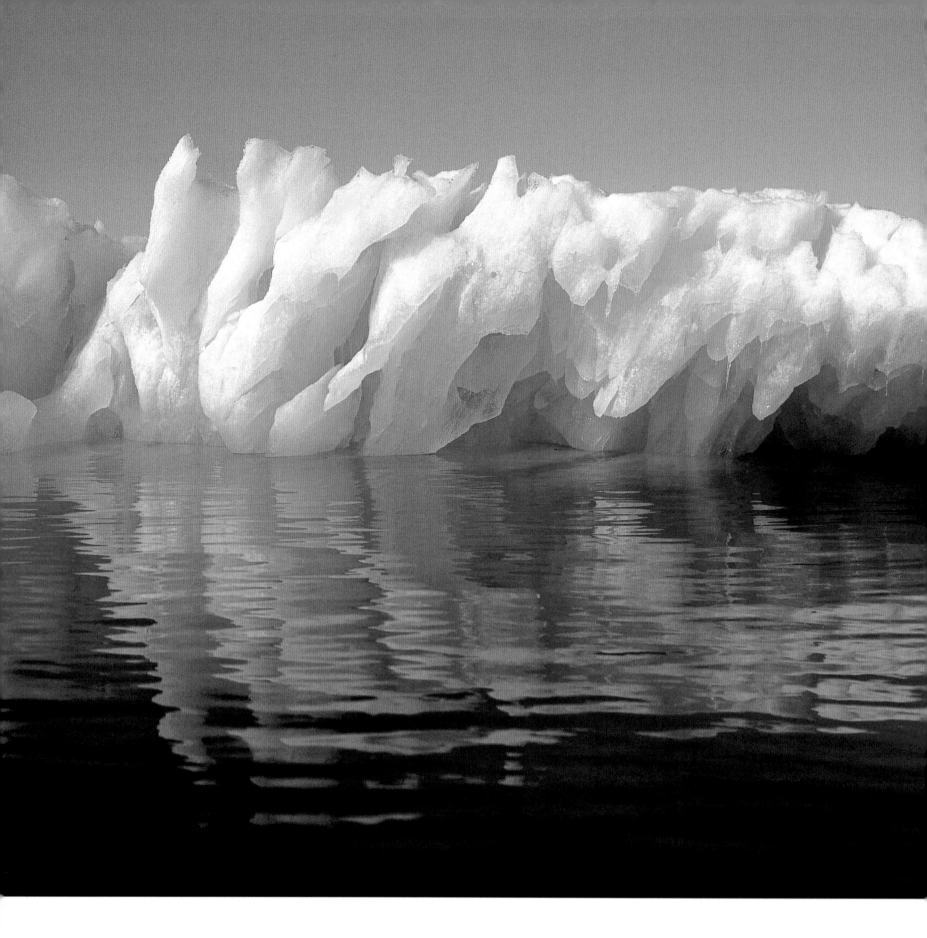

LIES, LOVES, AND JOURNEYS

The Kerguelen Islands are a magical, unsettling spectacle, lost on the edge of the ocean, where dreams can become nightmares in the blink of an eye.

The Kerguelen Islands owe their name to an eighteenth-century French sailor who was inspired to set sail for the southern oceans by the accounts of the voyages of Bougainville and Captain Cook. Captain Yves-Joseph de Kerguélen-Trémarec was a native of Brittany—a region with a long and proud seafaring tradition. He set off for the other side of the world with two ships, the *Fortune* and the oddly named *Gros Ventre*, meaning "fat belly." On February 12, 1772, he caught his first glimpse of some islands in the southern Indian Ocean, which he identified as the mysterious Eden that the French navigator Paulmier de Gonneville claimed to have discovered in the sixteenth century. Captain Kerguelen claimed that this large southern "continent" could make up for the recent loss of territories in India and Canada, and that it would be an ideal base for France to conquer land in Asia and America. Three years later, in 1775, he led a second expedition. This turned out to be a catastrophic failure, but this did not stop Kerguelen returning to France with tales of the fertile, sunlit land he had discovered and recommending that French colonies be set up there straight away.

Captain Cook sailed within a short distance of the islands on his second voyage. He noted that the islands were bare and inhospitable, with nothing to offer but snow-capped rocks and cliffs inhabited by penguins and seals. He christened the bare rocks Desolation Island. When word of Captain Cook's discovery spread throughout Europe, Kerguelen's exaggeration became apparent. Louis XVI of France was furious and

Preceding double page: A tabular iceberg.
Facing page: This iceberg
called to mind a psychedelic sculpture.

ordered Kerguelen to appear before the court, accused not only of lying but also of failing in his duty as a mariner and smuggling. He was also accused of smuggling a sixteen-year-old girl by the name of Louison onto the ship as his mistress. He was sentenced to twenty years in prison, but in the end served only four.

The Kerguelen Islands—one of the most isolated places on the planet—are the highest point of an immense underwater plateau which is a kind of wrinkle on the earth's surface, caused by the slow shifting of the tectonic plates. The archipelago lies in the far reaches of the southern Indian Ocean, 1,250 miles (2,000 km) from Antarctica, 2,800 miles (4,500 km) from South Africa, and 3,000 miles (4,800 km) from Australia, between 48°27 and 50° south. There are over three hundred islands in total, scattered over an area of twenty-seven hundred square miles (7,000 m²). The largest island, Grande Terre, measures twenty-three hundred square miles (6,000 m²). It is home to the research center and weather station of Port-aux-Français, where some eighty researchers are permanently stationed. The oceanographic research ship, the *Marion-Dufresne*, regularly puts in with supplies. The snow-capped peak and glaciers on Mount Ross—6,070 feet (1,850 m) in altitude—glisten in the sun. Over the year, the average temperature here is 45.5°F (7.5°C), but the winters are not extremely harsh, with an average winter temperature of 36.5°F (2.5°C). The islands are home to thirty-six species of nesting birds, including six species of albatross, petrels, prions, skuas, gulls, terns, sheathbills, and rockhopper, Macaroni, gentoo, and royal penguins. During the breeding season, millions of royal penguins gather on the shore. They make a striking spectacle, with their smart black-and-white plumage and gold and yellow cheek feathers. The chicks are kept warm in their fluffy brown down. There are also a number of mammal species on the islands—whales, killer whales, dolphins, elephant seals, and Kerguelen fur seals (now known as Antarctic fur seals). Over the last two centuries,

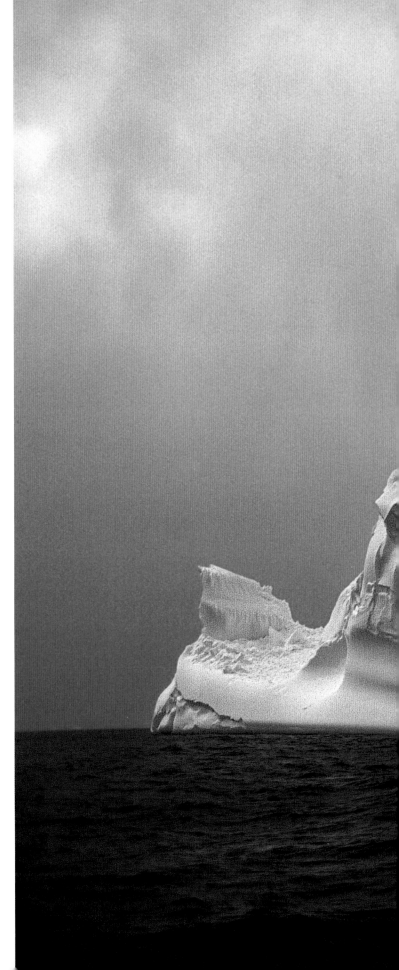

A pale blue arch of ice. Scotia Bay.

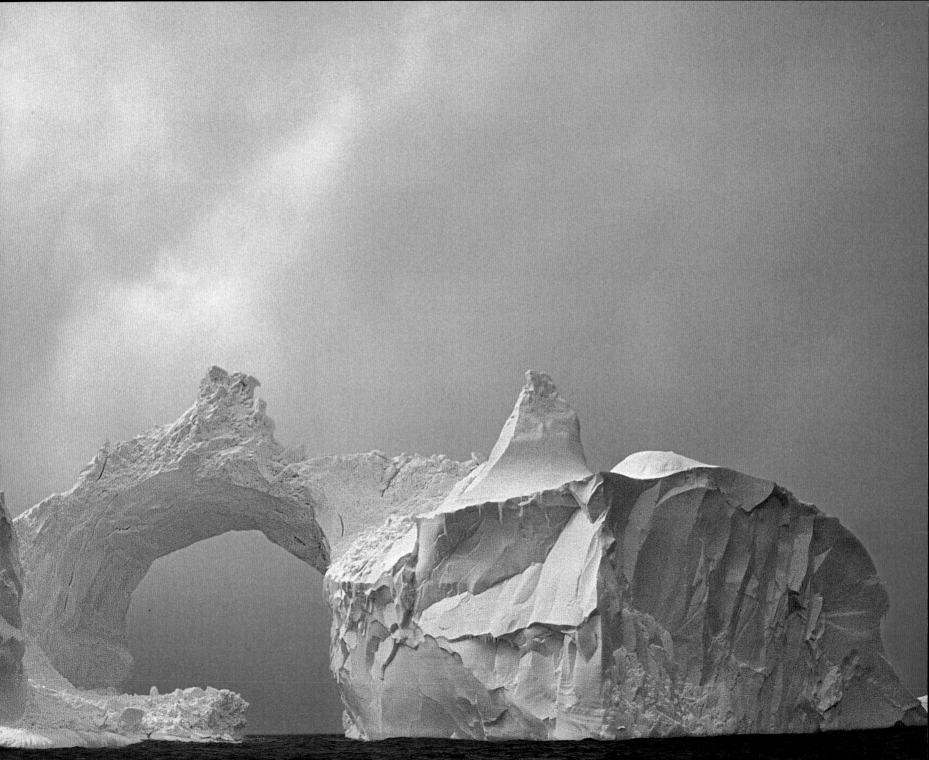

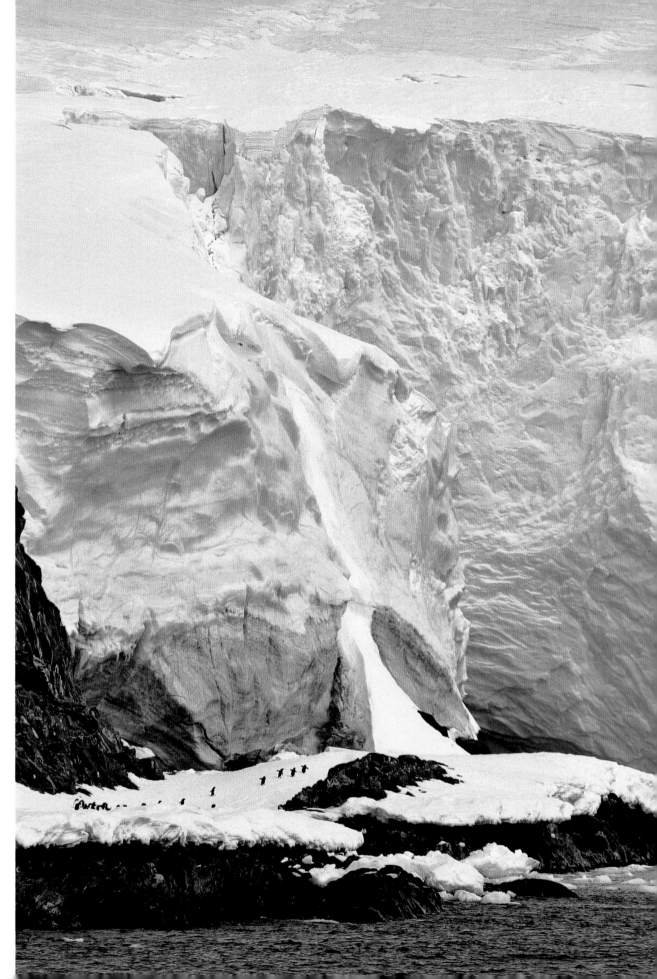

Penguins dwarfed by an ice sheet.
Commonwealth Bay.

these beautiful creatures were ruthlessly hunted for their fur. On dry land, clumps of meadow grass grow alongside the Kerguelen cabbage (*Pringlea antiscorbutica*), which feeds the rabbits, goats, and cattle introduced to the islands by settlers. Sheep, mouflon, and reindeer have also been introduced to certain islands, as well as cats and rats, which wreak havoc on the bird population.

There are a number of other islands nearby, including Saint Paul and Amsterdam—two volcanic islands. Despite the frequent storms that lash these waters, they attract many trawlers because they are extremely rich in fish, including particularly sought-after species such as the Patagonian toothfish, which has been dramatically overfished. Then there is the Crozet Archipelago, discovered by Marion Dufresne in 1772 and named after one of his lieutenants. The weather here is not excessively cold, but it does rain for 340 days a year on average. The giant forests of kelp that grow just offshore are a favorite hunting ground for killer whales, making it easy to catch young penguins and seals. The sight of killer whales launching themselves out of the water and onto the shore to snatch at a young seal that has ventured too far from its mother's side is one not easily forgotten.

Part of the fringe of the Antarctic continent is known as Adélie Land. It is claimed by France, but the claim is not recognized by the United States. It was named by the explorer Jules Dumont d'Urville for his wife. Dumont d'Urville is remembered today not only for his Antarctic explorations, but for his contribution to art history. In 1819, as a young captain, he commanded the *Chevrette* on a voyage to the eastern Mediterranean. The ship put in at the island of Melos, southeast of Greece. There he purchased a recently discovered statue, the Venus de Milo, now in the Louvre in Paris. His Antarctic expeditions took place in 1838–40. He commanded two ships, the *Astrolabe* and the *Zélée*; their hulls were strengthened with copper to break the thick Antarctic ice. He sailed via Hobart in Tasmania and headed south until he reached the continent of Antarctica. He took possession of the coast, naming it after his beloved Adélie. The polar research center that now stands on Adélie Land, not far from Geology Point, is named after the great explorer.

Less flatteringly, perhaps, Adélie is also the name of a species of penguin whose scientific name is *Pygoscelis adeliae*. The Adélie penguin is one of two species of penguin

that winter in Antarctica itself, the other being the emperor penguin. The Adélie penguin is black-and-white, with a white ring around the eye, a red beak, and gray feet. It stands over two feet tall and weighs some twelve pounds (5.5 kg). It is an outstanding swimmer, diving to depths of five hundred feet (150 m) and more. Its main food source is krill. In the southern spring, in October, the males depart for the nesting site, a stretch of rocky, icy ground, where they build a rudimentary nest out of a pile of pebbles. There they are joined by their mates. Each female lays two eggs, which are then preciously guarded by the male, who keeps them warm by balancing them on his toes and holding them against his abdomen. The females bring part of their catch back to the nest for the males. If they are just a day late, the males abandon the nest, leaving the chicks to die. Life can be cruel in the Antarctic.

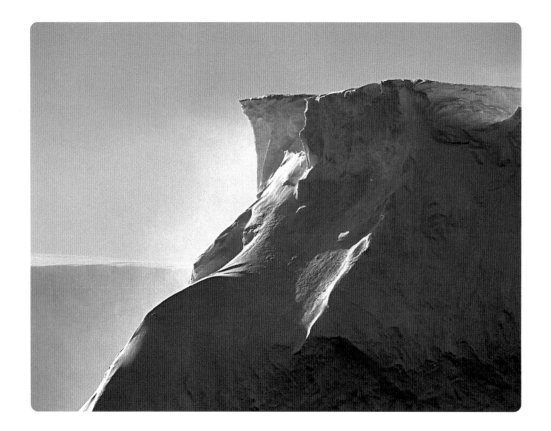

Seawater freezes at 30°F (-1.8°C).

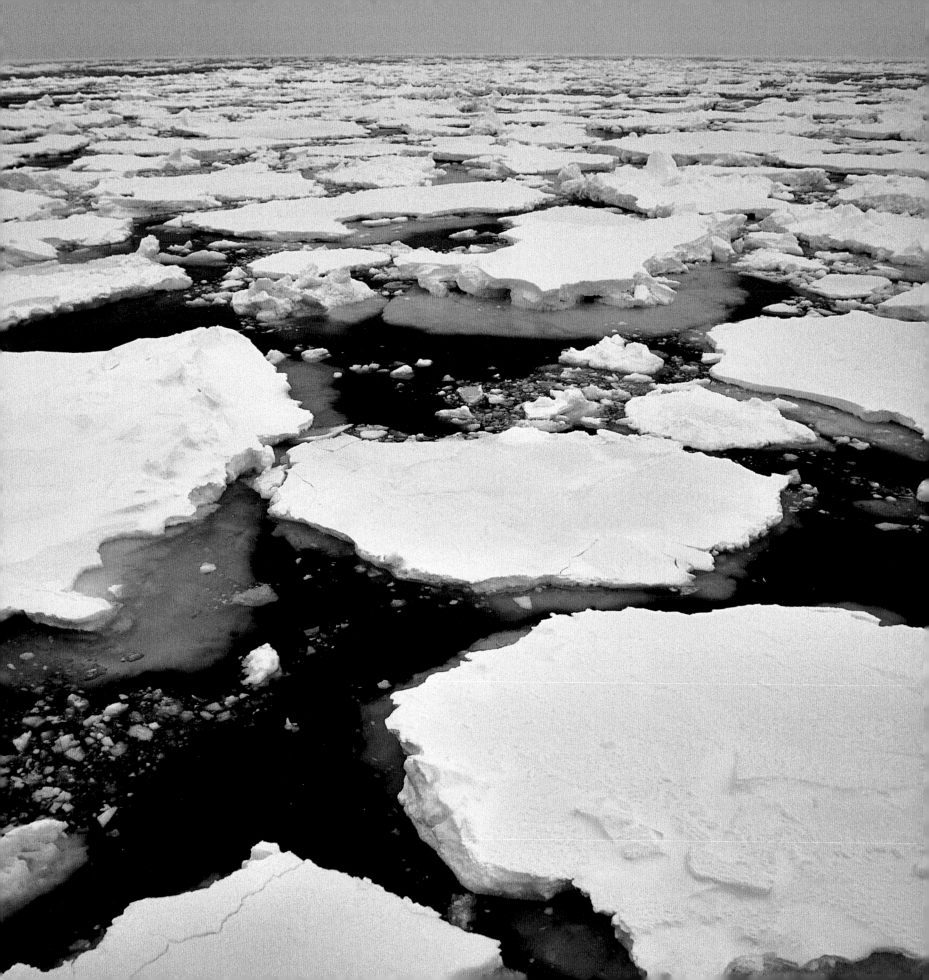

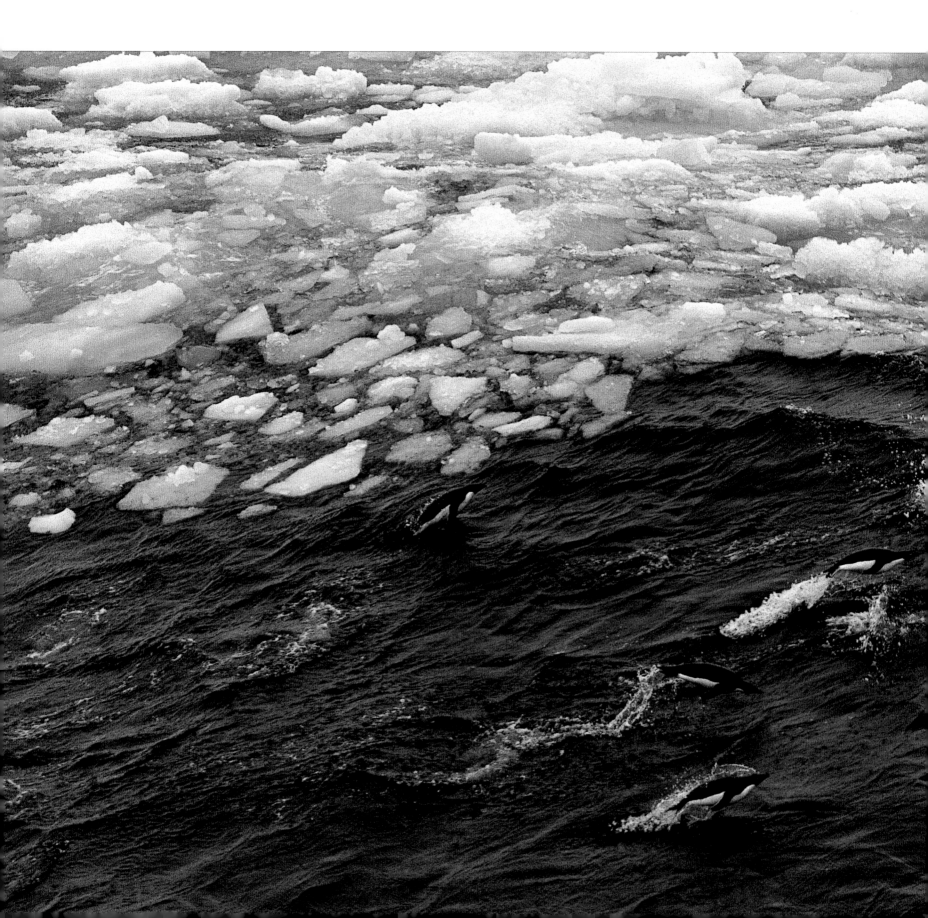

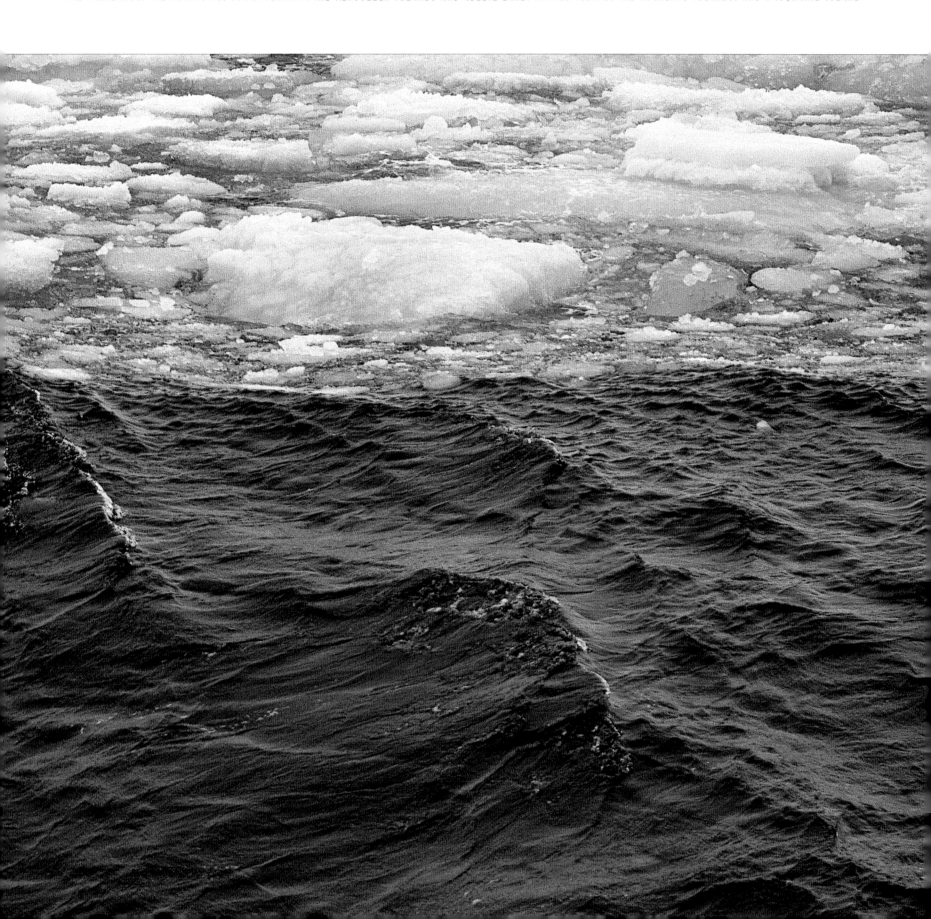

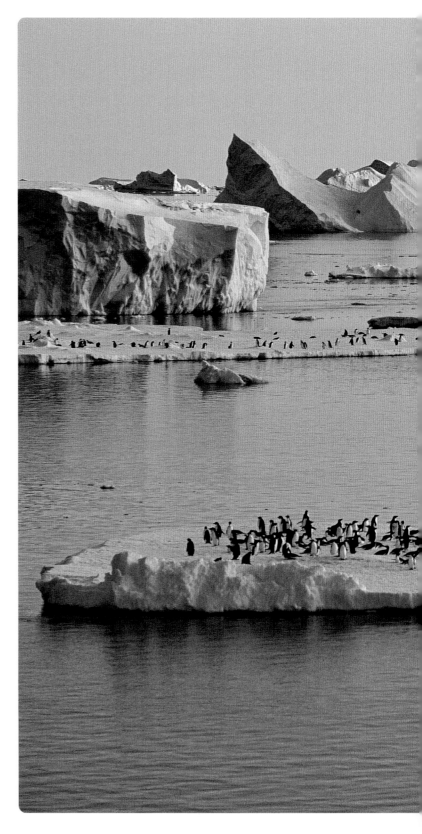

Preceding double page: Penguins navigating the water. Adélie Land.
Right: Penguins in a desert of ice and snow.

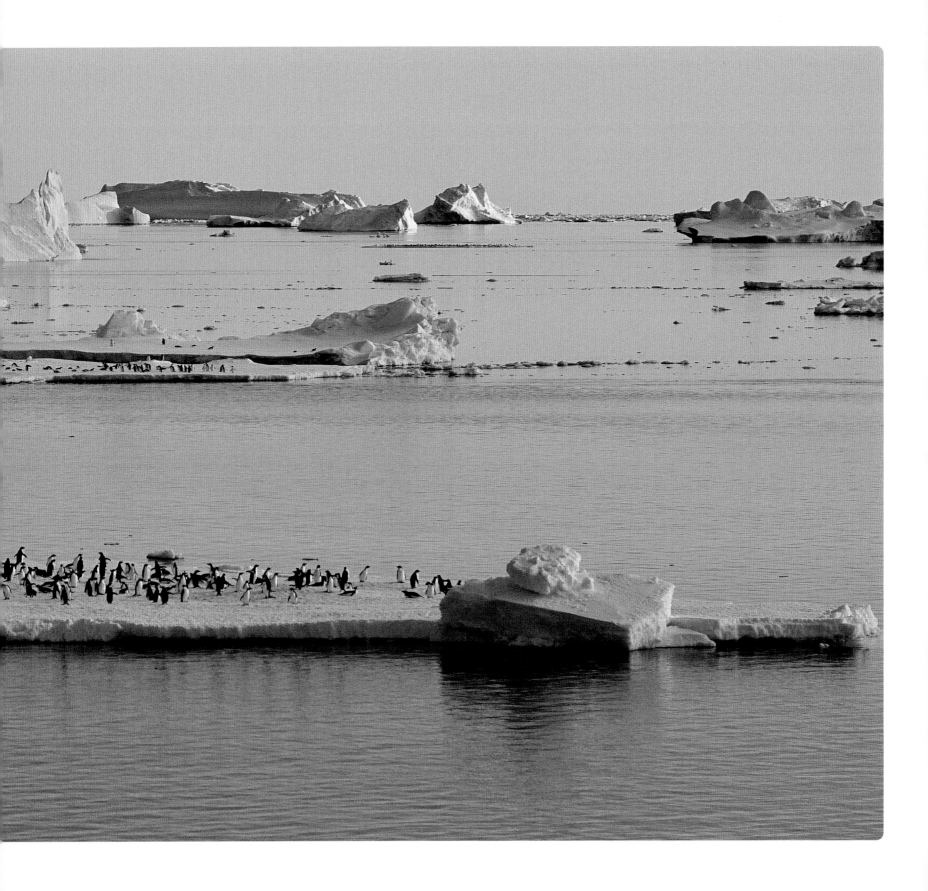

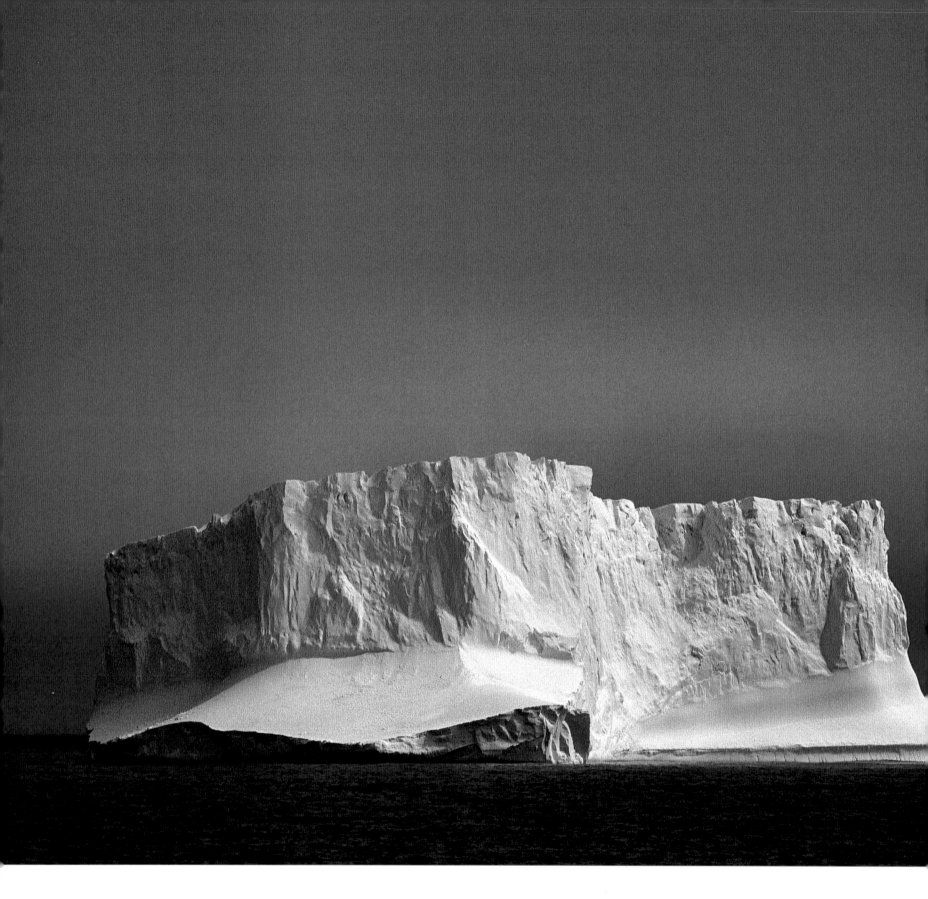

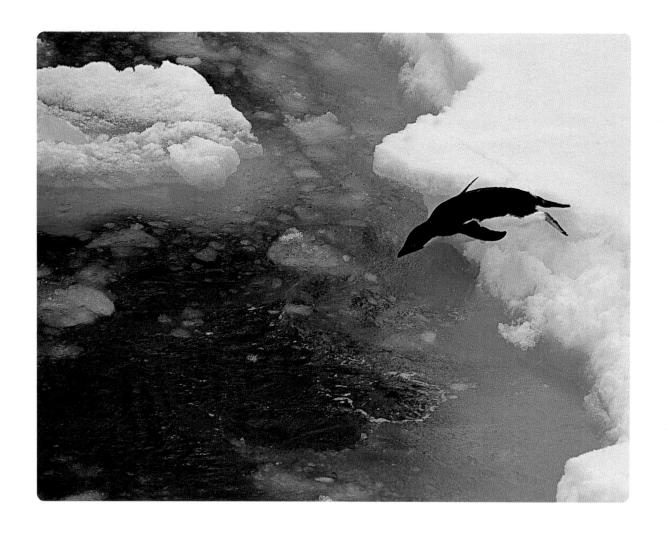

An Adélie penguin at the foot of a tabular iceberg.

Above: An Antarctic fulmar flies overhead.
Right: A humpback whale plunges into the deep.

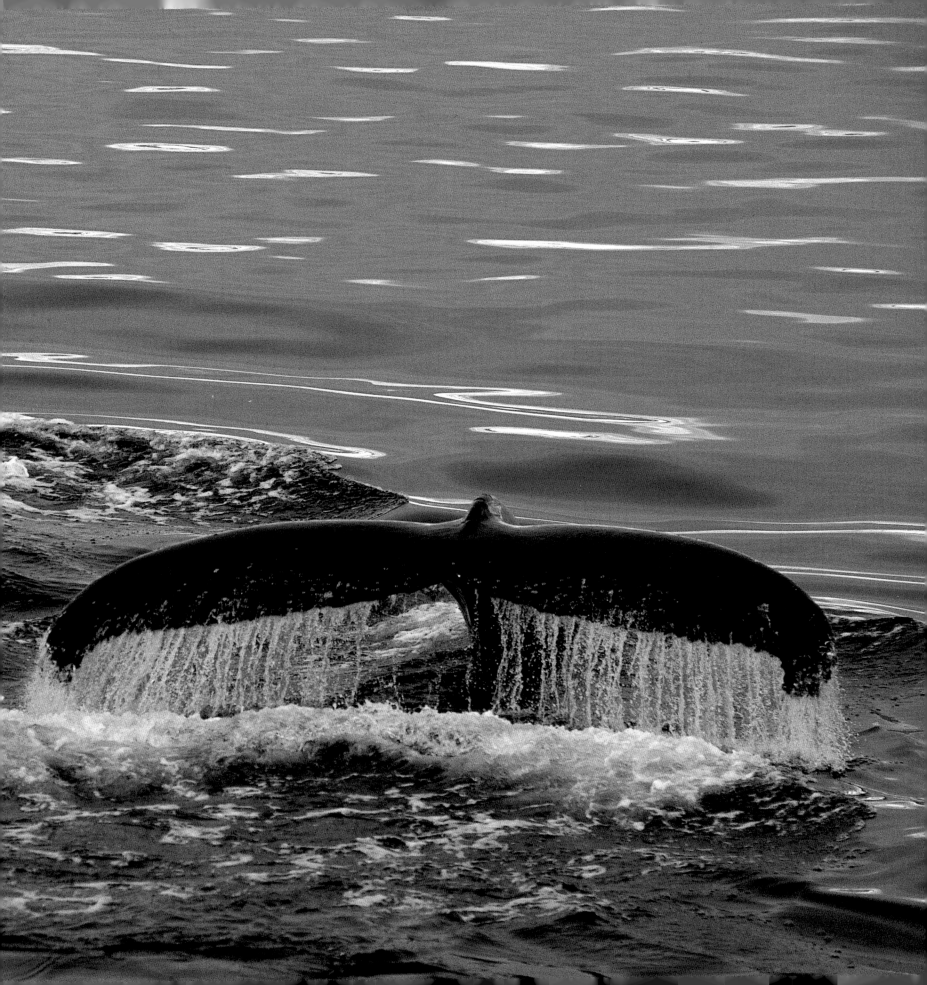

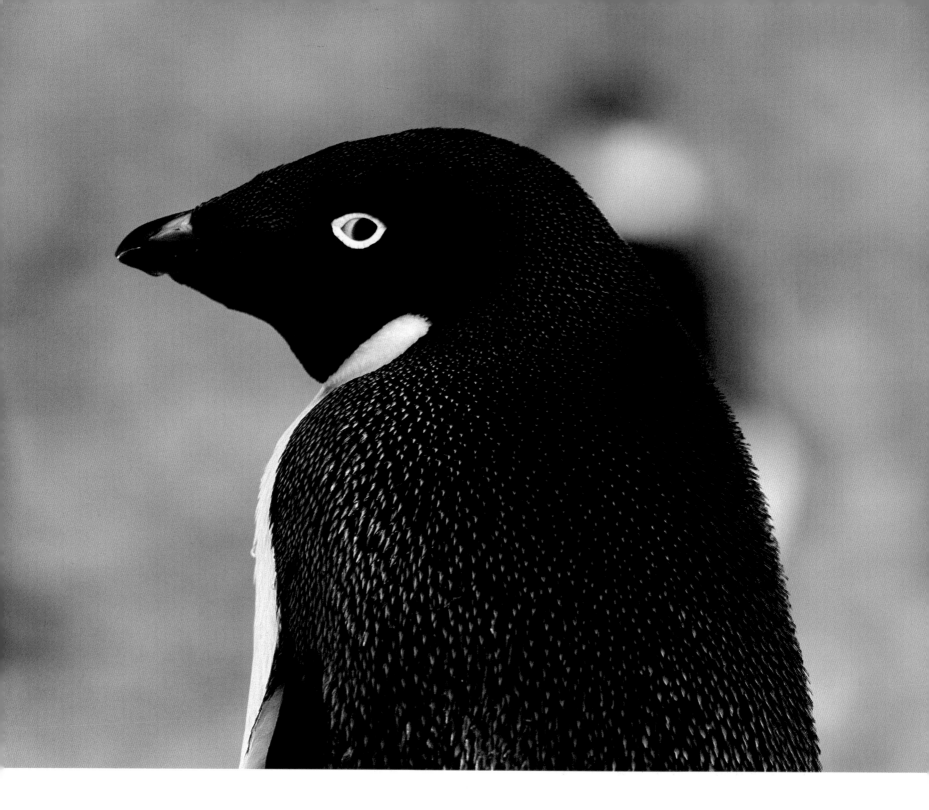

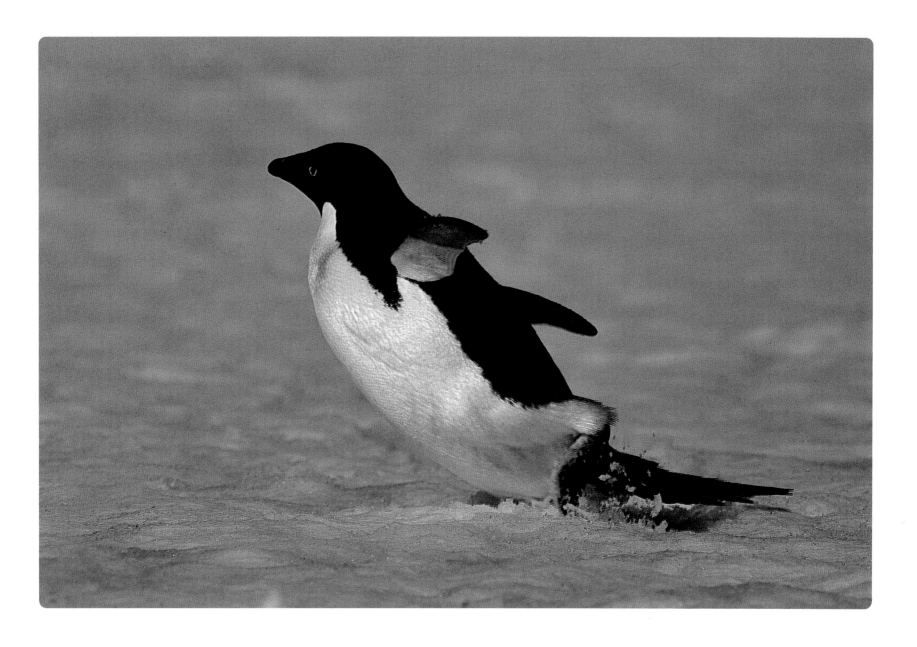

Adélie penguins in Petrel Cove on Dundee Island.

Atlantic Ocean

0° Bouvet Island

Marion Island Prince Edward Island

South Georgia

South Sandwich Islands

Crozet Island

South Orkney
Islands

Falkland Islands

Kerguelen Islands

South Shetland
Islands

SOUTH
AMERICA

McDonald Island
Heard Island

ANTARCTICA

Indian Ocean

Peter I Island

90° West

90° East

Scott Island. Balleny Islands

Southern Ocean

MACQUARIE ISLAND

AUCKLAND ISLANDS

Campbell Island

SNARES ISLAND TASMANIA

Antipodes Islands

Bounty Islands 180° NEW ZEALAND AUSTRALIA

THE FALKLANDS

THE ANTARCTIC

SOUTH GEORGIA

THE KERGUELEN ISLANDS
AND ADÉLIE LAND

SNARES ISLAND, THE AUCKLAND ISLANDS, AND MACQUARIE ISLAND

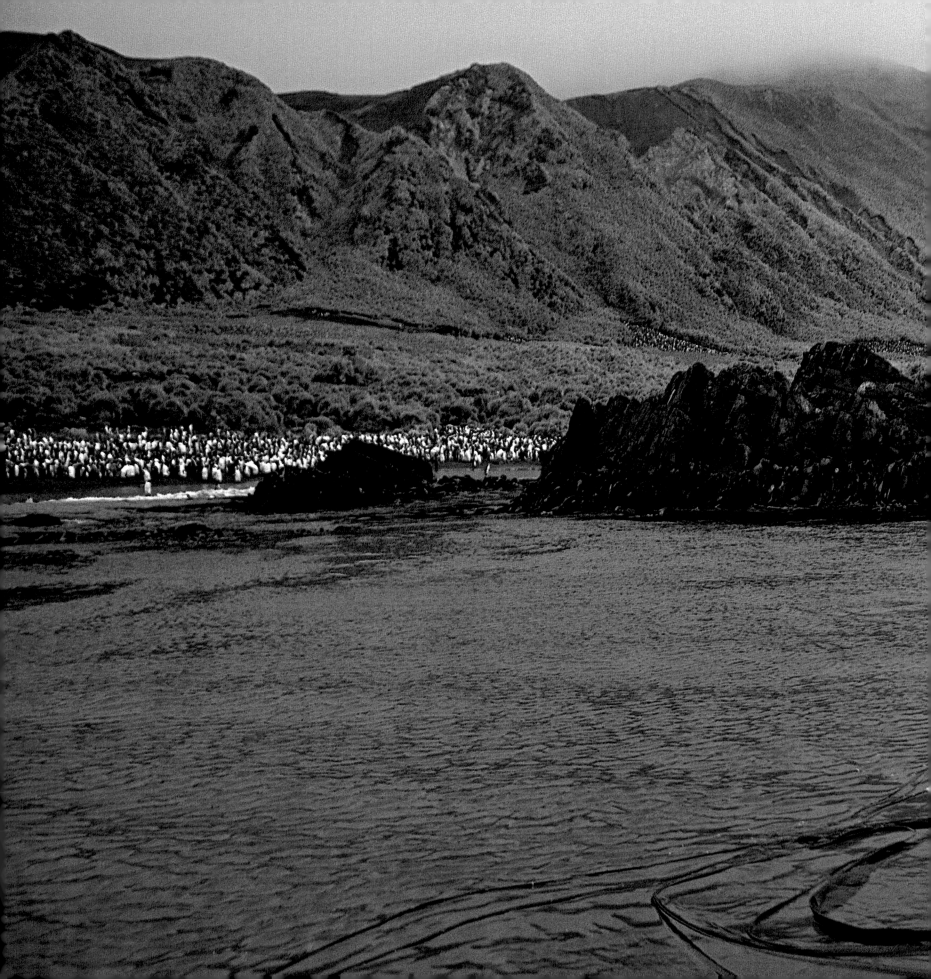

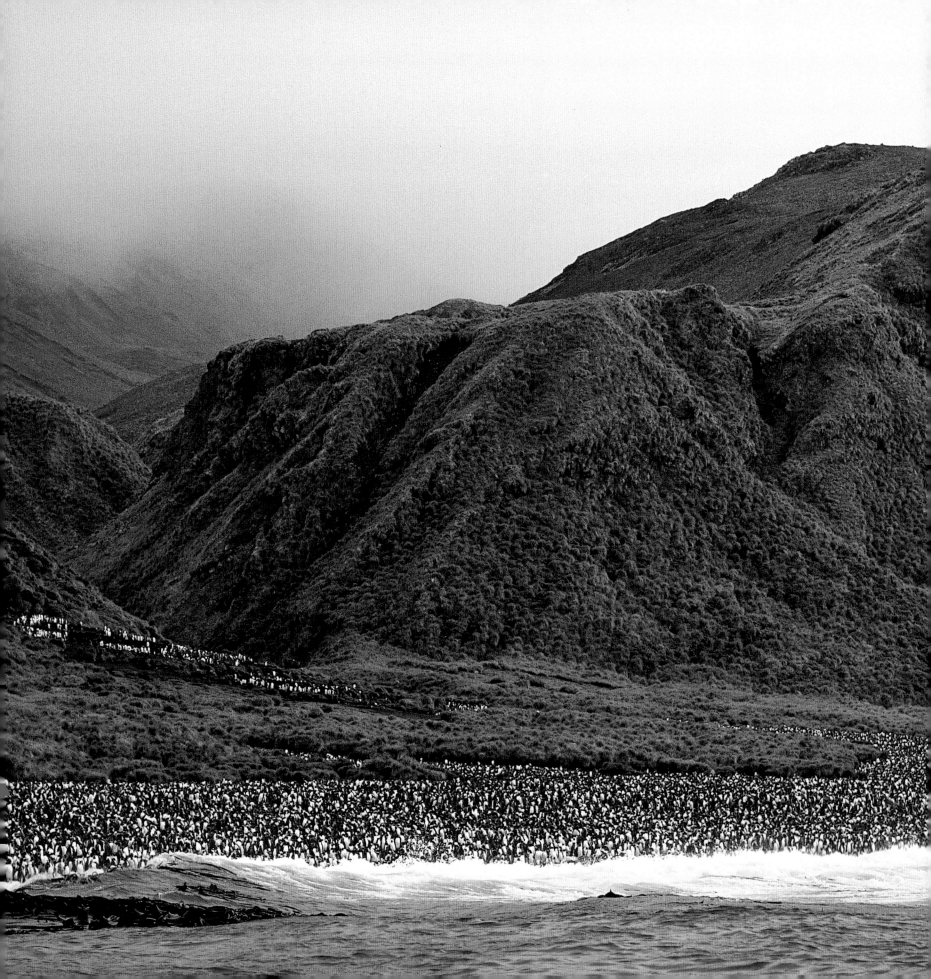

THE MYSTERY OF THE RED FOREST

We have come far to the south of New Zealand.

The islands—Snares, Auckland, Campbell, Macquarie—are tiny dots in the immensity of the ocean. I remember a terrible, storm-tossed night on the *Calypso*, when the ship rolled and yawed so hard that we were flung out of our beds. At one o'clock in the morning, the electricity failed under the constant onslaught of the waves that poured over the deck. I thought I was living my final hours. But the *Calypso* pulled through, battered and bruised. At first light, the waves were still towering over the ship and the wind was whipping the black clouds into an angry froth. It was a terrifying, awesome sight. The waves, tipped with spume like strands of spittle, were jagged with pale phosphorescence and lead-colored streaks. Surrounded by such power and fury, I felt as insignificant as a single shrimp in a vast, heaving bank of krill. It was a moment I will never forget. This was my first experience of the Roaring Forties and Furious Fifties.

Dawn breaks over the Auckland archipelago, roughly three hundred miles south of New Zealand's South Island. Our position is between Snares Island—which lies not far from Stewart Island—Campbell Island, and Macquarie Island, which is closer to the pole. The Aucklands lie at 166° east and 50°50 south. They offer a beautiful, if somewhat sparse, landscape. The largest of the islands, Auckland, is no more than three miles (5 km) long. It is ringed by islets with such names as Adams, Enderby, Dundas, Disappointment, Figure of Eight, Rose, and Ewing. The islets are fringed with reefs.

We are just off Disappointment, a vertiginous rock worn with a few clumps of grass clinging to ledges. Its name is well deserved. There is no way of landing on the island, which means it is a paradise for birds, which nest on the almost sheer cliff face. The plant growing on the narrow ledges is tussock grass, *Poa litorosa*, related to the *Poa flabellata* that grows in the Falklands. Nests are perilously perched wherever there is

Preceding double page: Penguins are the only inhabitants of Macquarie Island.
Facing page: A colony of royal penguins. Macquarie Island.

a shelf, however narrow, separated by the length of two birds' necks stretched out to their full extent. Each species has colonized a different level of the cliff face. On the lowest level are the cormorants, then come the gulls. The shy albatrosses nest halfway up, and the wandering albatrosses are at the top. The population of shy albatrosses numbers several thousand—the largest in the world, comparable to the colony of black-browed albatrosses in the Falklands. Although the biodiversity of the islands in no way compares to that of a jungle or coral reef, for example, the range of species found here is wider than might be expected. It is as if nature has produced a variety of species to be sure that at least some of them survive, whatever tectonic, ecological, or climatic disasters strike the earth.

I found the Aucklands a truly enchanting place, full of surprises, particularly the main island, where we landed after a thorough dousing of spray in a small launch that wove a path between the reefs and the long, tangling fronds of kelp. When we had climbed the cliff, we found ourselves in a magical forest, wandering beneath low-sweeping branches straight from a fairy tale. This is the only forest on any of the subantarctic islands. There is nothing similar anywhere in the Falklands, South Georgia, the South Orkney, Shetland, or Sandwich Islands, nor on Bouvet, Marion, Prince Edward, Crozet, Kerguelen, McDonald, Heard, Antipodes, or Bounty.

The trees in this remarkable forest are *Metrosideros umbellata*, southern rata trees or New Zealand Christmas trees. They grow no more than sixteen feet (5 m) high. Their branches and trunks grow twisted like bonsais, while their dense foliage provides the best possible protection against the wind and the rain. The clusters of flowers are bright scarlet in color. Seen against the steely gray of the sky or the green-gray of the waves, the trees appear to be on fire. These beautiful trees are home to rare and unique fauna such as the flightless Auckland Island rail and New Zealand's last few surviving red-crowned parakeets. This is the only place on the planet where parakeets—usually found in tropical climes—live alongside penguins, which can sometimes be seen waddling beneath the branches. A number of penguin species are represented, four of which are endemic to southern New Zealand and Australia—the blue penguin (the

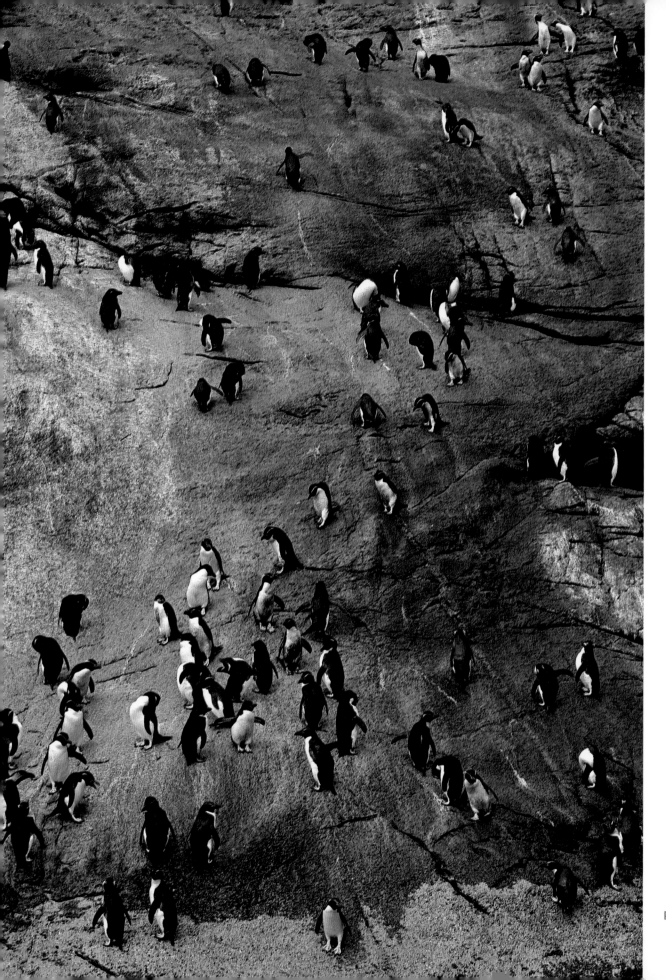

Penguins on Snares Island.

smallest species, measuring just seventeen inches [40 cm] in height), the yellow-eyed penguin, royal penguin, and erect-crested penguin.

As we walk through the forest, we can hear an uncanny tinkling sound. At first, I wonder if it is not a ship in distress off the coast, but no—it is the song of the tiny bellbirds, balls of fluff perched on the branches overhead. The most striking inhabitants of the island, however, are the New Zealand or Hooker's sea lions. As I approach the shore through a tangle of trunks and branches, I spy a family of them. The females, elegant in their reddish-brown fur, are suckling their pups. The pups are just a few days old and have shiny, curly, brown-black fur. Once their hunger is satiated, the pups begin to play, chasing each other over the rocks and tumbling down in heaps. A male with an impressive mane keeps watch over his harem. A new-born pup lies on a bed of scarlet petals. The sun shining on his pelt brings out a rich palette of chestnut tones. The air is filled with a powerful scent, a blend of the sweet fragrance of the rata flowers, the acid tang of the carpet of dead leaves beneath my feet, and the musky odor of the sea lions.

Today, life in the Auckland Islands seems in perfect harmony. However, this was not always the case. The riches of these islands were ruthlessly plundered by man. The story of the Hooker's sea lion is symptomatic of man's relationship with Antarctica as a whole—a relationship, until recently, based on plunder and exploitation. In scientific terms, Hooker's sea lions—*Phocarctos hookeri*—are among the largest species of seals. The males can grow to eleven feet (3.3 m) in length and weigh up to 900 pounds (400 kg). The females, however, are smaller, weighing up to 300 pounds (135 kg). Both males and females have a superb pelt of thick, shiny fur that is an excellent insulator. After the Auckland Islands were discovered in 1806, it took less than a quarter of a century for hunters to slaughter almost the entire sea lion population. Today, the animals are protected, but unfortunately that does not mean their future is guaranteed. The sea lions spend most of their time in the waters offshore, feeding on fish, crabs, and squid. Although they are now safe from hunters, their traditional food sources are being decimated by modern industrial fishing techniques, which are emptying the seas.

Royal penguins. Macquarie Island.

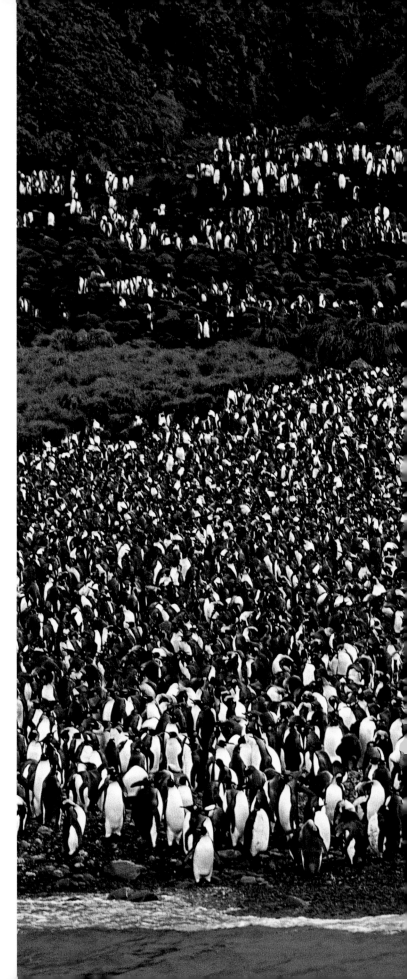

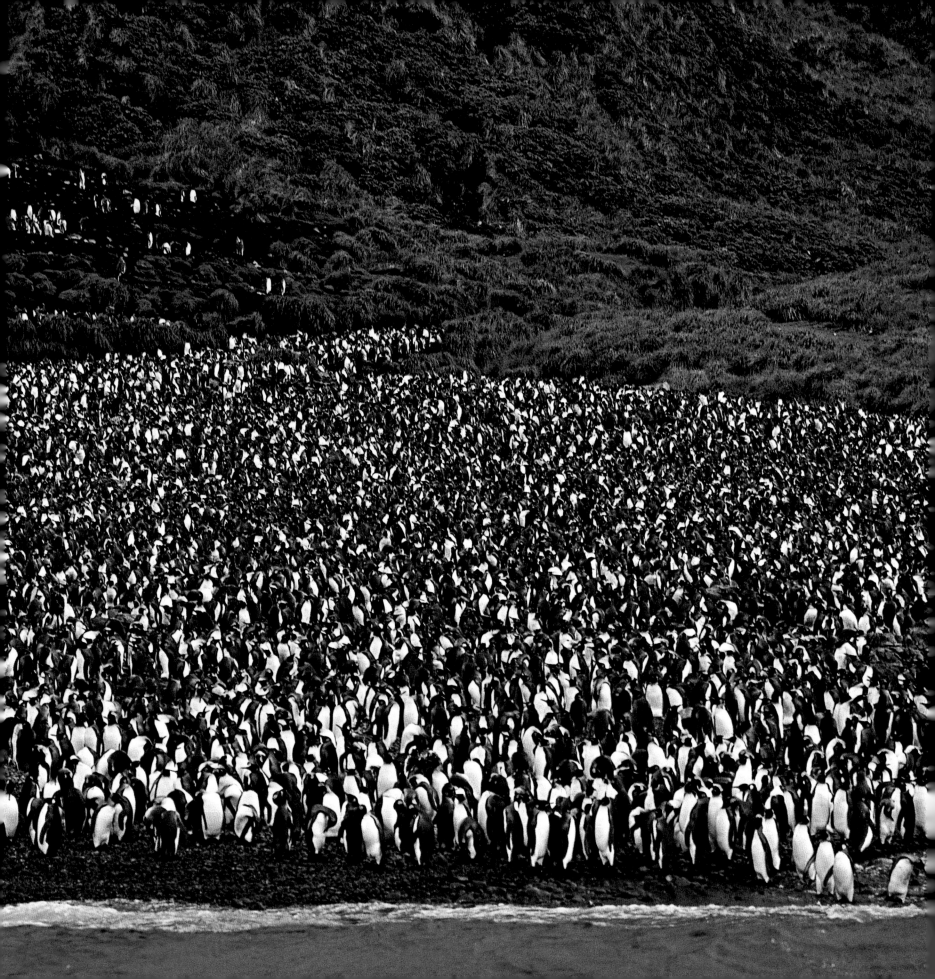

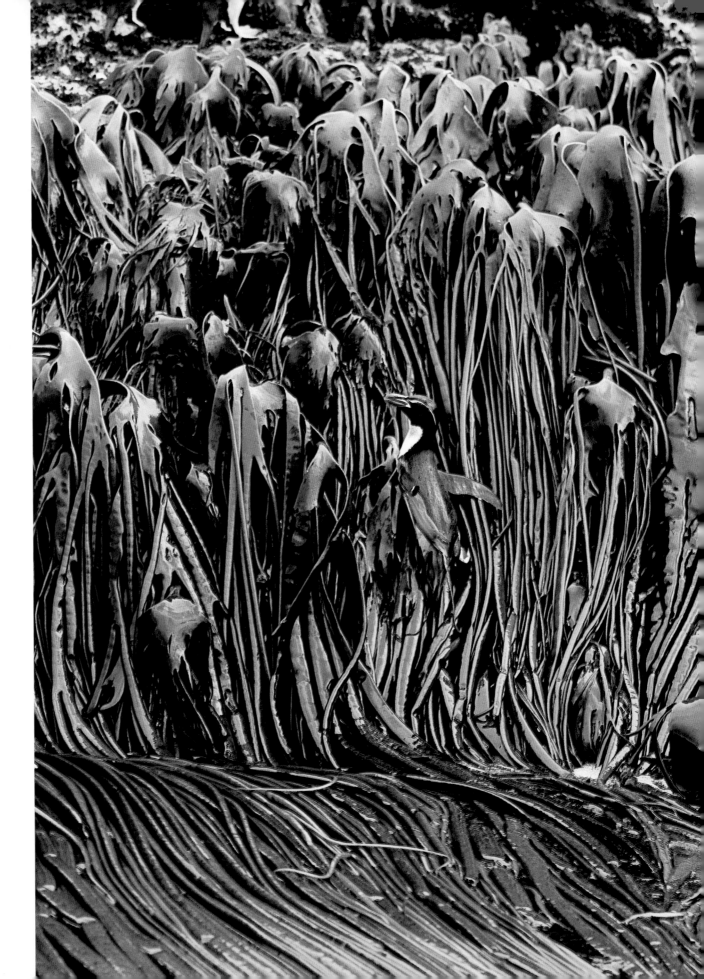

Today, no more than seven thousand Hooker's sea lions survive. Every spring, in November, the males fight for possession of a patch of the shoreline. The females arrive in December and give birth to the pups that they conceived in exactly the same spot a year earlier. They suckle the pup for a week with their milk rich in nutrients, and then the breeding season begins in earnest, each female mating with several males. The sea lion's gestation period is eight months. To prevent the females giving birth four months early, before their return to the shore where they conceived, the fetal development takes place in two parts, with a four-month break at an early stage.

Summer is at its height on the Auckland Islands. The sea lion pups are playing in groups while the mothers dive into the waves to feed, then return to suckle their young. Each mother recognizes her pup by its unique cry and odor. In late January, the breeding season is over for another year. The males are exhausted. They have not eaten for weeks and are alarmingly skinny. They return to the ocean to stock up on blubber for the winter. The females snooze beneath the rata trees. The pups are endearingly clumsy as they play-fight and tumble on the beach. Here, they are safe. I turn and head for the *Calypso*, gently rocking in the swell just offshore. The smell of the scarlet rata flowers always reminds me of my old friend Cousteau. The cries of the sea lion pups grow fainter. I find myself praying that this island will always remain a haven, and that one day, man will learn not to be nature's worst enemy.

Macaroni penguins in the kelp. Snares Island.

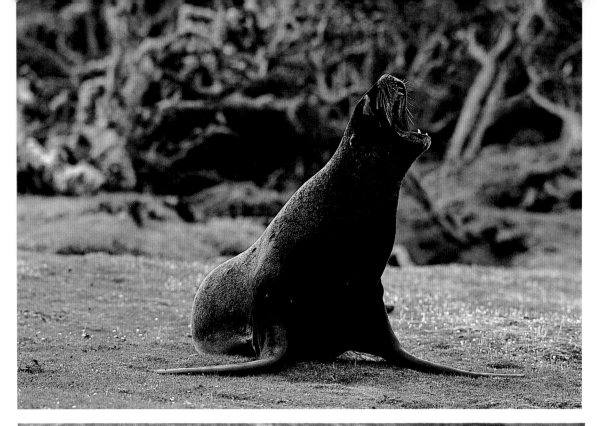

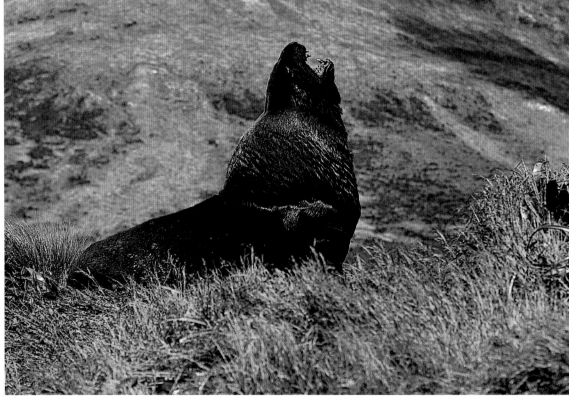

Hooker's sea lions on the Auckland Islands, Campbell Island, and Enderby Island.

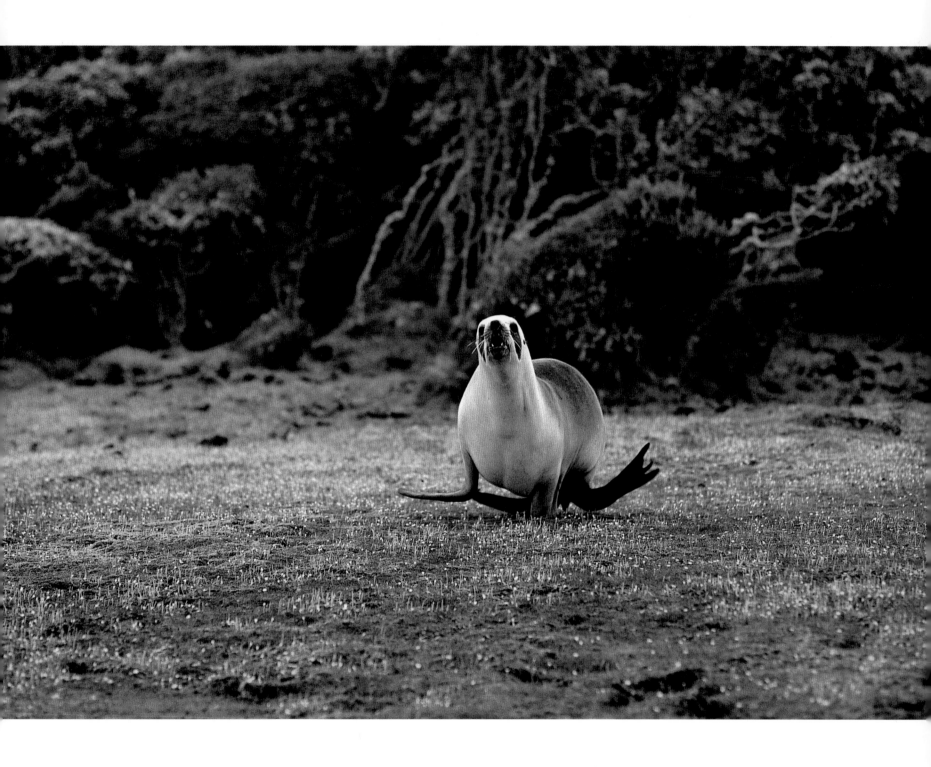

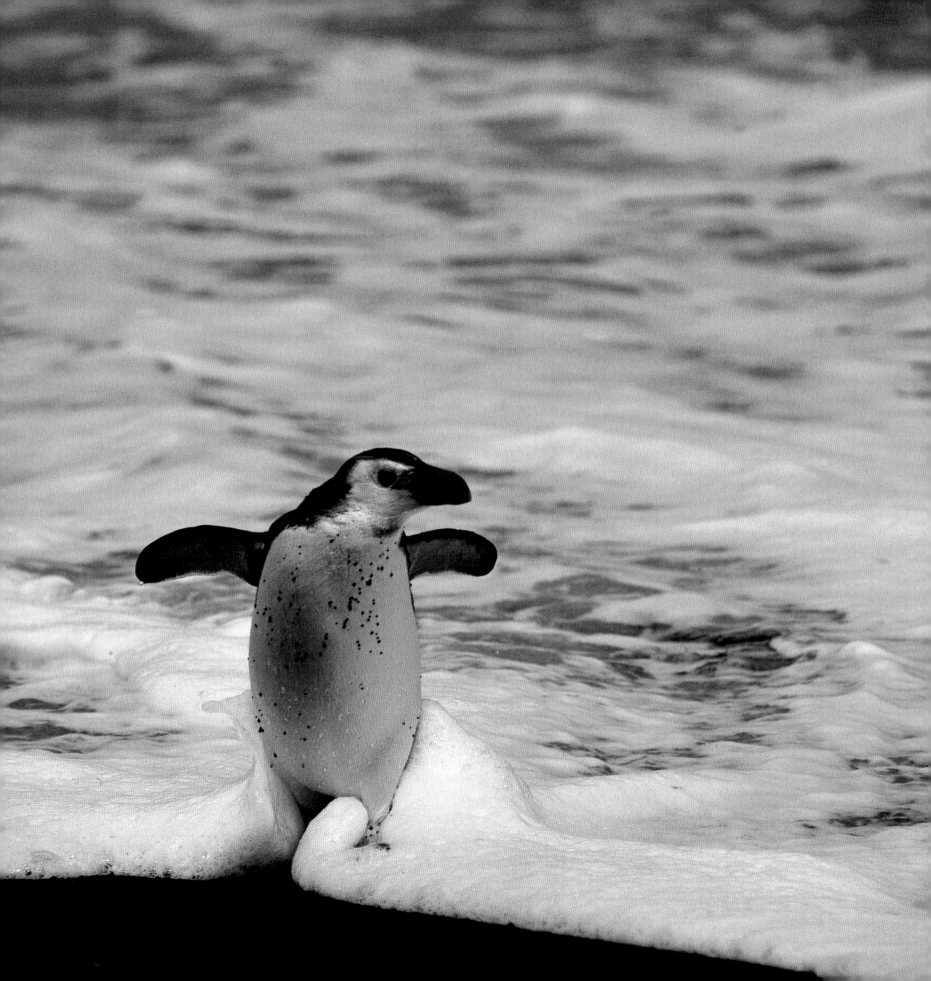

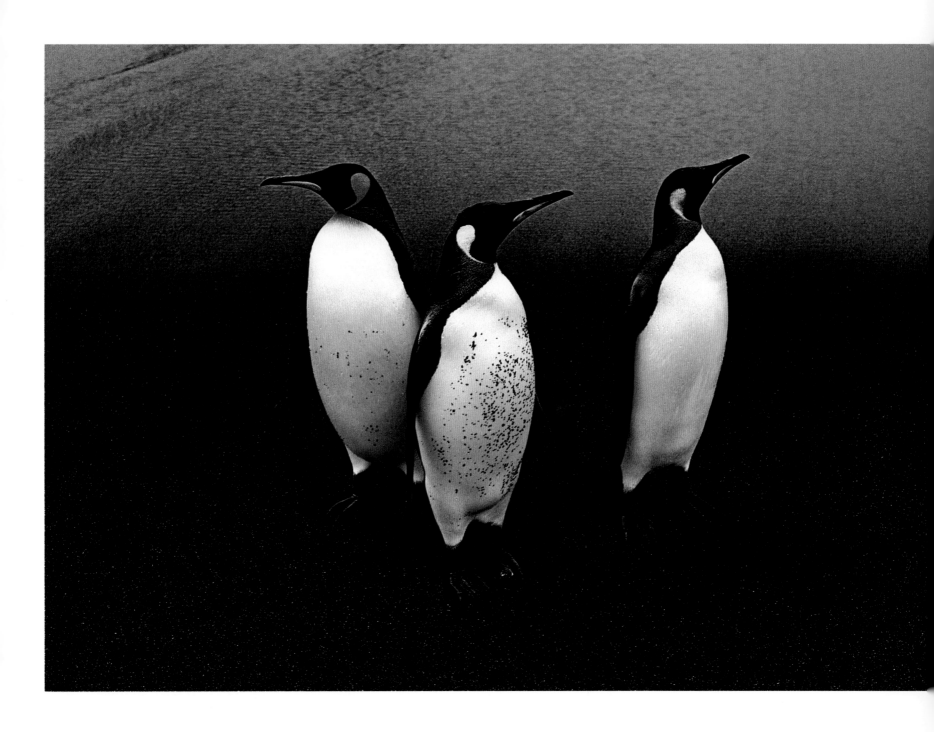

Facing page: A yellow-eyed penguin. Macquarie Island.
Above: Royal penguins on the shore.

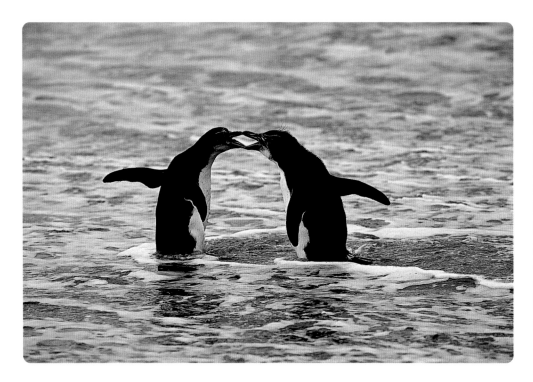

Above: Royal penguins fighting.
Right: A female Hooker's sea lion
arriving on the shore to breed. Lusitania Bay.

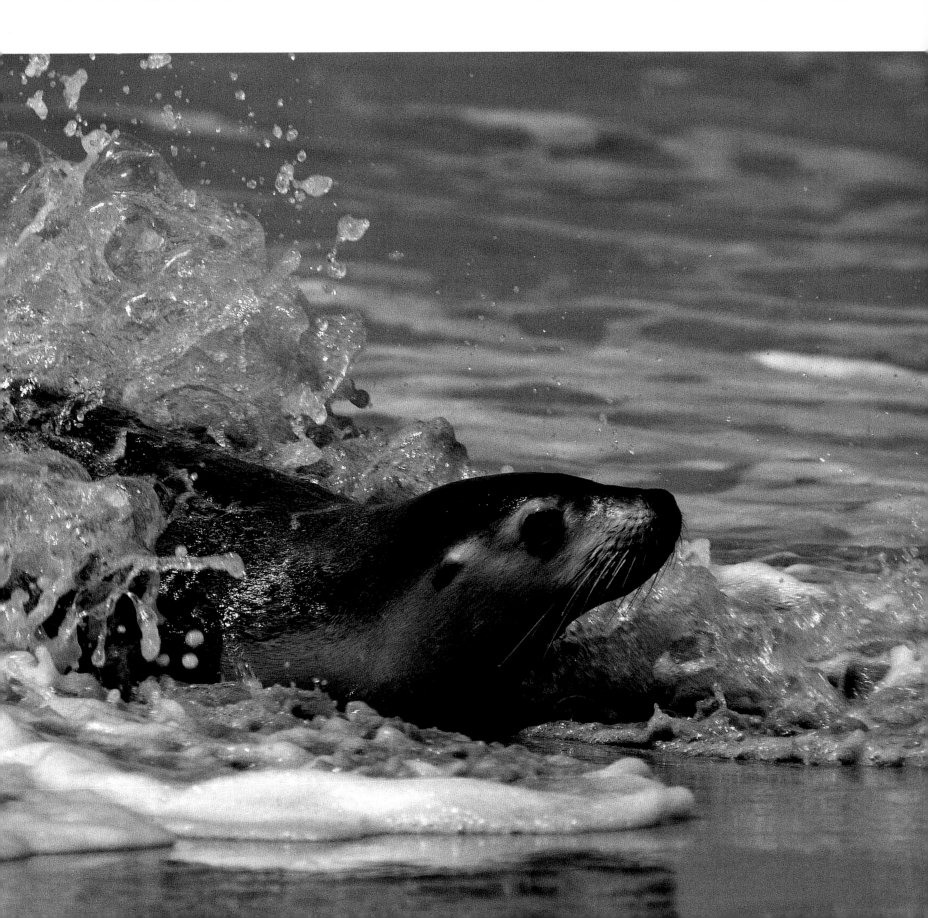

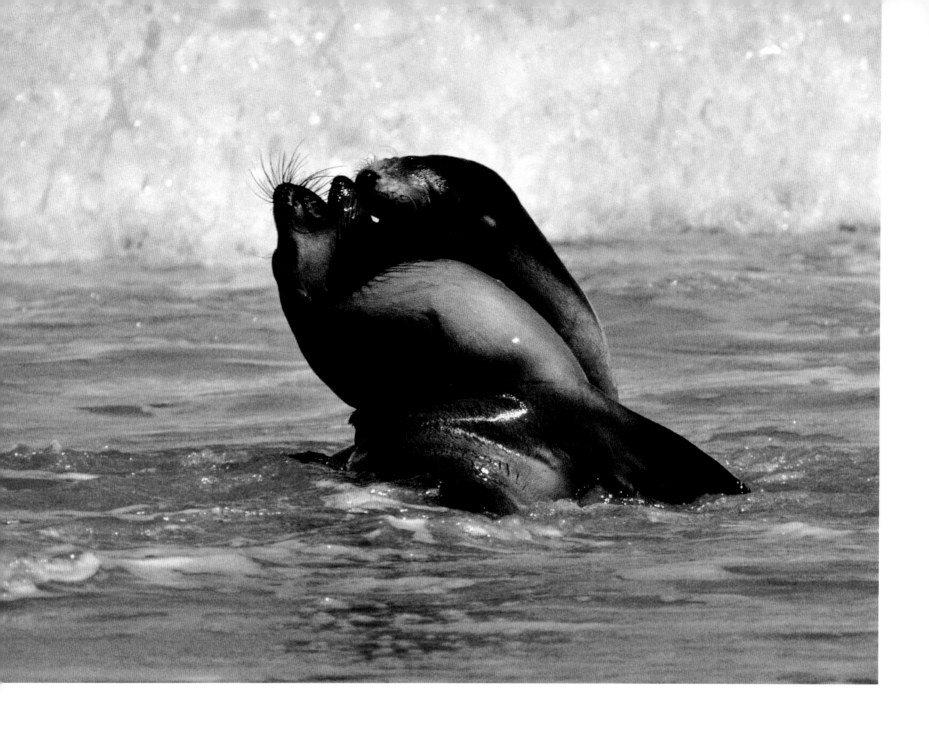

Hooker's sea lions. Kangaroo Island.

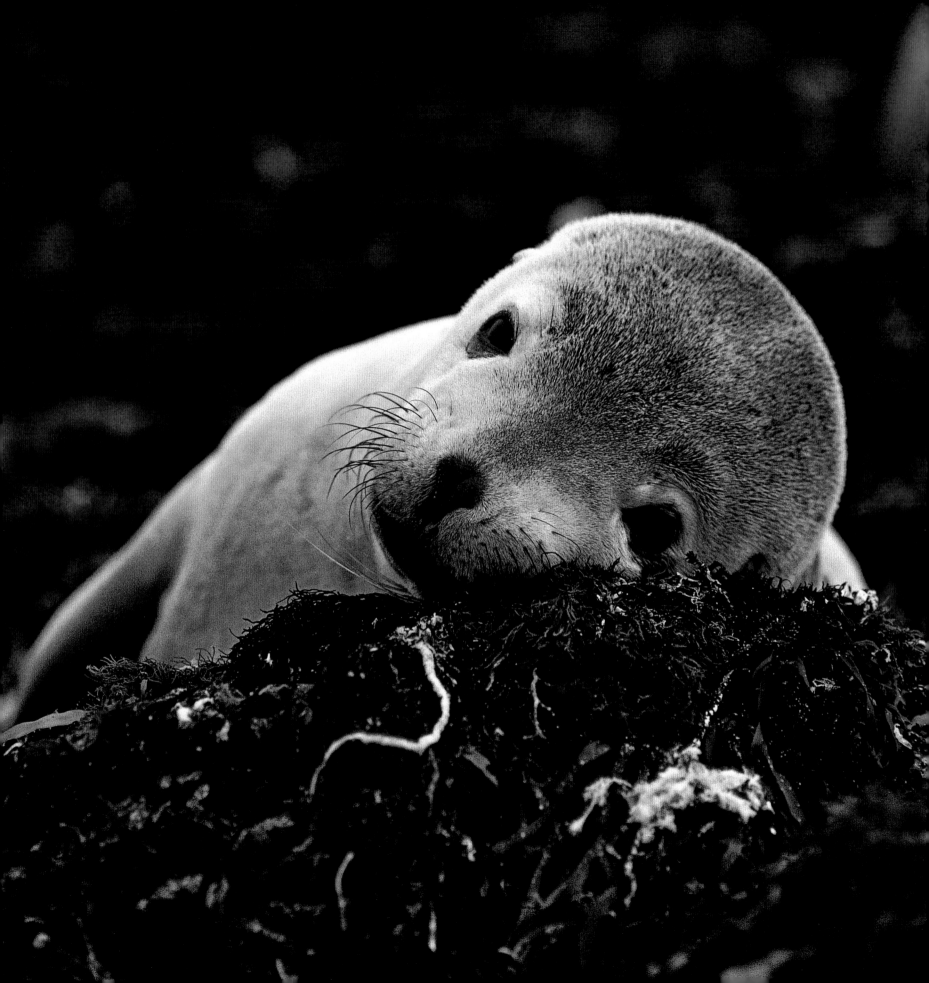

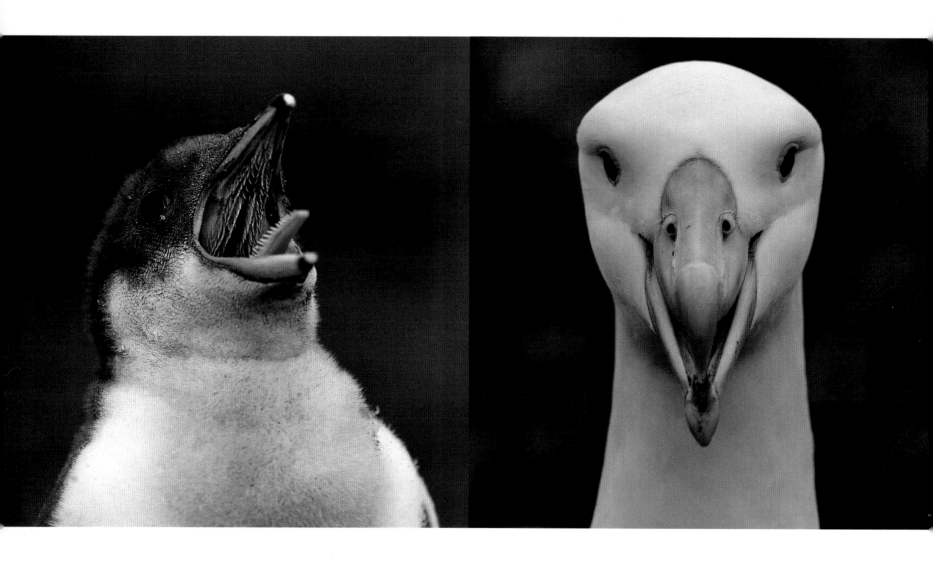

From left to right: Gentoo penguin chick, wandering albatross, royal penguin chick, adult royal penguin.

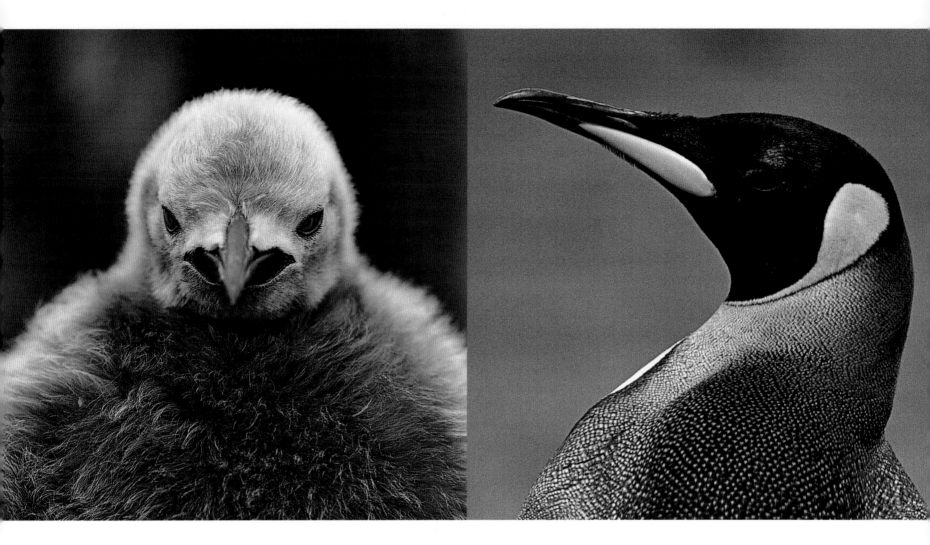

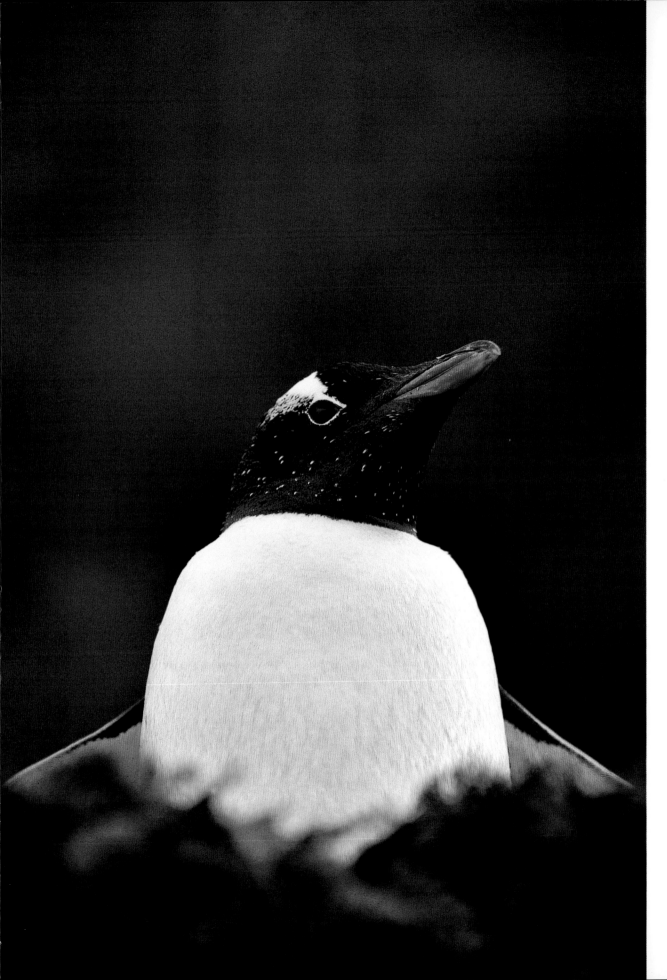

Like all penguin species, gentoo penguins recognize each other by their cries. Macquarie Island.

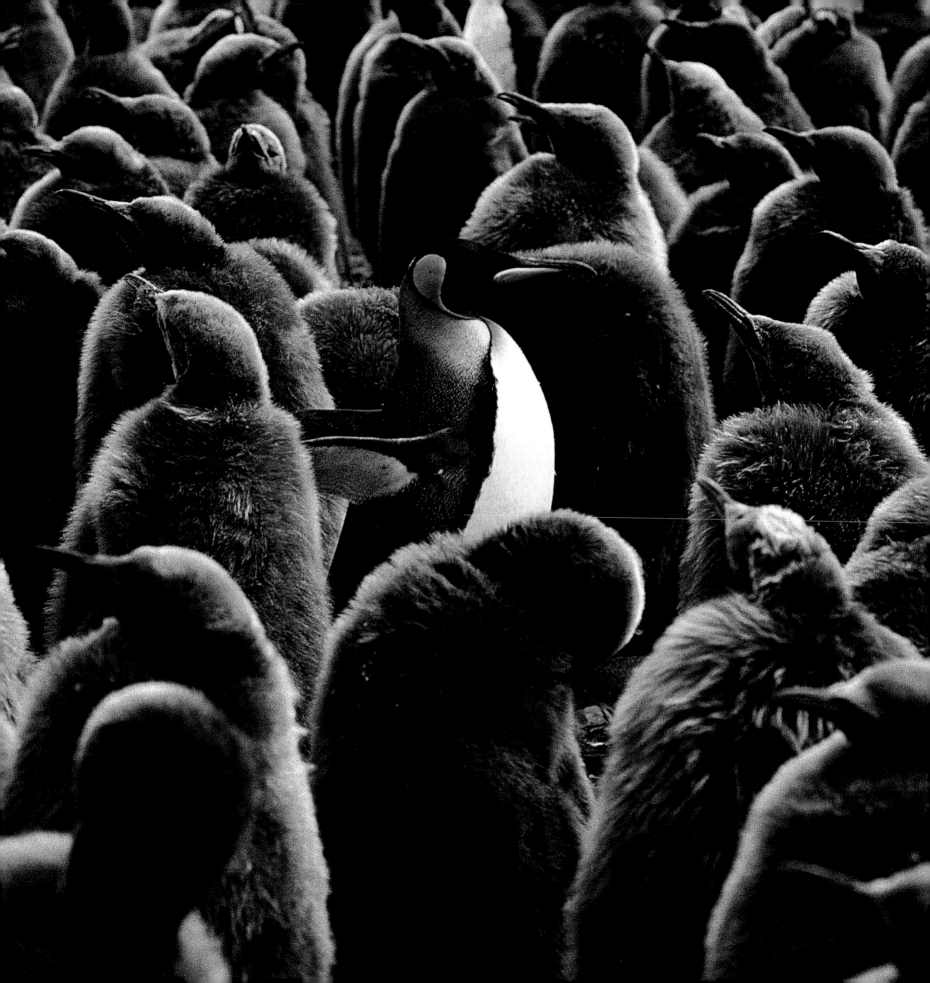

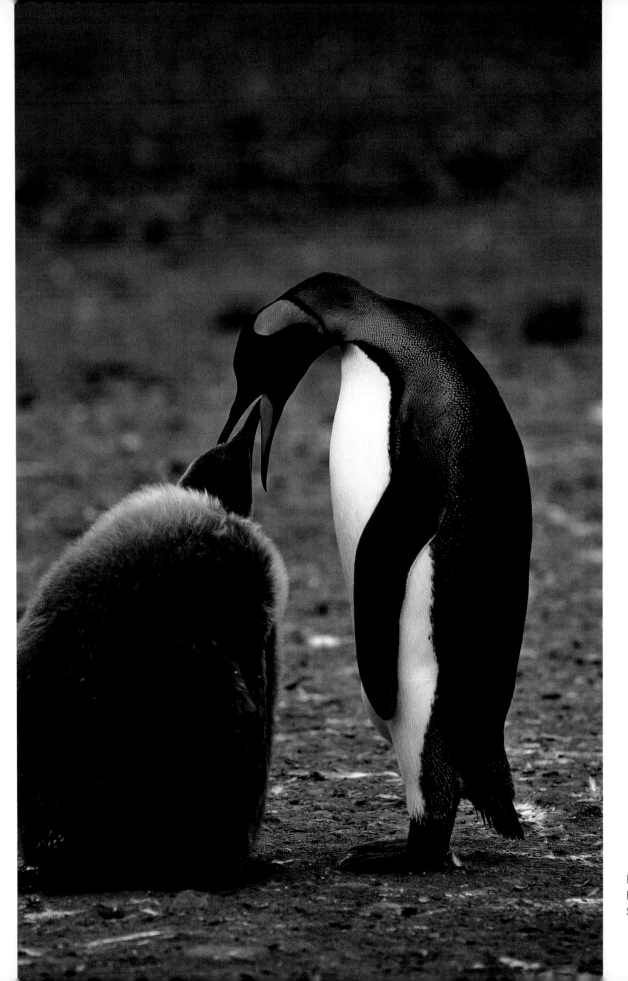

Royal penguin chicks rely on their blubber and fluffy down to stay alive. Salisbury, South Georgia.

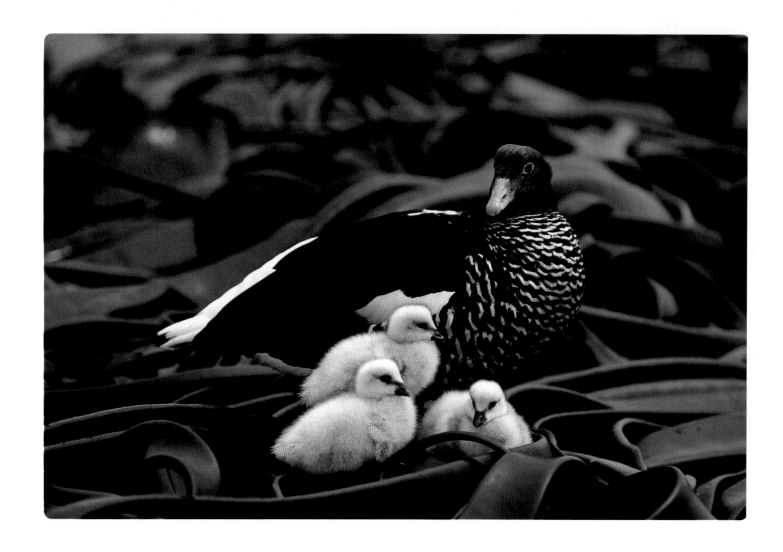

Above: A female goose and her chicks exploring the long fronds of kelp.
Facing page: A colony of cormorants. The nests are placed just far enough apart—the length
of two outstretched birds' necks—so that the birds do not fight over territory.
Sea Lion Island, Falklands.

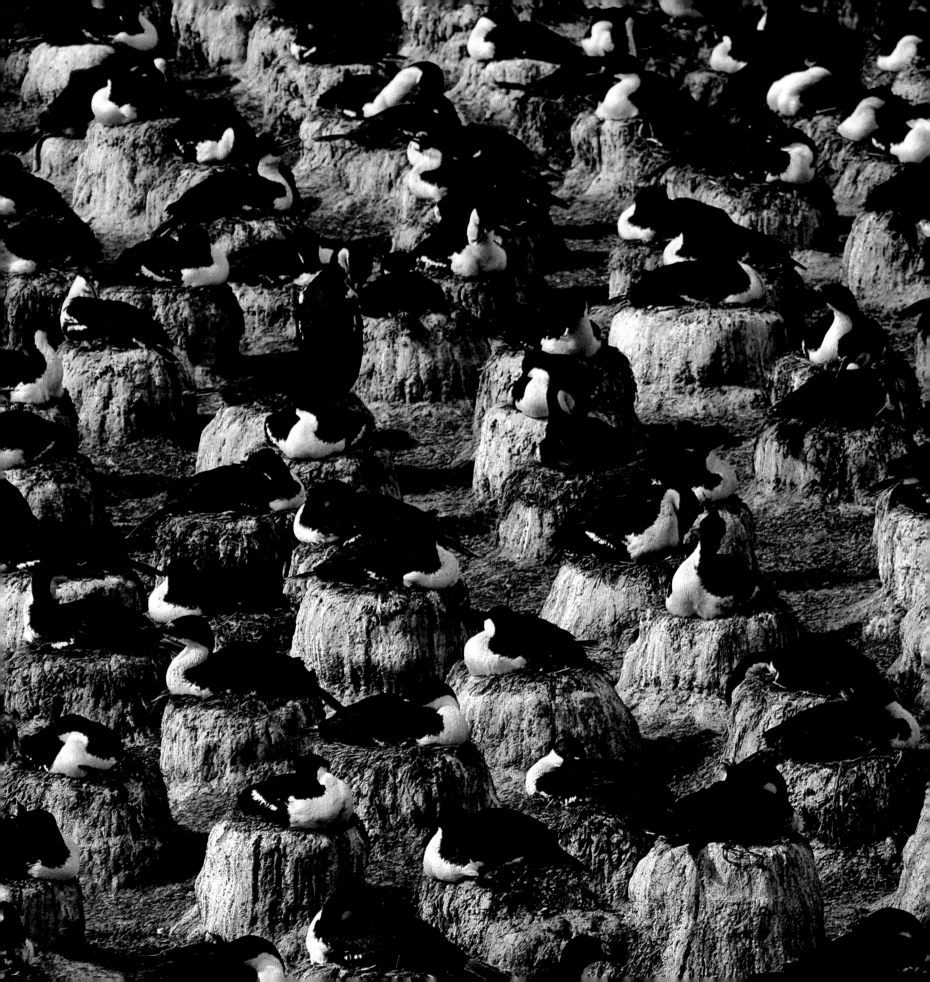

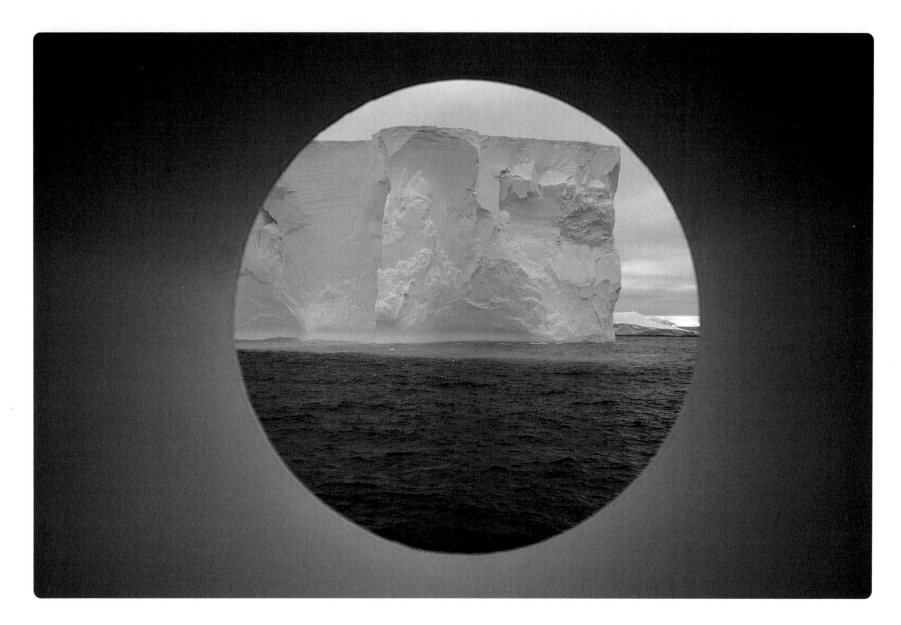

All photographs by Patrick de Wilde

Translated from the French by Susan Pickford
Copyediting: Slade Smith
Typesetting: Claude-Olivier Four
Proofreading: Chrisoula Petridis
Color Separation: Penez, Lille

Distributed in North America by Rizzoli International Publications, Inc.

Simultaneously published in French as *Extrême sud: périples antarctiques*
© Arthaud, Paris, 2005

English-language edition
© Flammarion, 2005

87, quai Panhard et Levassor
75013 Paris
www.editions.flammarion.com

06 07 4 3 2
FC0510-06-IX
ISBN-10: 2-0803-0510-7
ISBN-13: 9782080305107
Dépôt légal: 10/2005

Printed in Italy by Canale